W9-DFU-538

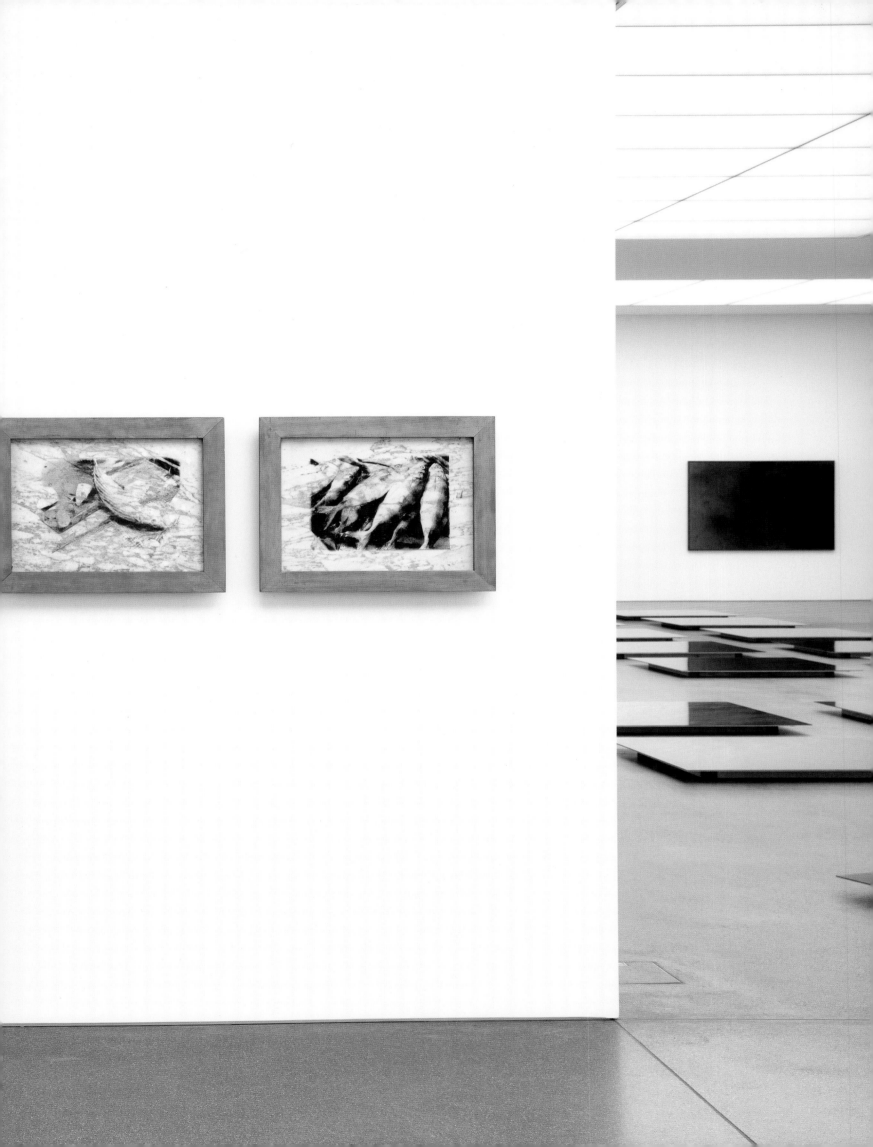

Photography in Motion

Stephan Kunz

In 1989, plans were being made to memorialize the invention of photography 150 years earlier. During that time, the medium had rapidly evolved in terms of technology, form, and content and had become a mass medium. Consequently, there were various ways in which this anniversary could be celebrated. At the Aargauer Kunsthaus we thought about what contribution we could make to the celebration of this anniversary. At the time, art museums did not view it as self-evident that the same worth should be attached to photography as to other artistic media, both in exhibitions and collections. In this context, we wanted to take a strong stance, carving out an important place in the art realm for photography, and this not as an isolated action for the anniversary, but as the starting point for a new approach.

We therefore organized three exhibitions to mark the 150th anniversary of photography: *Heraus aus Dreck, Lärm und Gestank* (Out of the Dirt, Noise and Stench) was dedicated to classical documentary photography and showed photographs taken from an archive of images of workers. The second exhibition was dedicated to Anita Niesz, a Swiss photographer who was not well known at the time; she had started out in commercial photography and then devoted herself above all to the human image. The third exhibition was the greatest challenge for us: How could we offer a platform for contemporary photography? A large survey exhibition or an exemplary solo exhibition? I remember well the beautiful day when we withdrew into a darkened meeting room: myself and Beat Wismer, along with Urs Stahel, whom we had invited. Stahel had arrived with several boxes of slides (!) and offered us an impressive perspective on the photography being produced in Switzerland at the time. There was a great deal we learned or began to see in a new way; we tried to determine characteristics, identify trends, find commonalities—always remaining open to all the different possibilities of an exhibition of contemporary photography in Switzerland.

The "Reinvention of Photography"[1]

In the end, we chose Hans Danuser, who in the years prior had been working on *In Vivo* (fig. on p. 124) and had at that point just finished it, making it possible to show the entire, extensive work for the first time. We were interested in the urgency of these seven series, which touch on socially volatile themes. But we found his unconventional approach to the medium of photography convincing. Although Hans Danuser retains the form of classical reportage photography in the series, and also employs its techniques, he moves decidedly beyond it. In the end, this approach is not a documentary one, but rather an attempt to create images that have great intrinsic value and contribute to one another in the series that they form. Expression is given far more weight than realistic content. Yet Hans Danuser operates in a space entirely beyond the medium of photography; he wants to develop its specific qualities, in order to give it a new pictorial value. It is precisely because he has so decisively chosen to move within the medium of photography, without trying to preserve anything or deny its elementary features, that Danuser was predestined to celebrate the invention of photography and to ring in its "reinvention."

Each new group of works by Hans Danuser reveals another step in the evolution of photography, right up to his most recent large project, which was first presented in the exhibition at the Bündner Kunstmuseum in Chur in 2017, and whose title, *The Last Analog Photograph*, is programmatic in character. Before this came the *Frozen Embryo* series (fig. on p. 166), in which everything

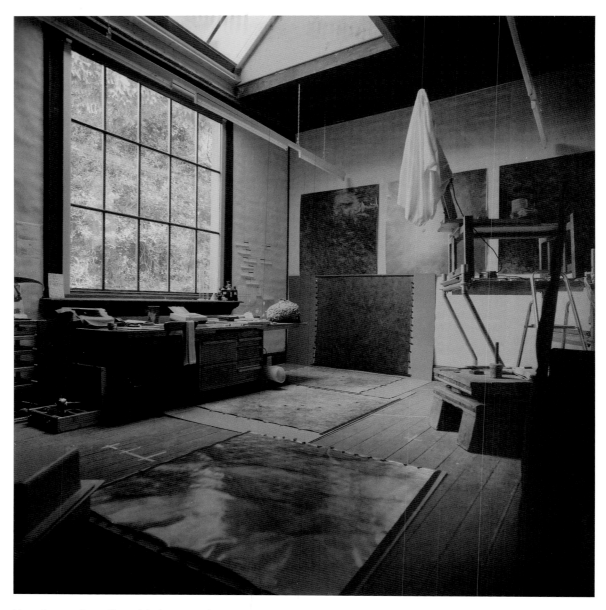

Hans Danuser's studio and darkroom at the Arnold Böcklin studio in Zurich from 1991 to 2001, view of the interior with pictures

centers on what cannot be shown and ultimately also what cannot be said of research on the human embryo; the series entitled *Strangled Body* (fig. on pp. 186 – 195), which features close-ups of maimed bodies that Hans Danuser elevates to an abstract monumentality and at the same time gives them an overpowering physical presence; the floor installations with photographs from the series *Erosions* (fig. on pp. 56 – 73), in which the slate sand in the photographs is very consciously linked to the tonality of the baryta paper. His numerous experiments with the material aspects of photography have preoccupied Hans Danuser since his earliest days as an artist and are found in all his series. When, in his latest cycle of sand photographs, he collaborates with scientists in a chemistry lab to develop photographic layers that make it possible to connect the material and the image in new ways, he is opening another chapter in this "reinvention," remaining at the same time conscious of its endpoint.

Photography in the Context of Art

That the first comprehensive presentation of the seven-part photographic work *In Vivo* in 1989 was held in an art museum makes sense for both Hans Danuser and his work. At the time, the exhibition would also have been conceivable as a project of the Schweizerische Stiftung für Photographie (now Fotostiftung Schweiz); at the Musée de l'Elysée in Lausanne, which specializes in photography; at the Schweizerisches Landesmuseum; or at the Museum für Gestaltung in Zurich. From the outset, however, Hans Danuser's understanding of photography as artistic work has been part of his self-image, and he wanted photography to be conceived of in this context too. It was also part of his artistic methodology that various different paths for the reception of his work should be left open—including those which fell outside of the art context.

Hans Danuser had already set off on the path to art by the mid-1970s, when he successfully applied for the Eidgenössisches Kunststipendium (Federal Art Scholarship) in 1976 for his experiments with photographic materials, the *Marblegraphs* (fig. on p. 6), and he is still proud even today that he was permitted to enter his photographs into that competition, despite photography having been categorized as applied art. The art critic Hanna Gagel observed on the occasion of the exhibition *Fotografie 3* at the Strauhof in Zurich in 1982 that his *A-Energy* series, which was being shown for the first time, represented a "refinement of commercial photography that can be grasped at a glance,"[2] thereby definitively opening up the reception of that work within the framework of fine art. In 1983 Hans Danuser participated in the *aktuell '83* exhibition at the Lenbachhaus in Munich, which was an attempt to use examples from the work of around forty artists from Milan, Vienna, Zurich, and Munich to illustrate what painting and sculpture, video, photography, and the environment meant in those years. Erika Billeter selected the artists from Zurich. They included Anton Bruhin, Hans Danuser, Martin Disler, Peter Emch, Peter Fischli/David Weiss, Leiko Ikemura, Urs Lüthi, Thomas Müllenbach, and Klaudia Schifferle. Hans Danuser was the only

Brigitta and Hans Danuser with their son Hans Andrea at the
In Vivo exhibition, Aargauer Kunsthaus, Aarau, 1989

Swiss photographer represented in the art context, which, as Hans-Joachim Müller noted in the weekly newspaper *Die Zeit*, was primarily looking inward: "That is what strikes one immediately looking at this vividly nonhomogeneous cross section: hermetic impenetrability, insular self-references, a climate of looking inward. Hardly any artists sought a break with accepted forms, on the contrary: the questions of what had been constructed and how it had been constructed were not up for discussion. [...] Anything which seemed to represent a reaction against the contemporary context was not placed center stage, and instead remained hidden in a state of torpor. Clearly, they are all seeing the same specters, these artists, but they cannot say what they are called. The postmodern condition is the awareness of the lateness of the age."[3] It is interesting that the series of photographs shown by Hans Danuser at the time, *A-Energy*, was examined within the framework of subjective worldviews, against the backdrop of the "darkest emblem of the epoch: angst."[4]

In 1987, Hans Danuser was again invited to exhibit at a representative exhibition of recent Swiss art. In the exhibition *Offenes Ende* (Open End), curated by Manfred Rothenberger and Urs Stahel at the Institut für moderne Kunst in Nuremberg, of the forty-eight artists only six showed photographs: Francisco Carrascosa, Hans Danuser, Peter Fischli/David Weiss, Felix Stephan Huber, Beat Streuli, and Hanna Villiger. Increasingly, however, photography has become a mainstay of contemporary art, and Hans Danuser's works contributed to this process. Collections also demonstrate this development: since the mid-1980s, Danuser's works have entered the collections of the Bündner Kunstmuseum in Chur, the Aargauer Kunsthaus in Aarau, the Kunsthaus Zürich, and the Metropolitan Museum of Art in New York, as well as private collections.

This initial reception of Hans Danuser's photographic oeuvre was important for the artist, who was thereafter seen in the context of a contemporary photography that was leaving behind traditional ideas and opening up new fields. The few solo exhibitions that Hans Danuser has had in museums underscore this trend: the exhibition at the Aargauer Kunsthaus in Aarau in 1989 was followed by exhibitions at the Lenbachhaus in Munich (1991), the Bündner Kunstmuseum in Chur (1993), the Kunsthaus Zürich (1996), and the Fotomuseum Winterthur (2001). The exhibition at

Hans Danuser and Juri Steiner installing the exhibition *Hans Danuser: Delta* at the Kunsthaus Zürich, 1996

Hans Danuser working on the *Alphabet City* project in New York, 1984

the Bündner Kunstmuseum in Chur in 2017 was the first comprehensive presentation of his artistic oeuvre since the large solo exhibition at the Manege Central Exhibition Hall in Moscow in 2006, more than ten years ago. It was the first attempt to provide a survey of his work since the mid-1970s.

Expanded Reality

Hans Danuser is one of the most important Swiss protagonists of the new photography that has emerged since the 1970s, which was presented in the exhibition *Wichtige Bilder* (Important Images) at the Museum für Gestaltung in 1990, curated by Urs Stahel and Martin Heller. Hans Danuser, too, was represented in that exhibition, with individual series from *In Vivo*. His work also formulated the core of the heated discussion of photography which surrounded the exhibition. Urs Stahel formulated his critique of classical photojournalism in the catalog to the exhibition, claiming that it was outdated in the contemporary context: images "fail when their faith in the subject and their old understanding of observing and mirroring fragments no longer conform to our experience."[5] And he called for a contemporary photography which would reflect the new questions being asked of artists in the face of an increasingly complex world of images.[6]

Hans Danuser begins precisely here. Although in *In Vivo* he still seeks out places in which to make his observations, he does not remain stuck in the phenomenological experience of the world, but rather reflects on his experiences and perceptions in a complex engagement with the themes selected. His photographs avoid pointing to one unambiguous interpretation. Instead, Hans Danuser seeks out open discourse. Collaboration with experts from specific spheres of knowledge provides the basis for his work. Hans Danuser's art has repeatedly put him in contact with people from different contexts. A work such as *In Vivo* would be inconceivable without the trust that the artist is able to earn for himself and for his equally conscientious and urgent work. The participants in his conversation come from very different spheres of knowledge. From the outset, however, he has actively sought to bring his photographs into new contexts so that they

are not appreciated solely in the art world. As a result, the circles of reception for his work have continuously expanded.

The list of thematic exhibitions in which his works have been included is as long as it is revealing. Publications and exhibitions have in turn inspired new collaborations: for example, the architect Peter Zumthor saw the first three series of *In Vivo* at the Bündner Kunstmuseum in 1985 and then invited Hans Danuser to photograph three of his buildings. A little later, the writer Reto Hänny studied the artist's photographic oeuvre intently and produced an autonomous literary work based on it. As early as 1982, Hans Magnus Enzensberger published photographs from *In Vivo* in his journal, *Transatlantik*. In 1984, photographs from the series appeared in *pan arts*, a magazine from New York's subculture that combines all the arts, and also in 1989 in *Fabrik-Zeitung*, produced by the Zurich cultural center Rote Fabrik. Other photographs found their way into theater programs (Stadttheater St. Gallen 1989, Stadttheater Bern 1992) or literary journals (*Entwürfe*, 1992). All this is evidence not only of Hans Danuser's connections to the active and involved cultural scene of his time, but also of his clear interest in his photographs becoming part of the discussion. This exposure was presumably much less about self-marketing than about a keen interest in the process of exchange.

Art and Space

Hans Danuser has been concerned not only with a broad reception of his art but also with the careful presentation of his work. I still recall quite vividly how important the special presentation of the photographs from *In Vivo* was at the Aargauer Kunsthaus in Aarau in 1989: the work is clearly divided into seven series, each of which has not only a specific sequence but also a rhythmical arrangement that turns the linear presentation into a spatial composition. Hans Danuser made that very explicit in the title of his Zumthor project: *Partituren und Bilder* (Scores and Images). With the *Frozen Embryo* series, in which the works feature strikingly larger formats and all have multiple parts, it became clear that the exhibition space should now be considered as well and that Danuser's photographic oeuvre was increasingly reflecting on concepts from the fine arts. Hans Danuser quite deliberately presents these series above eye-level, resulting in a special relationship between the viewer and the image. The artist takes this idea even further in the floor installation *Erosion*. He leads us on a walk through this landscape and encourages us to observe what we are seeing. At the same time, he radicalizes his chosen theme, erosion, since fixed points are increasingly lost. Perhaps the photographic material ultimately remains the only solid thing, whereas the image as image increasingly disappears or is exposed as pure fiction. Not least for that reason, we are as fascinated as we are baffled when we stand in front of the photographs of *Sandstorm I–III* (fig. on p. 20), as our gaze sinks down into unfathomable expanses and concrete space breaks down, while in the grain of the close-up we perceive the materiality of photography, and recognize it as a constitutive element of a world view that has become uncertain.

We made a very conscious decision to leave the spatial structure open at the Bündner Kunstmuseum, not placing partition walls between the groups of works—the exhibition photographs in this volume show that clearly. The idea was to make it possible to experience Hans Danuser's creative work as a path. This reveals both his artistic development and the connections between the groups of works. This spatial arrangement also permits us at this point to draw a

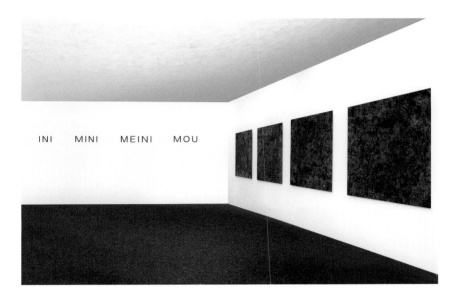

INI MINI MEINI MOU

Installation of the *Frozen Embryo series*, 4ᵉ biennale d'art contemporain de Lyon, 1997

parallel with the series of spatial works by Danuser that began with the *Schrift-Bild* (Type Image) installation at the Universität Zürich-Irchel in 1992[7] and evolved over a number of exhibitions and projects which were situated within and with architecture. Again and again, they manifest Hans Danuser's spatially subtle approach, which has its origin in the arrangement of his photographs into installations.

Art and Commitment

Hans Danuser made it clear from the outset that for him making art always had something to do with our time, with our society, and with the circumstances in which we live. This becomes explicit in the classical eyewitness photographs of New York which offer insights into its politicized subculture in the early 1980s. Hans Danuser is here not an impartial observer, but instead himself part of the scene. Right from the beginning, he was moved by the currents of the age. That is still manifested in his art today. His commitment is very clear in the work *In Vivo*, which by his own account he hung on the spray-painted walls in Brooklyn to lend them particular urgency. In other series, the artist's cultural and sociopolitical engagement is much more subliminal. In the *Frozen Embryo* series, of course, discussions of gene research and gene technology resonate, and *Strangled Body* manifests a nonspecific brand of violence, even if it was the war in Yugoslavia, with its excessive violence, which formed the political backdrop for these large-format photographs. Don't these images get under your skin more than press images from theaters of war? Considered in this way, the photographs of the floor installation *Erosion* are much more than closeups

Double page: Setting up the exhibition *Dunkelkammern der Fotografie (Darkrooms of Photography)* at the Bündner Kunstmuseum, Chur, 2017

of alluvial land made up of slate sand. The floor literally slips away from under our feet—a symbol for a time in which so much is slipping away, both socially and politically. And in his latest monochrome photographs, which put us into the middle of a "sandstorm," we lose every certainty and are ultimately completely thrown back onto ourselves and our perception.

Hans Danuser has developed his artistic work on the basis of a worldview turned uncertain and a faith in his own powers of perception, and in the process he has explored photography in its different dimensions.

1
Bettina Gockel and Hans Danuser, eds., *Neuerfindung der Fotografie: Hans Danuser; Gespräche, Materialien, Analysen* (Berlin: De Gruyter, 2014).

2
Hanna Gagel, "Das 82er Lebensgefühl in fotografischen Spuren," *Tages-Anzeiger*, December 29, 1982.

3
Hans-Joachim Müller, "Himmel und Hölle," *Die Zeit*, October 7, 1983.

4
Ibid.

5
Urs Stahel, "Fotografie in der Schweiz," in *Wichtige Bilder: Fotografie in der Schweiz*, exh. cat. Museum für Gestaltung (Zurich: Der Alltag, 1990), 235.

6
Ibid.

7
Institutsbilder: Eine Schrift Bild Installation, Universität Zürich, 1992, typography on the wall in the departmental corridors of the Universität Zürich-Irchel. Typography applied directly by stencil, watercolor on white, interior, emulsion paint. Overdoor: photograph on baryta paper mounted on 2-mm aluminum.

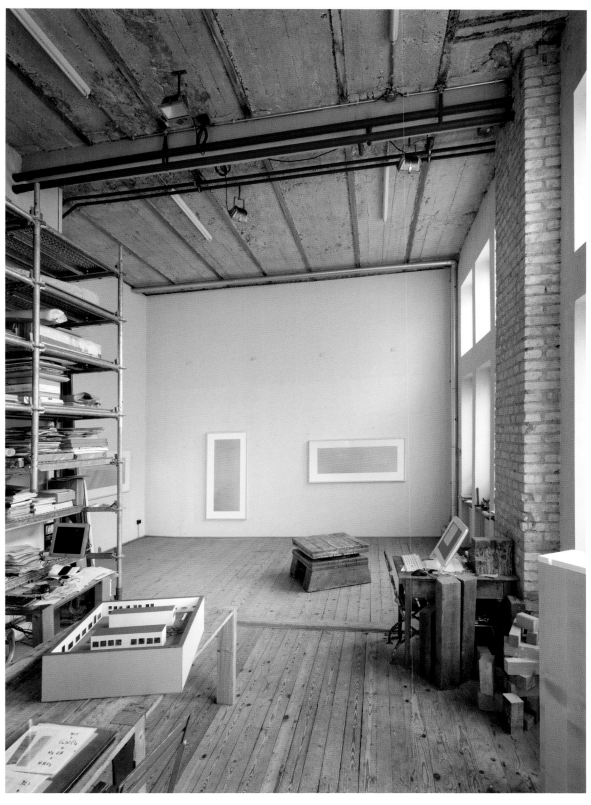

Hans Danuser's studio and darkroom on Ottikerstraße in Zurich since 2001, view of the interior

THE LAST ANALOG PHOTOGRAPH
LANDSCAPE IN MOTION
2007–2017

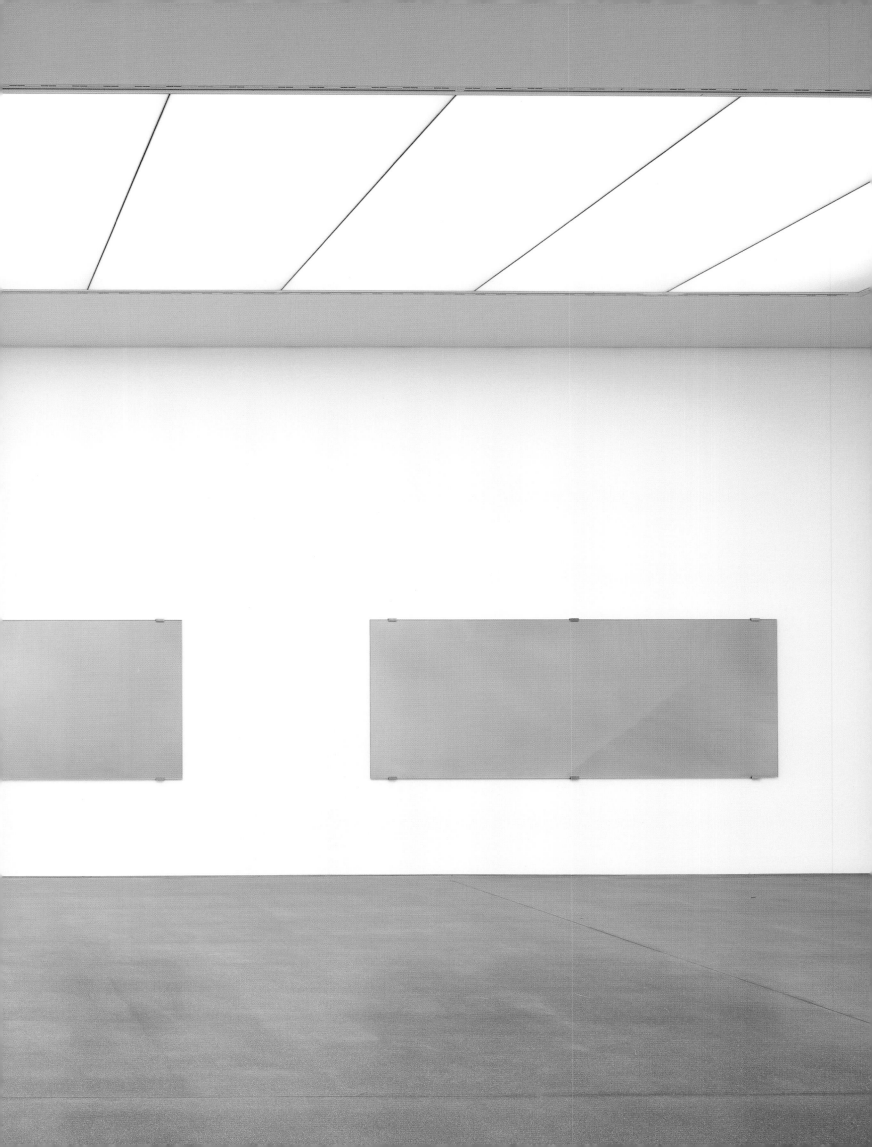

SANDSTORM

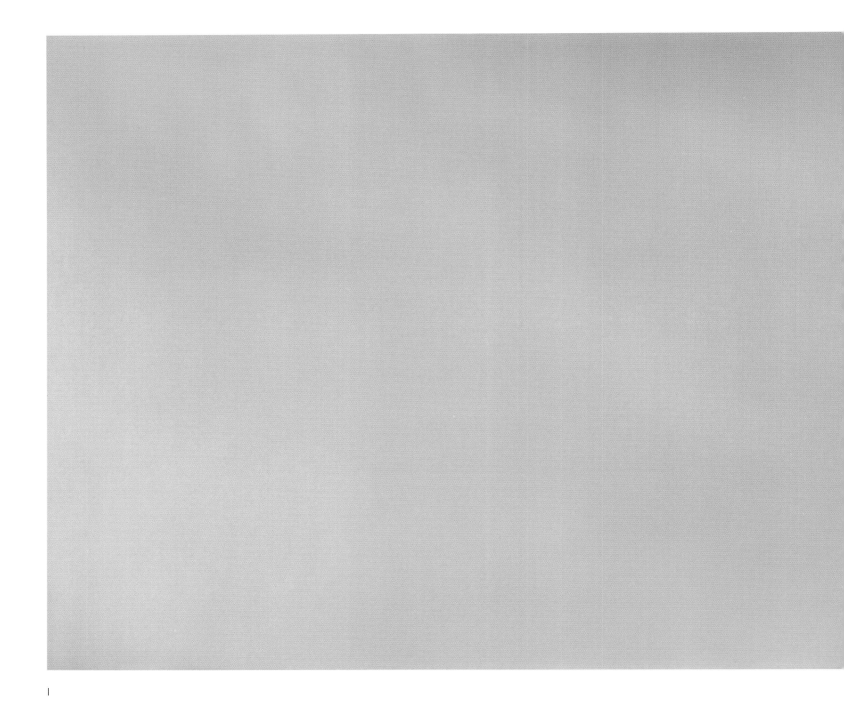

I

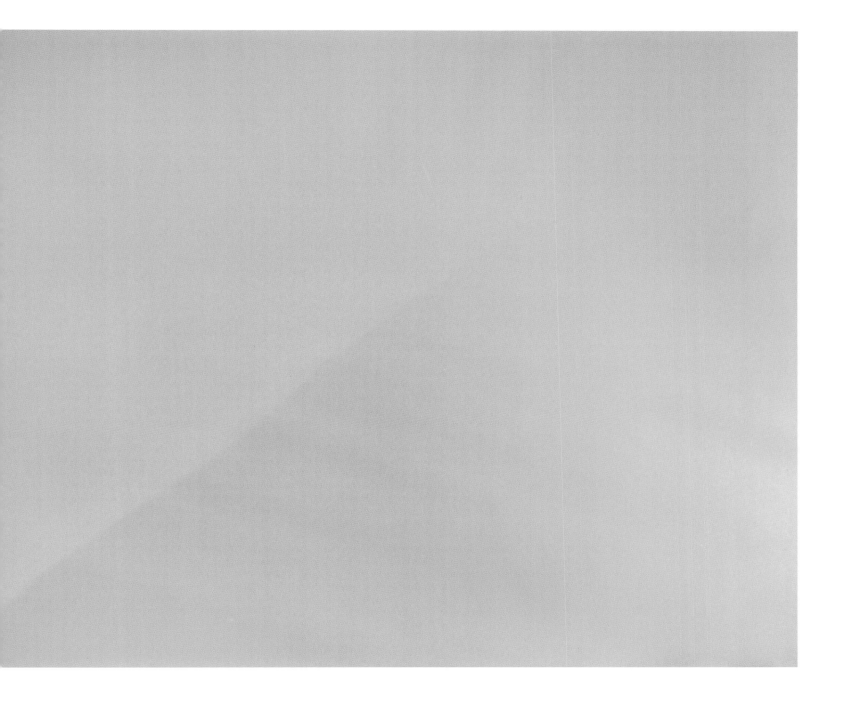

II

III

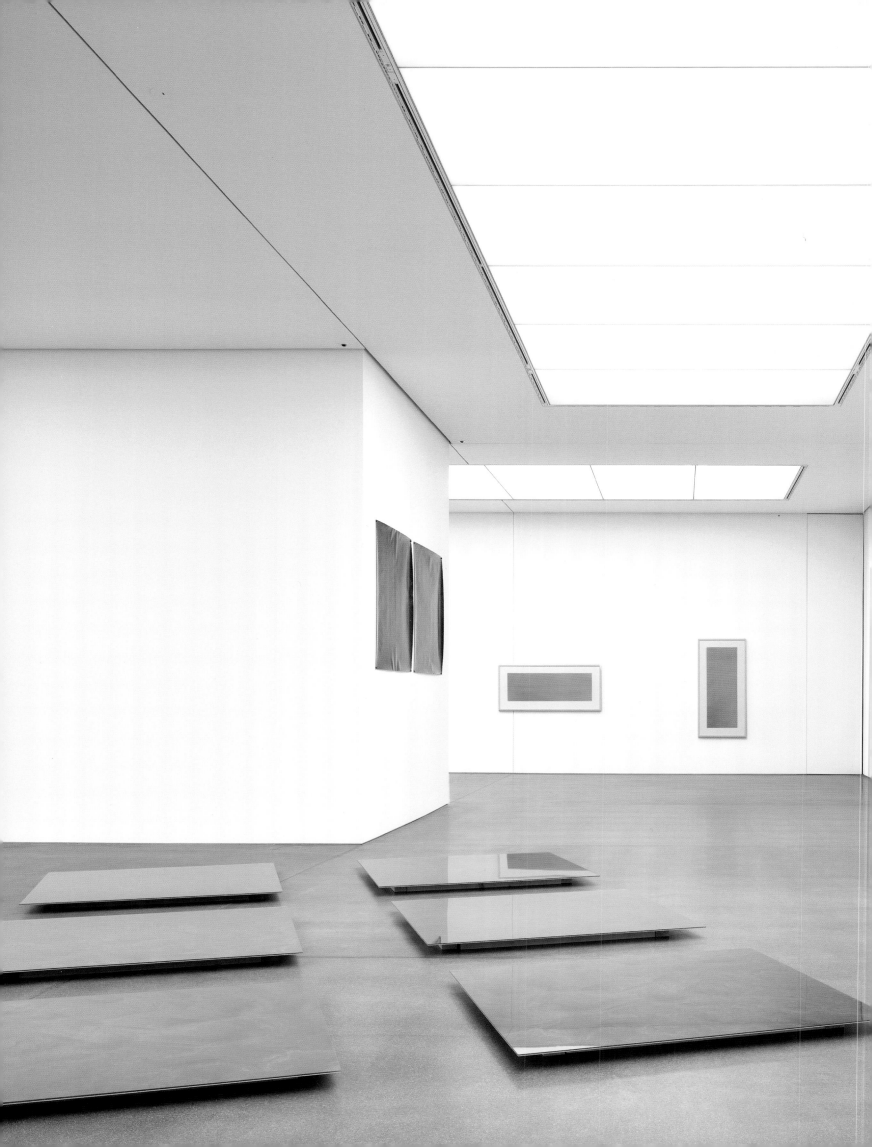

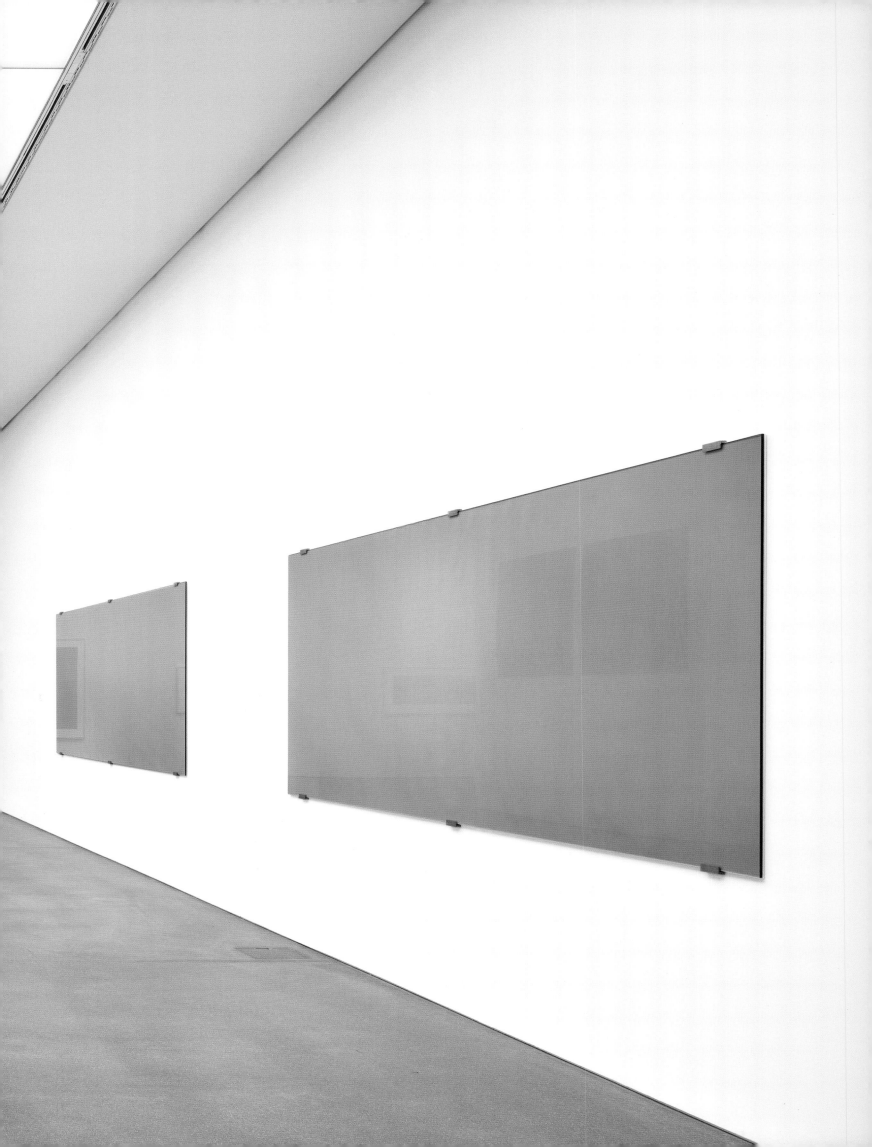

THE LAST ANALOG PHOTOGRAPH

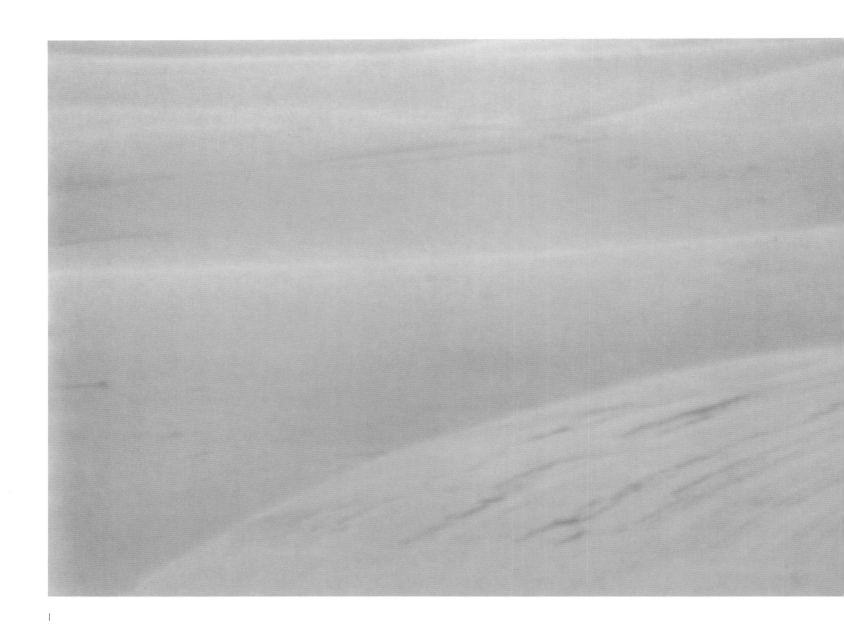

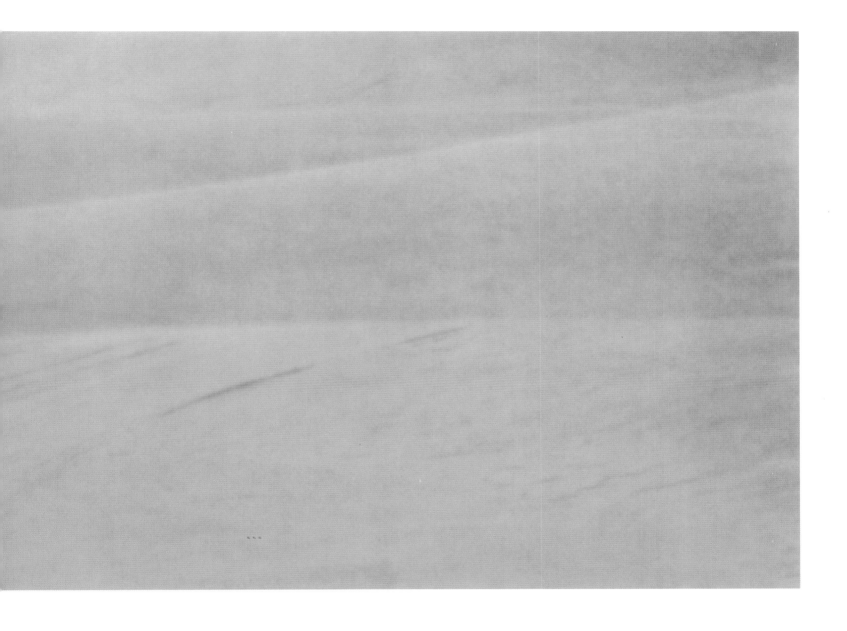

V

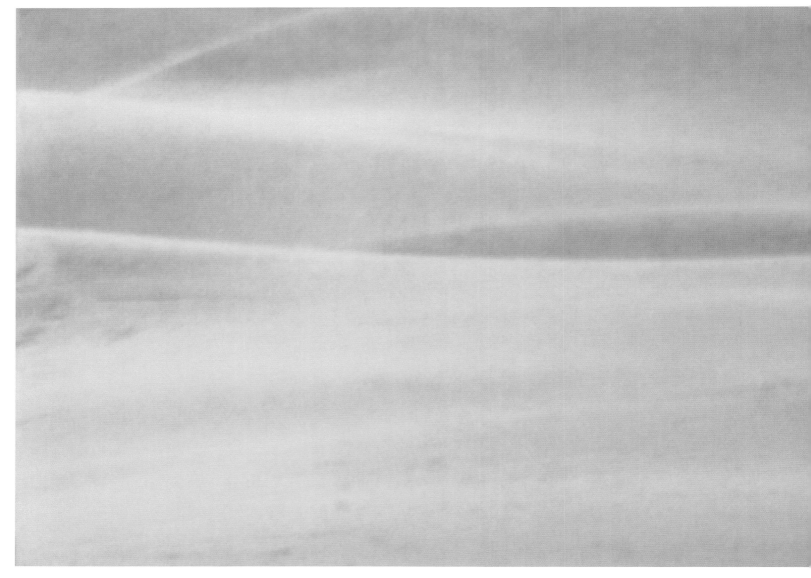

VIII

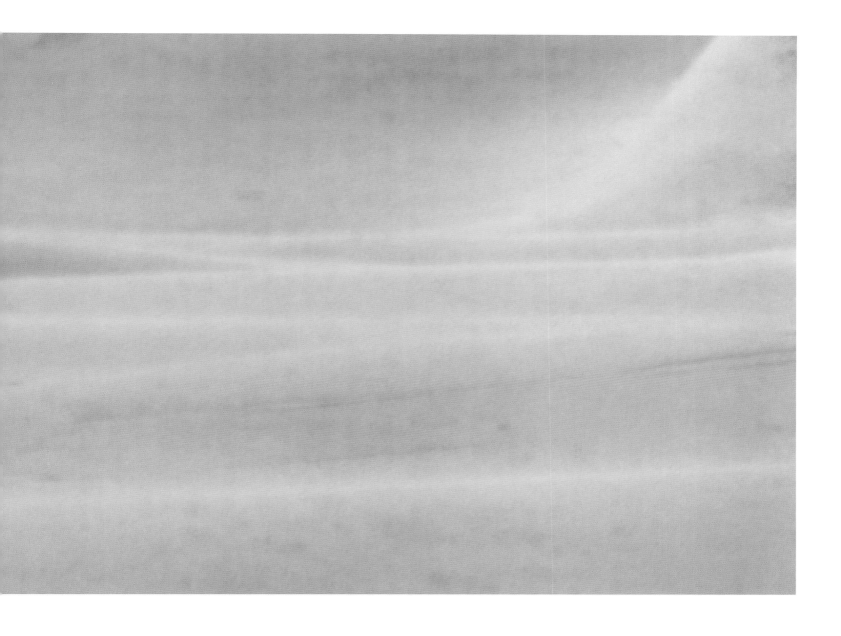

XXII

THE LAST ANALOG PHOTOGRAPH

A1

A2

A3

A4

A5

A6

A7

A8

C1

C2

C3

C4

J1

J2

J3

J4

45

A9

Through the Looking-Glass: Hans Danuser's "Last Analog Photograph"

Kelley Wilder

Analog photography is layered in many ways. Some of these layers occur, so to speak, "in front" of the photograph and some occur "behind" it. Up front we encounter the image. It has meaning upon meaning, altered slightly by installation, viewer, lighting, and caption. Behind the image and less visible are a series of material layers made of silver bromide suspended in gelatin, optical brightener, paper, and so on. The material layers and the layers of meaning in the image are inextricably linked.

Like Lewis Carroll's fabled Looking-Glass, on one side of the photograph is the image of the world as it appears to be. To Alice, it was the image of her sitting room. Once she stepped through the glass, she arrived in a world governed by different laws. To climb to the middle of the garden, Alice had to set off determinedly in the opposite direction, on a trail "more like a corkscrew than a path." The material side of analog photography is also governed differently, not by foreground, background, and middle ground, but by lattice structures, electron traps, and Frenkel defects. Here the book of nature is written in another language; the chemical language of the latent image $e^- + Ag_i^+ \rightarrow Ag_i^0$.

Carroll was the pen-name for Charles Dodgson, a mathematics tutor at Christ Church, Oxford, and a prolific Victorian photographer.[1] Each collodion negative Dodgson prepared was an exacting affair, and he was well versed in the upside-down and back-to-front camera image, as well as in the oft-recalcitrant chemistry of handmade analog photography. We forget that behind photographic images are materials and the people that prepare those materials. We forget, too, that all the decisions they make in the preparation of those materials affect the image that we eventually see. All too often, though, it is the image that is privileged at the expense of a more material understanding.

In *The Last Analog Photograph*, Hans Danuser has set out to examine the photographic image and to highlight its material nature, by delving deeply into its structures and unpicking the threads from which photographic images are made. Like the first photographic experimentalists in the 1830s and 1840s, nature is his inspiration. The project is rooted in a larger, overarching investigation of the complexities of *Erosion*. Through all three parts runs a strong narrative about the relationship of photographic material to its resulting images. Before *Erosion* though, Danuser brought the color of monochrome photography to the surface of ice in the *Frozen Embryo* series. The light and dark distortions of ice are at once familiar and strange. Black ice, white ice, and gray ice emerge from the crystalline structures of photography and evoke the inner symmetry of ice crystals. The lattice structure of salt crystals (also silver salts) and the crystalline structure of ice created a dialog in constant motion. It was a dialog about structure as well as about impermanence. Land ought to be so much more fixed, but Danuser shows us that it too is in a constant state of transformation. The first part of *Erosion* consists of photographic slates of silver bromide baryta paper supporting an image of the eroded, anthracite-laced slate sand. In this metamorphic landscape, silver bromide (AgBr) with its cool, bluish grays not only represented the tonal values present in the slate; it also reflected its subtle coloring. He found, in the layered landscape of the Alps in Switzerland and the slate hills of Wales, a natural target mimicked perfectly by the chemistry of analog photography. It was, as photographic inventor William Henry Fox Talbot put it in 1839, "Nature magnified by Herself."[2] Early writing on photography is redolent with similar language that posited photography as the mechanical conduit for natural imaging. Talbot's image of nature was likely a reference to the similarity of the forms that left their mark on the paper, rather

than the chemical reactions that led to the image. He wrote of an uninhibited enjoyment of the wonder of natural imaging. In the case of *Erosion* and its third part, *The Last Analog Photograph*, nature is also wondrously magnified. More importantly, it is also colored.

In 1896, Charles Cros, the French poet and photographic inventor, described colors as essences with three dimensions.[3] No better description could characterize the colors of the photographs made for *The Last Analog Photograph* project. They have a physical and metaphorical depth that is tangible and lasting. Not content with limiting his investigation of such an extraordinary co-incidence of chemistry and landscape to Switzerland, and the palette provided by eroded slate, Danuser set his sights on a new landscape, exchanging eroding ground for the fluid and ever-changing landscape of the desert.[4] In choosing sand as his muse, Danuser invokes not only a *Landscape in Motion*, as the series is subtitled, but also the fragility of a single moment of organization of material grains of sand and silver. The phenomenon of desert movements extends across the world but it is also intensely local. As it moves, it drives change before and behind it. Houses are slowly covered over, people relocate, dunes change shape, deserts expand, geological borders are redrawn. Deserts are both natural and man-made, evolving in a complex series of events that in the past have been natural, but in the present are more likely to be the result of climate change or land misuse. "Desertification" is a relatively new word describing the intricate, centuries-old transformation of semi-arid landscapes into deserts. Slowly, slowly the sand inches in between and then over the top of greener vegetation until the landscape inexorably changes to the colors of sand.

The complexity of photographic layers is an apt analogy for the complexity of the desert. Natural forces that order sand into sculpted dunes are evoked by the moment in which silver particles coalesce in image formation. If bromide chemistry could mimic not only slate, as it did in *Erosion*, but also the shifting perception of colors as light strikes those formations, surely it could also achieve such a singular correlation with the dunes of the Gobi desert? To achieve such a correlation, Danuser and a team of scientists at the ETH Zurich would have to turn a century of commercial photographic paper production on its head, and reinvent analog photography one layer at a time.

Creating the last analog photograph is very much like creating the first. The experimental process is fraught with uncertainty; expensive, time-consuming, and often fruitless. Almost any combination of materials seems possible. Danuser at least could lean on the knowledge of 180 years of chemical manipulation. The first inventors had no such support. Talbot's 1839 and 1840 notebooks suggest the kind of profusion of possibilities in the absence of such knowledge: hydri-odate of zinc, bromide zinc, bismuth, gum benjamin and chloride silver, sublimed muriate ammonia washed with nitrate of silver and dipped in water saturated with nitrate potash, a pasty mass of chloride or bromide silver pressed between hot copper plates, milk or cream for opalescence—the list is both long and unexpected.[5] Sir John Herschel and Mary Somerville, also working in the 1840s and 1850s, extracted colors from flowers to create light-sensitive papers on which they performed hundreds of experiments.[6] Here, the upside-down and inside-out world of botany and chemistry prevailed. Robert Hunt, another early experimental chemist, warned colleagues, "[t]he color of a flower is by no means always, or usually, that which its expressed juice imparts…" For instance, red damask roses gave "a dark slate blue" and red poppies a "rich and most beautiful

blue color."[7] Sometimes, to achieve the most natural colors, they needed to head in the opposite direction. For all the precision of Danuser's original idea for *The Last Analog Photograph*—to create a photographic paper that mimics the color of sand—nature has her own agenda.

To find a chemical substance that would color bromide paper according to the artist's wishes, and render a photographic image as well as a photographically natural color, Danuser and Professor Reinhard Nesper, working alongside a team of enthusiastic scientists, had to follow a path parallel to that of the original inventors.[8] Knowledge that had been kept secret under patent protection for nearly a century needed to be utilized once more. Turning what was essentially bulk-manufactured commercial paper back into individual handmade photographic surfaces required the precision of a laboratory chemist. The back-to-front natural reactions had to be made to yield predictable, and replicable, results. The only way to begin was with trial and error. Some combinations resulted in dead ends, while others showed promise. Certain metal salts were more reliable than others. Long before the results could be translated into a clear set of rules about combinations and colors, there was a more speculative phase. Each layer of the process is important. The paper is one element, the chemistry another, the brightening layer yet another. Each layer was trialled separately, and then carefully combined. These trials, and even some of the errors, elicited repeated exclamations of wonder: dark red! colorless! The experiments were not just a mechanism for making a certain kind of photographic paper. They were a vehicle for rediscovering wonder in this strange world of photochemistry. Wonder is also an ever-present emotion in Herschel's and Talbot's notebooks of the 1840s. The snippets of paper produced in their experiments are coded and sequenced symmetrically. They evoke the orderly natural history catalogues of the eighteenth century and imply a seductive sort of mastery over the chemical world.

The "Last Analog Photographs" that resulted from these trials are a delicate tightrope walk of light sensitivity, practicality, and durability. While this balancing act has always been present in photography, Danuser brings it to the surface, making this conflict as present as the image. It is perhaps presence that marks out the differences between these photographs and what Lyle Rexer has called "the antiquarian avant-garde."[9] In the more alchemical works of that period, the reactions of photographic chemistry are the subject of the photographs. Here the subject is still the ice, the slate, and the desert. *The Last Analog Photograph* is not a project steeped in nostalgia about analog photographic chemistry. At its heart is still the image. That differential focus turns the photographs from a chemical discussion into a dialog about how we see. Perhaps it is a dialog that has only become possible in the digital age.

The moving landscape at the heart of *Erosion* and its last part, *The Last Analog Photograph*, asks difficult questions about how we see analog photographs in our digital age. Photography is also a shifting landscape here. One that reminds us that vision, like the landscape, is not fixed. Walking in front of the triptych *Desert Storm*, the grains gather up into images and dissolve back into grains (fig. on pp. 22–27). A ridge of a dune becomes visible, then melts away on either side into a sea of sand. The color of the image shifts in the changing light, mirroring the unstable foundation of a dune. At times, the lustrous baryta exerts enough force to be seen as the image, and at times it retreats into the image. It is as if the landscape is emitting its own light and forming its own colors. The effect has something to do with the subject matter and viewing distance, and something to do with the structure of the paper.

Hans Danuser in Rafael Buess's
darkroom in Bern

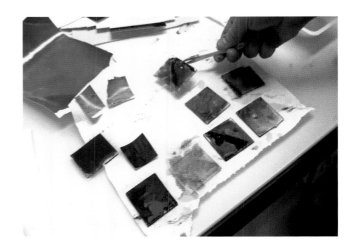

Samples of paint on glass supports in the Laboratory
of Inorganic Chemistry at ETH Zurich

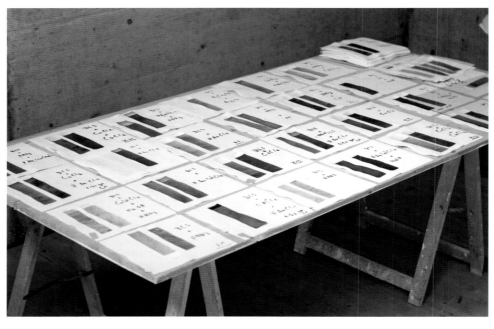

Samples of paint on paper supports in the studio

The effect is in part the result of the baryta layer, scattering light back through the silver bromide particles. Baryta, which is commonly called barium sulphate but often also includes strontium sulphate in photographic papers, has been used as a coating for photographic papers since Juan Laurent and José Martínez-Sánchez offered their Leptographic photographic paper for sale in 1866.[10] Not only does it whiten the paper much better than Talbot's suggested milk or cream, it also scatters light. The scattering of light effects color changes in most photographic materials, and the works in *The Last Analog Photograph* are no different. While the base colors of gray-brown, orange-brown, and yellow set parameters for the color change, they do not limit it in any way. A change in the quality of the light or the angle of viewing elicits shifts from blue to red to orange, and sometimes toward a neutral brown monochrome. This effect most often stems from reflected light, which acts very differently from transmitted light. Digital images have their own materiality, and part of it is fixed in the light source. That light source is more constant than daylight, and fixed at a certain angle. It is evenly distributed and lacks the variability of reflected light. The startling homogeneity of the constant light source once elicited astounded reactions from crowds in lantern demonstrations. Now it dazzles the eye to the point of fatigue.

What makes one photographic way of seeing "normal"? In the nineteenth century, photographic materials were more sensitive to the blue, violet, and ultraviolet end of the spectrum. Yellow was represented in the same dark gray as green. Red looked darker than blue. After the introduction of panchromatic film, a correlation between monochrome gray scales and the world around us became naturalized. Advertising convinced audiences that this was so. Analog photography of the 1970s was predictable. When Danuser made the series *In Vivo*, photographic materials were reliable and for the most part predictable in their reactions to light situations. These photographic materials were the result of half a century of commercial film research and production by firms like Ilford, Kodak, and Agfa. Each new film cost each company years of work and hundreds of thousands of euros to develop. Each embodied this delicate balance of resolution, light sensitivity, and predictability. In spite of these standardized reactions, created for a commercial market, Danuser noticed peculiarities surrounding the color of ice when rendered in monochrome film. The warmer the ice was, the blacker it appeared on film. From these observations emerged the *Frozen Embryo* series. White ice, black ice, and ice in shades of gray demonstrate how present the commercial photographic chemistry was in the images. Attention shifts from the image to the colors, and back to the image—it is never still.

In this shifting landscape of perception, Danuser has given us a new way of seeing color. The variation of color and color perception was perhaps most famously elicited in Goethe's theory of colored shadows. In *Zur Farbenlehre*, he argues against Newton, who conceived of shadows as merely the absence of color. Goethe's argument turned the vision of shadow from an absence into an opportunity. He saw the possibility of shadows and their constantly changing colors. Danuser renders a similar service to light. *The Last Analog Photograph* invites us to see light through the eyes of photography, and to conceive of monochrome analog photography as subtly and pervasively colored. It requires time and patience and a certain amount of diligent observation. Experiencing the desert requires a similarly patient attiude. At first, the scrubby browns seem to indicate the absence of green. In time, though, the browns distinguish themselves from one another, transforming into a rich kingdom of color that lacks for nothing. By using

the color of sand as a guide for the chemical experiments, Danuser invites us to contemplate what a true image of sand might look like.

To find the true image, it is necessary to look at a single spot from many different angles, or to examine it many times from the same angle. A single photograph usually opens up only one fixed perspective, but Danuser's images require to be examined from multiple angles. In spite of their description as "monochrome," the images are not all one color. Repeated viewing of the photographs throws up a cloud here and a cloud there, and perhaps the ridge of a dune. One photograph is a bit orange, the other nearly gray with a yellow cast. Horizontal but without a horizon, the photographs urge us to contemplate the colors of land in the absence of sky. Comparisons to Turner's fantastic mergers of sea and sky abound in both the colors and the images. Turner's pair of paintings *Shade and Darkness—The Evening of the Deluge* and *Light and Colour (Goethe's Theory)—The Morning after the Deluge—Moses Writing the Book of Genesis* are visual testament to Turner's interest in color theories and the broader scientific dialogs about light, light sensitivity, and perception that interested so many in the middle of the nineteenth century.[11] Danuser's photographs go a step further by merging the image with the material. The grains of silver and grains of sand create a new dialog that not only concerns the image, but also shapes it. It makes it impossible to consider the images without considering the materials.

How do these structures form the perfect image of our imagination, of the lens through which we see the world? *The Last Analog Photograph* is an installation of living, moving things fixed in a photographic image. Like the dunes, which are in constant motion, the audience moves, changing the way the light reflects off the photographic surface, setting the materials in motion as well. It is a landscape of infinite possibilities. Deserts are laid out on maps but are constantly reshaping their borders. Color is also a shifting target, infusing the monochromatic emulsion. That there is color in monochromatic photography is one clear conclusion to draw. These photographs also extend the bounds of photographic representation, and transform it into something wholly new.

In *The Last Analog Photograph*, photography's layers are brought to the surface and merged into an image that is both material and ephemeral. The particular connection that photography has with the light that initiates the latent image is normally hidden, and taken to be a necessarily invisible part of how photography works. We are supposed to look past the photography toward the image it depicts, but this series makes us question that very action. It makes us aware that we are looking through a looking-glass into a land with wholly different physical and chemical rules. Each photograph calls into question not only *what* we see, but *how* we see it. Our vision becomes the sum of the possibilities of a particular moment, captured during an era in which we can contemplate analog photochemistry as a historical, but hardly irrelevant object.

1

See Roger Taylor and Edward Wakeling, *Lewis Carroll Photographer: The Princeton University Library Albums* (Princeton: Princeton University Press, 2002).

2

William Henry Fox Talbot, Notebook P, in Larry Schaaf, *Records of the Dawn of Photography: Talbot's Notebooks P & Q* (Cambridge: Cambridge University Press, 1996), 35, March [3]–April 5 1839.

3

Charles Cros, 'Solution générale du problème de la photographie des couleurs' [1896], in *Oeuvres Complètes* (Paris: Gallimard, 1970), 499. As translated by Kim Timby in 'Colour, Photography and Stereoscopy: Parallel Histories,' *History of Photography* 29:2 (2005), 183–96: 183.

4

Hans Danuser photographed the movements of the desert in North America in Arizona and New Mexico, in North Africa in the Islamic Republic of Mauritania and journeying from Morocco to Egypt, and in Asia in Outer Mongolia and North China.

5

See entries throughout Notebooks P and Q in Schaaf, *Records of the Dawn*.

6

See the papers of Mary Somerville at the Bodleian Library in Oxford (MSSW-13), and an extract of a letter communicated by Sir J. Herschel, published in *Philosophical Transactions of the Royal Society of London*, Pt. II for 1846 (London: 1846).

7

Robert Hunt, *Researches on Light in its Chemical Relations: Embracing a consideration on all the photographic processes* (London: 1844), section 334: 193.

8

Development of the project *Hans Danuser—The Last Analog Photograph* at the Institute of Inorganic Chemistry, ETH Zurich with Prof. Reinhard Nesper, Max Broszio, Matthias Herrmann, Florian Wächter, Dipan Kundu et al. as part of the image series *Hans Danuser—Landscape in Motion* (2007–2017), part three of the *Erosion* project.

9

Lyle Rexer, *Photography's Antiquarian Avant-Garde: The New Wave in Old Processes* (New York: Harry Abrams, 2002).

10

John Hannavy, 'Printing Out Paper,' in John Hannavy ed., *Encyclopedia of Nineteenth Century Photography* (New York: Routledge, 2008), 1175.

11

See for instance Martin Kemp, "Turner's Trinity," in *Visualizations: The Nature Book of Art and Science* (Oxford: Oxford University Press, 2004), 56–57.

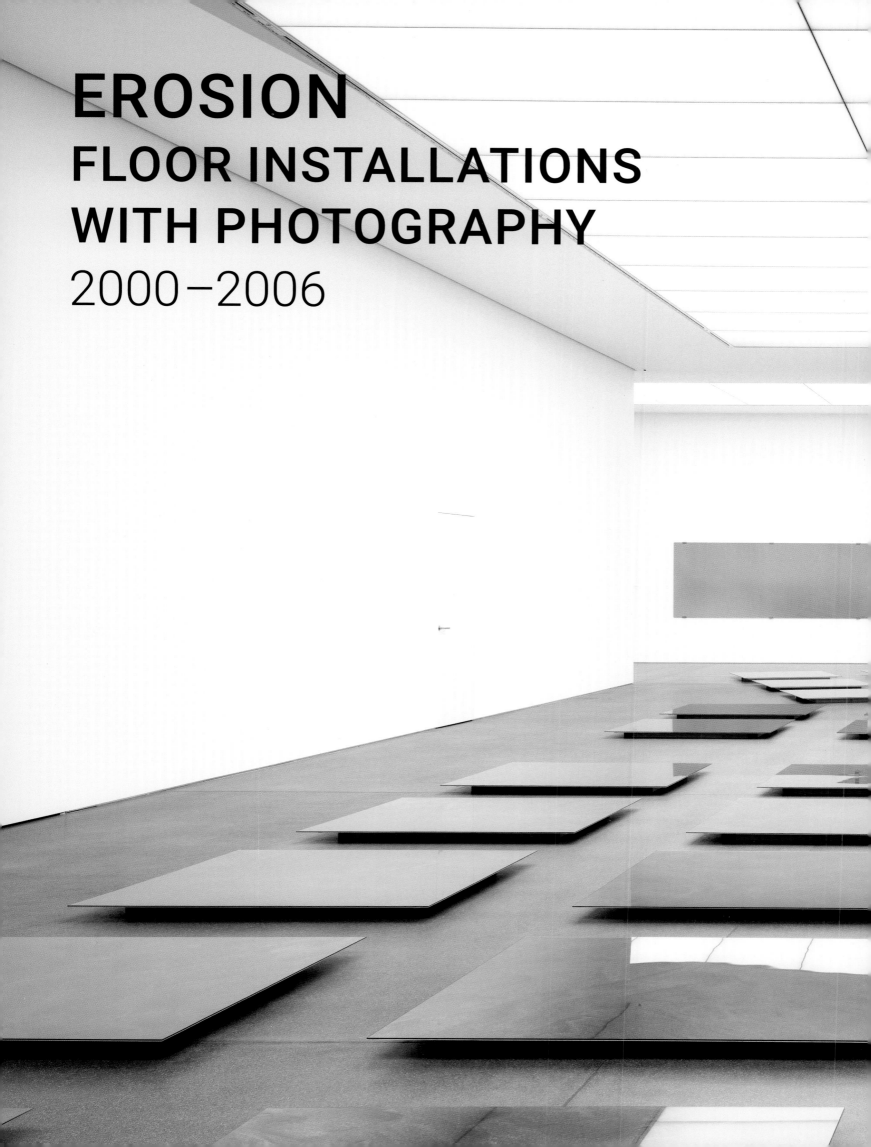

EROSION
FLOOR INSTALLATIONS
WITH PHOTOGRAPHY

2000–2006

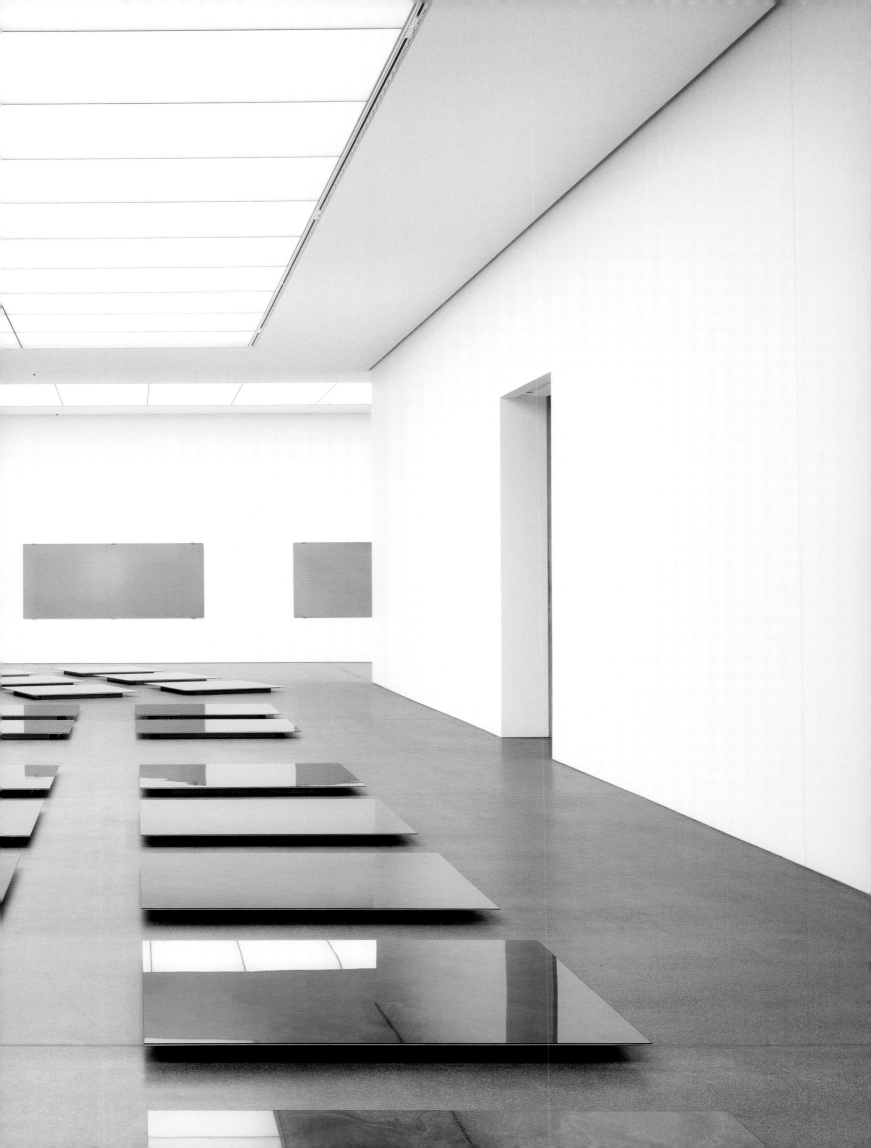

EROSION II

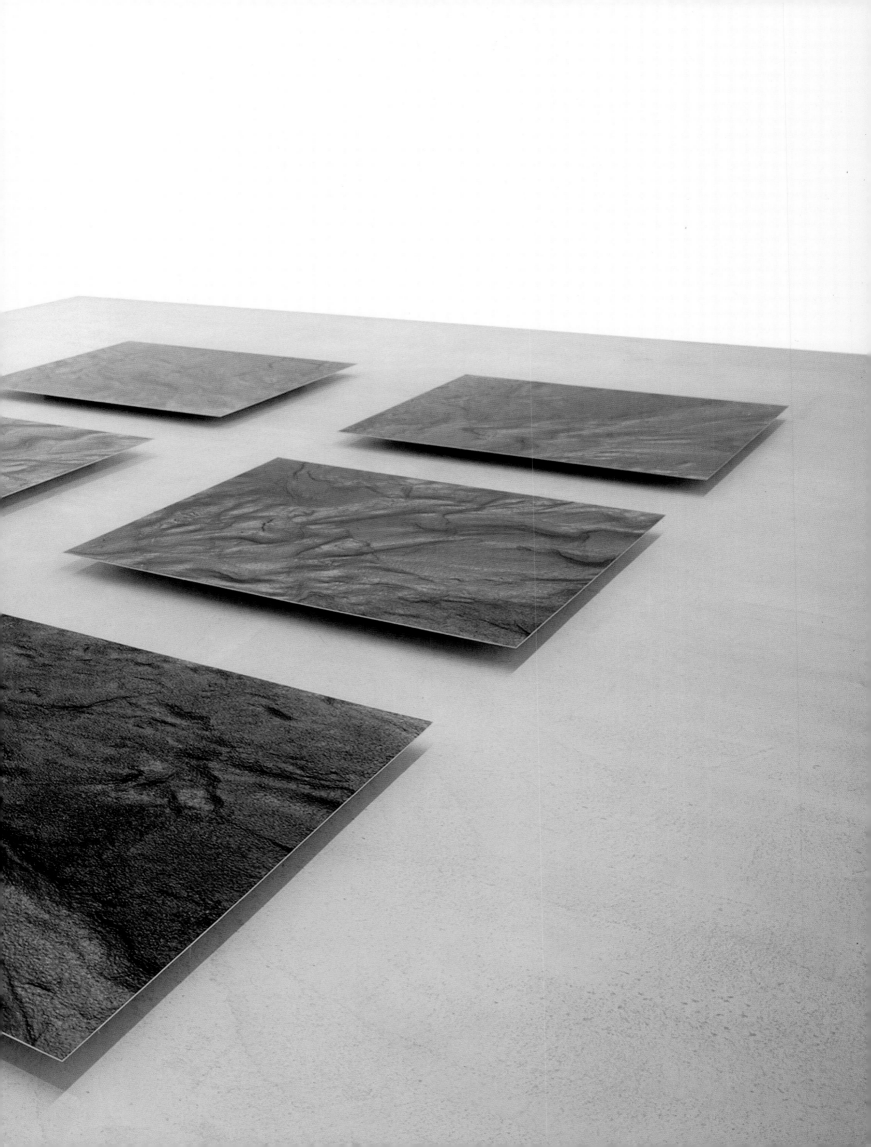

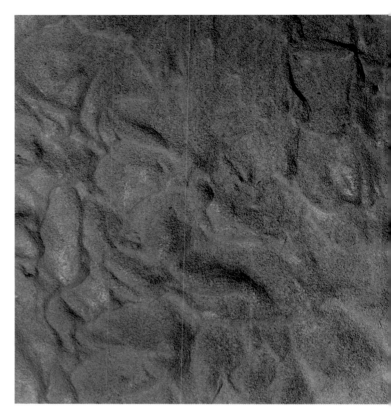

II 1

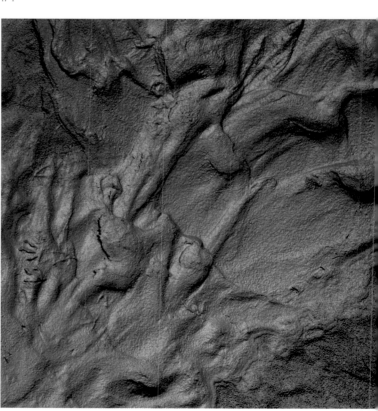

II 2

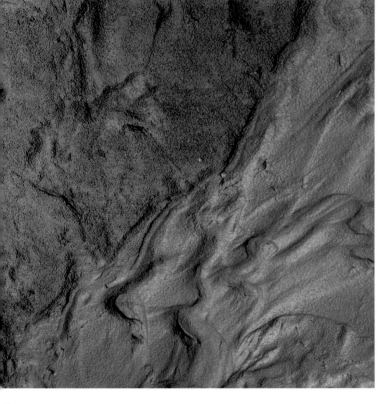

3

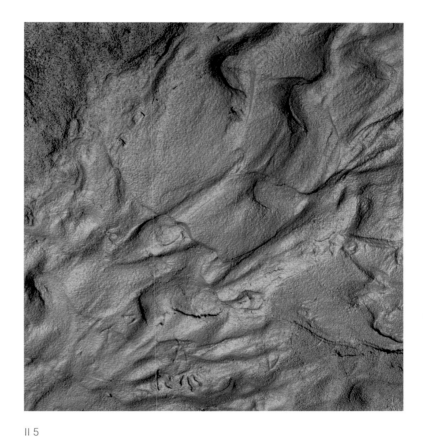

II 5

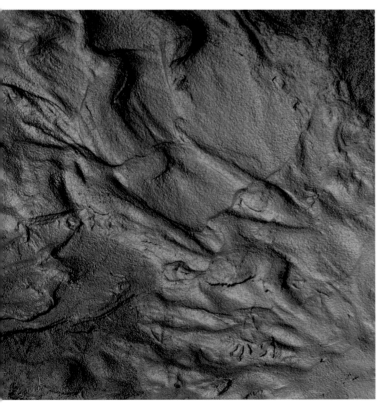

4

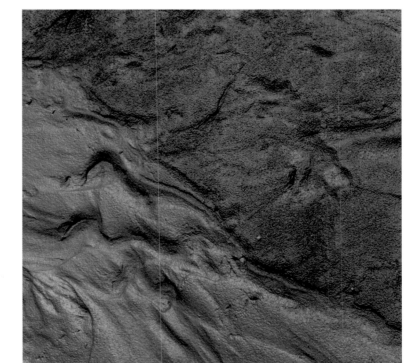

II 6

EROSION I

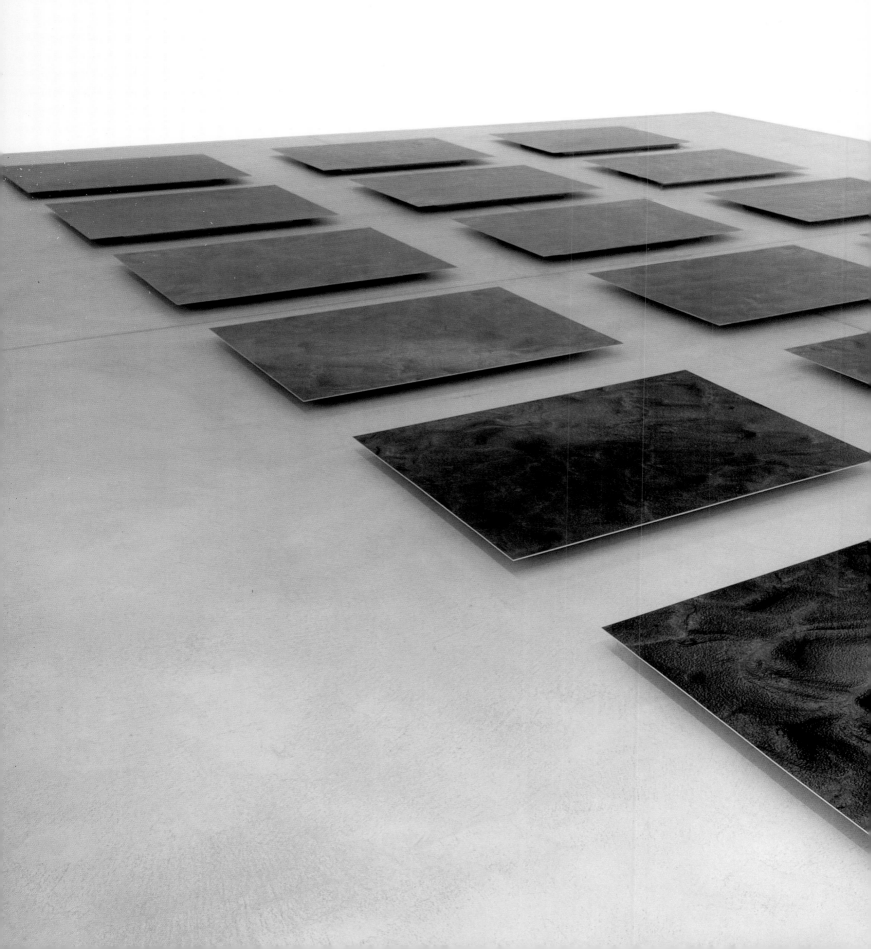

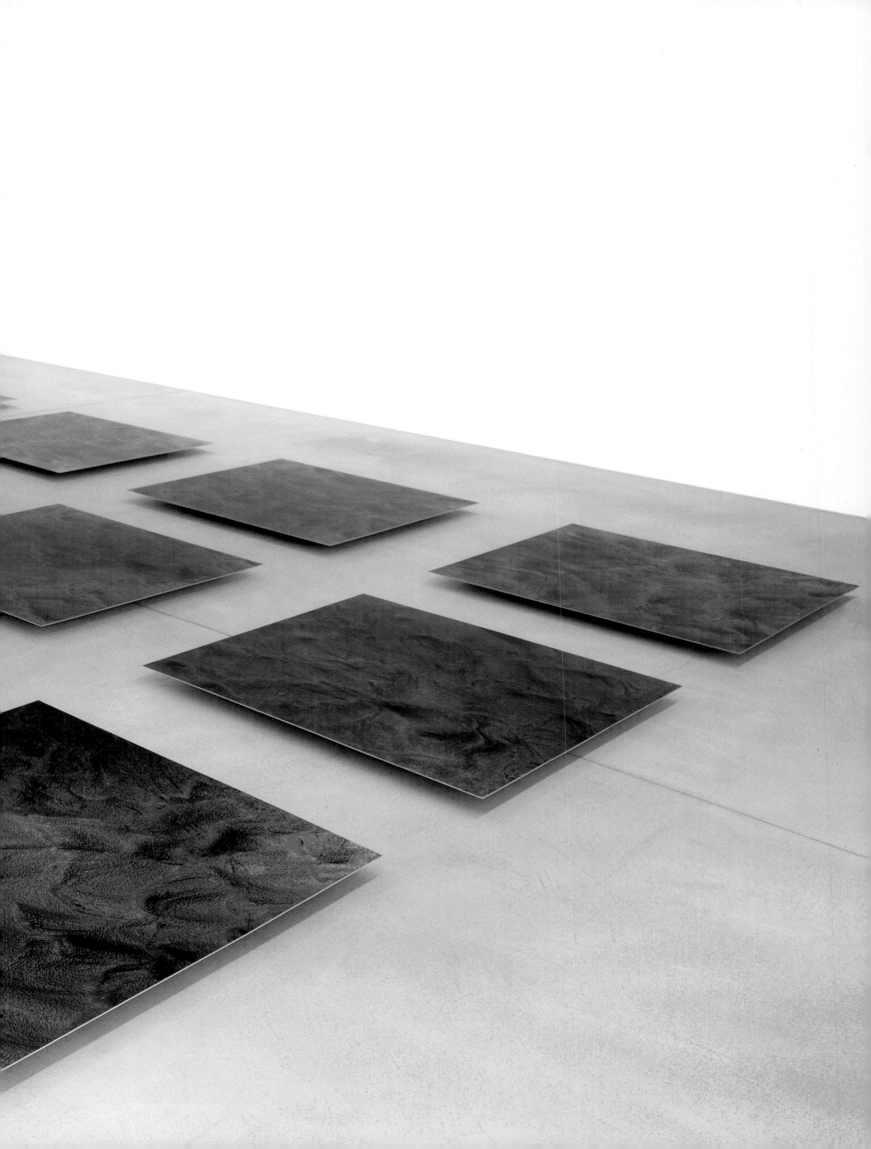

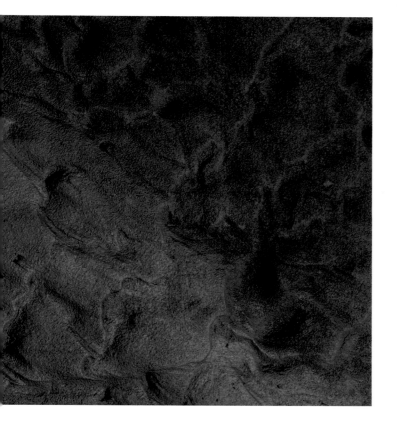

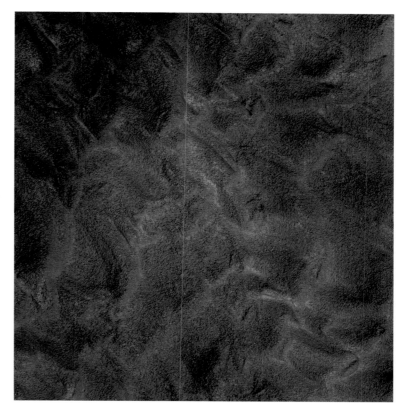

13

14

15

17

16

18

I 13

I 15

I 14

I 16

17

8

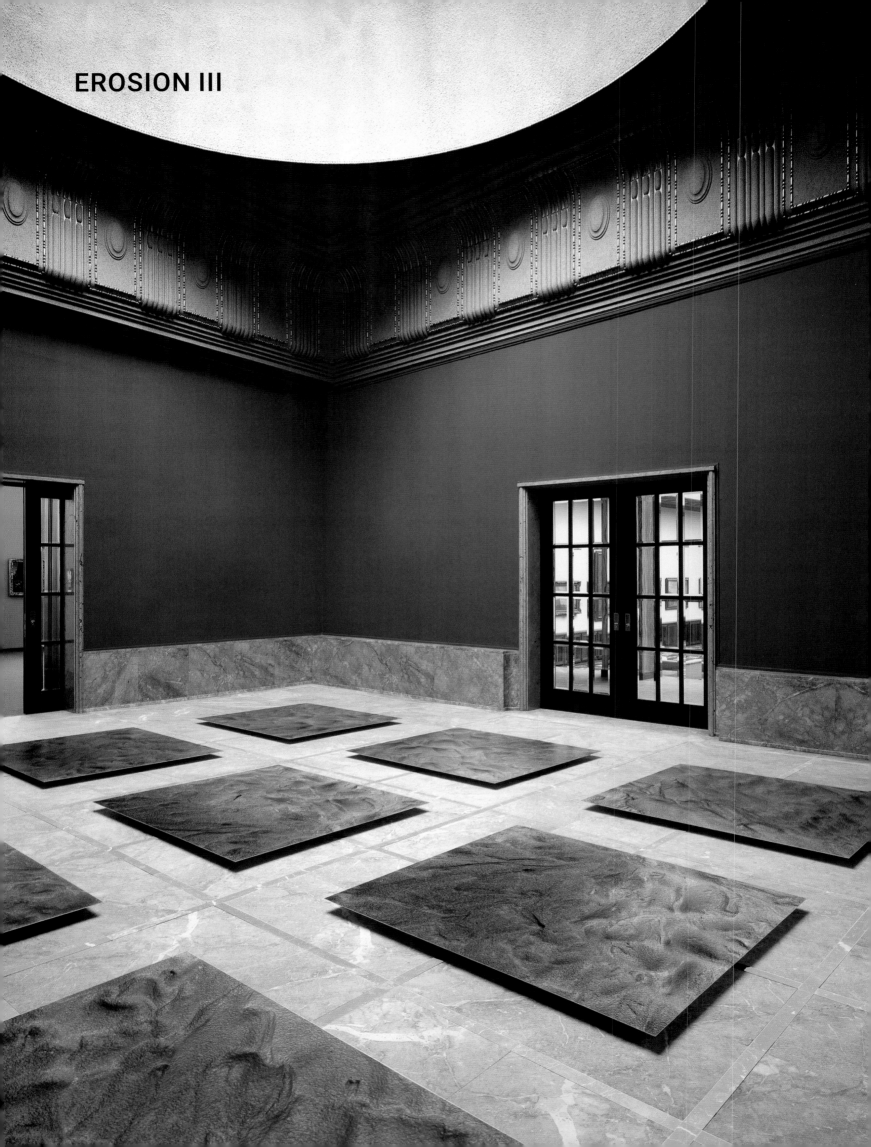

EROSION III

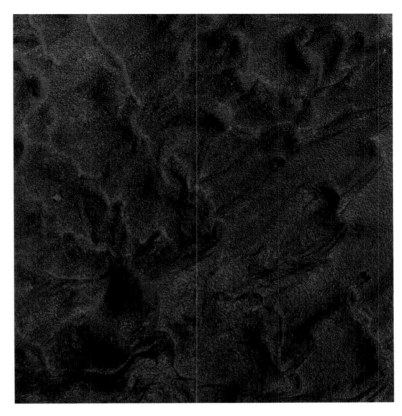

III 1

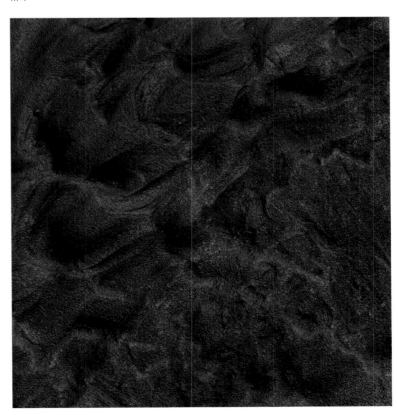

III 2

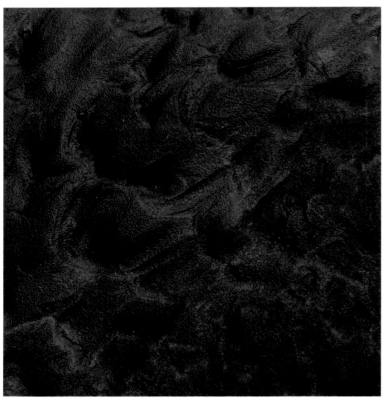

III 3

III 5

III 4

III 6

II 7

III 9

II 8

THE PARTY IS OVER

1984

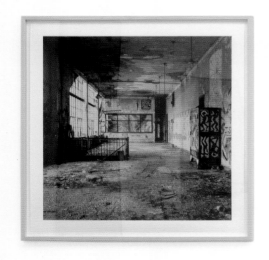 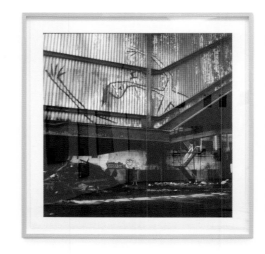

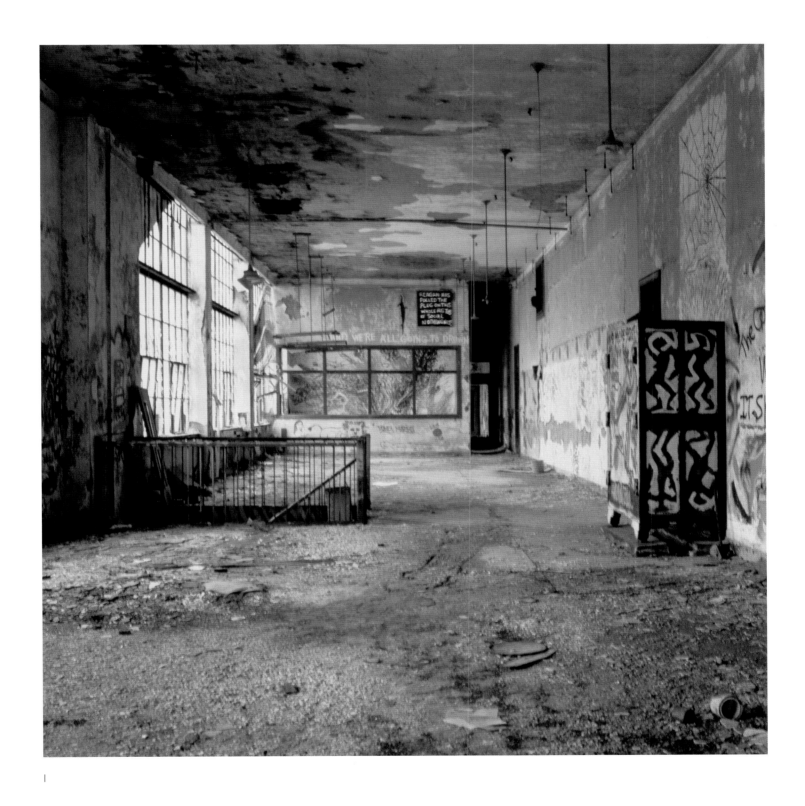

III 1

III 3

II

V

XV

VIII

X

XI

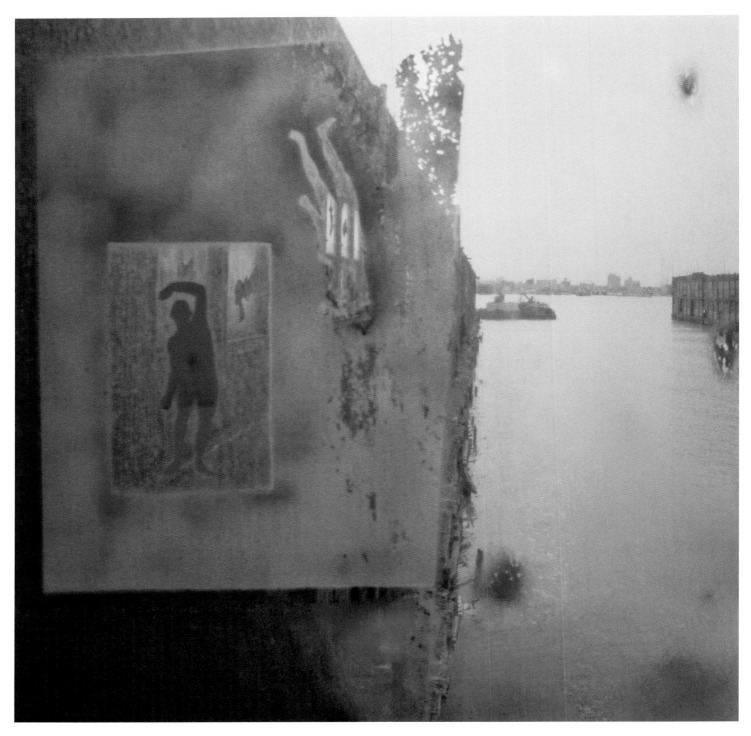

XII

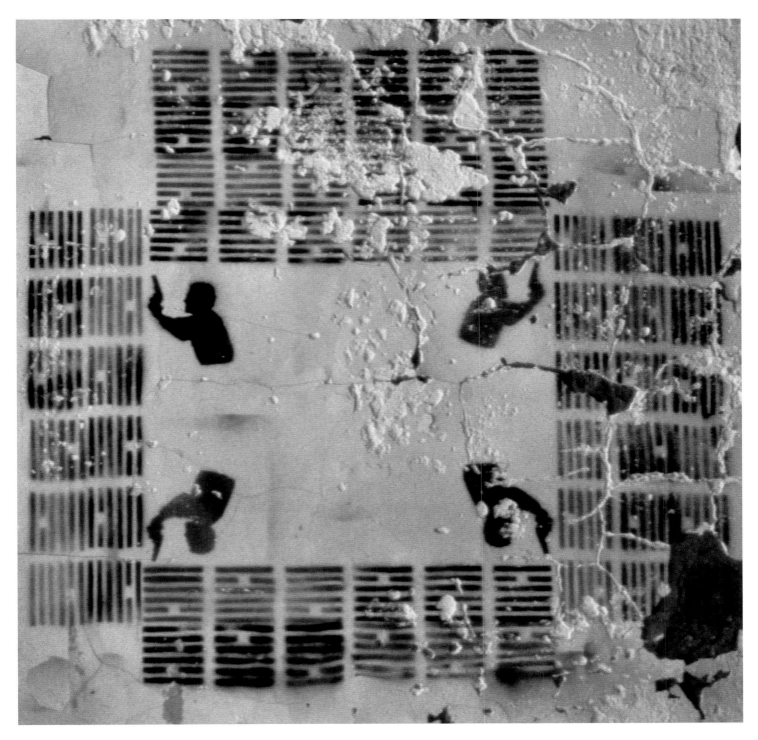

XIII

XVI

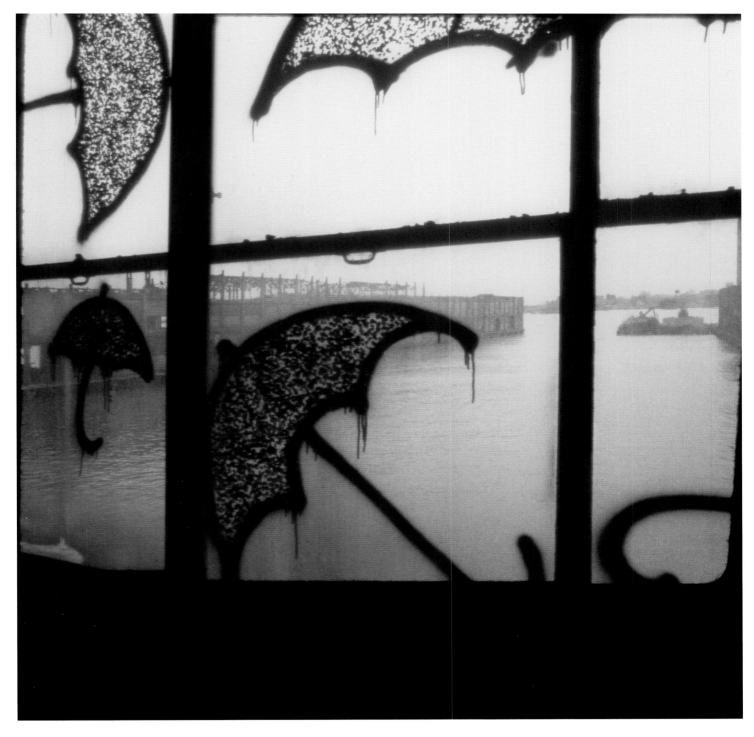

XVIII

ALPHABET CITY
1984

HARLEKINS TOD /
HARLEQUIN'S DEATH
1982

PARTITUREN UND BILDER /
SCORES AND IMAGES /
ZUMTHOR PROJECT
1988–1999

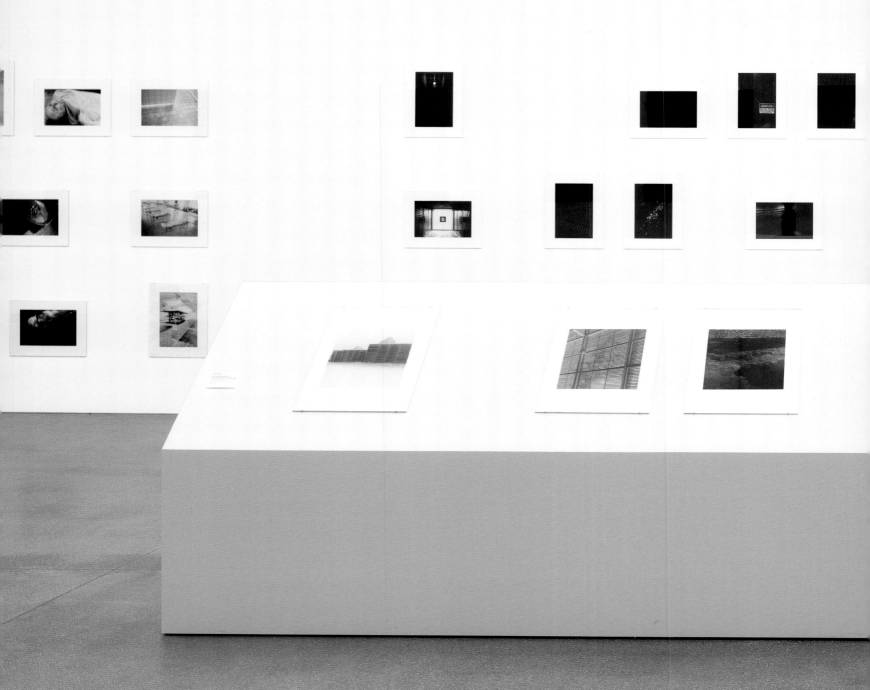

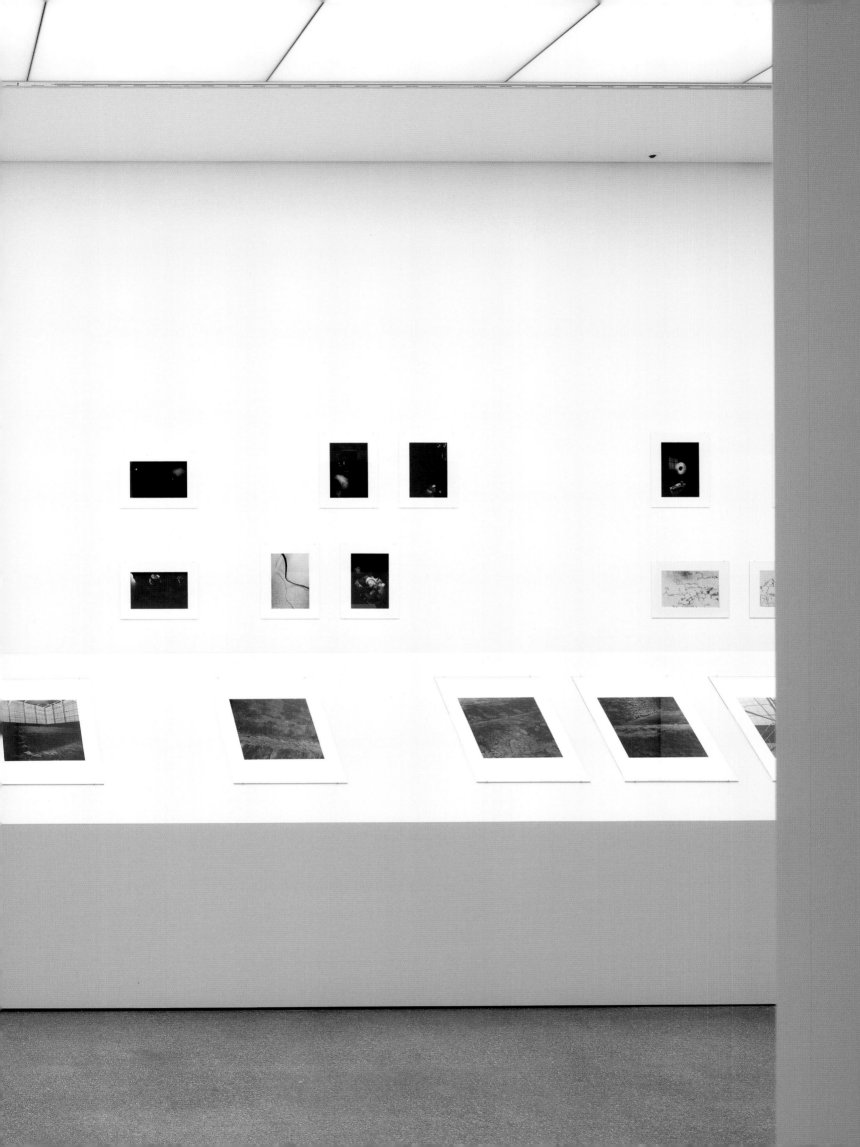

ZUMTHOR STUDIO, HALDENSTEIN

I

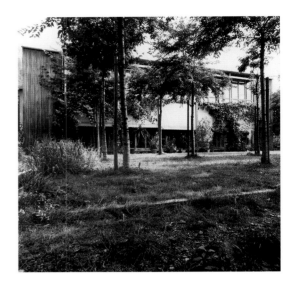

II 1

III 1

III 2

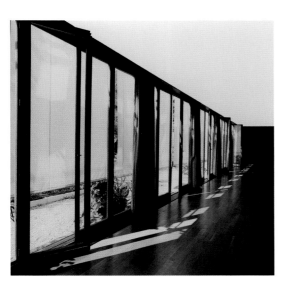

II 2

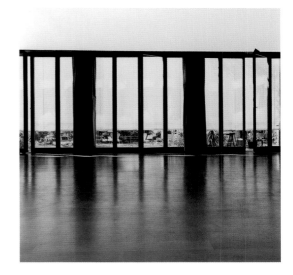

II 3

IV

III 1

III 2

SOGN BENEDETG CHAPEL, SUMVITG

I

II 1

IV 1

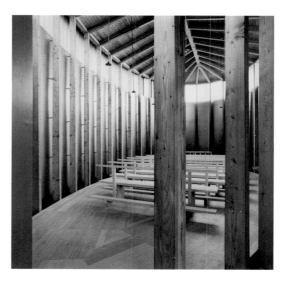

IV 2

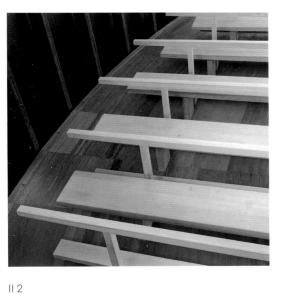

II 2

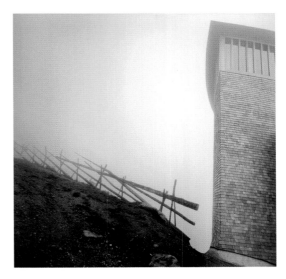

III

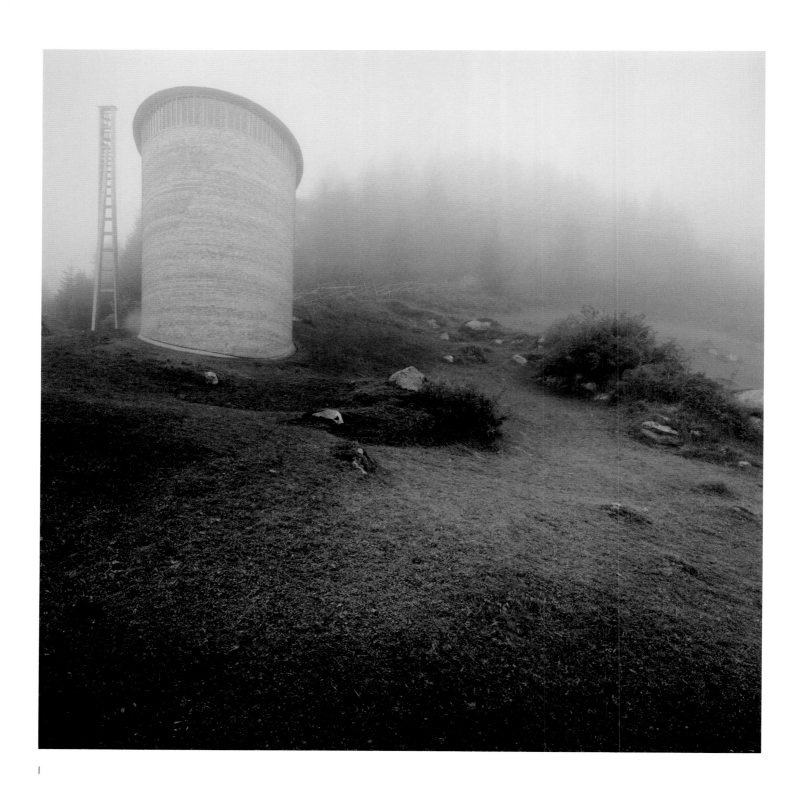

II 1

SHELTERS FOR THE ROMAN ARCHAEOLOGICAL SITE

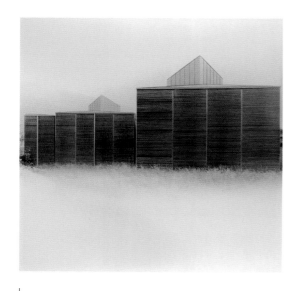

I

II 1

IV 1

IV 2

IV 3

II 2

III

V

II 1

THERMAL SPRING VALS

I

II 1

IV 1

IV 2

IV 3

II 2

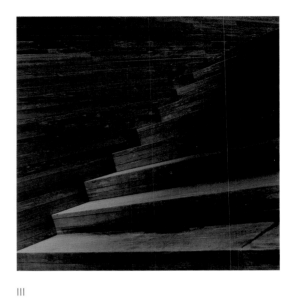

III

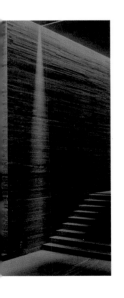

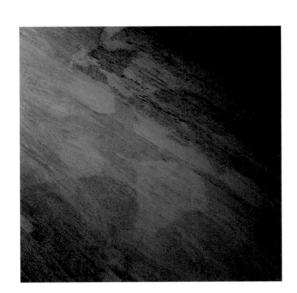

IV 4

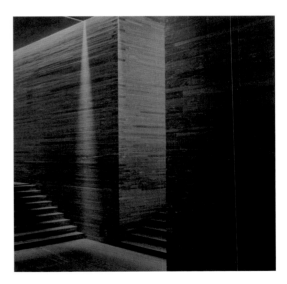

IV 5

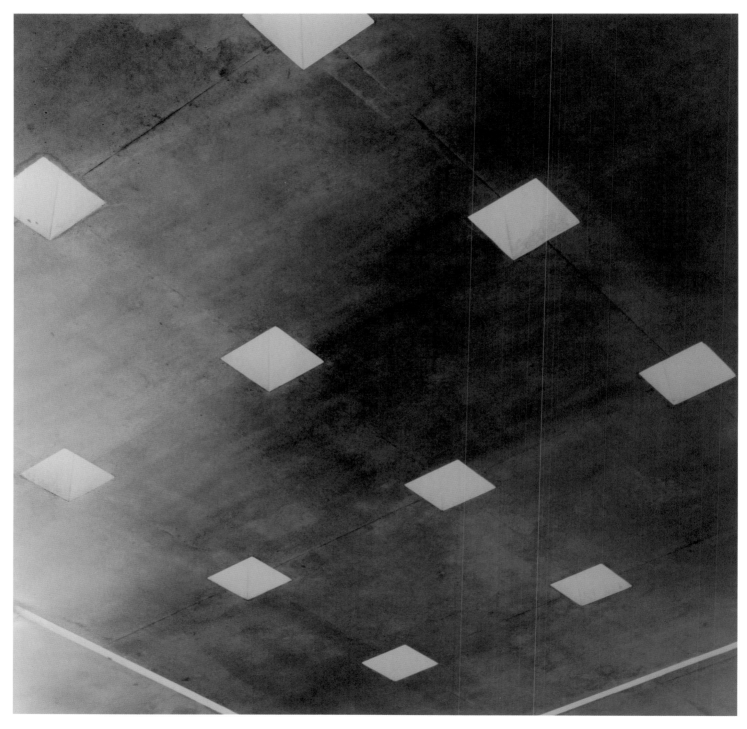

II 1

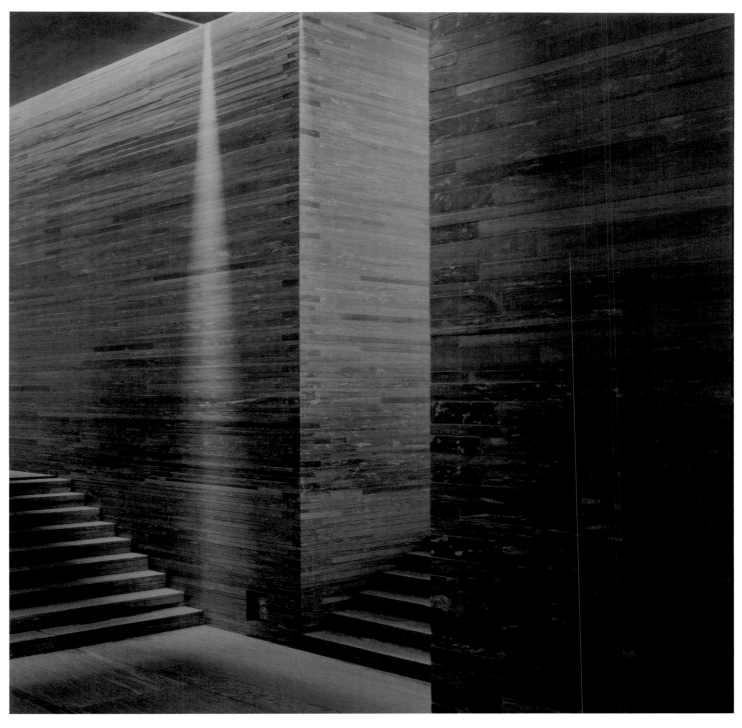

IV 5

Silver Surfaces, Deep Images: Hans Danuser's Photography and Peter Zumthor's Architecture

Philip Ursprung

In the mid-1980s, a lucky star stood over the Bündner Kunstmuseum. Beat Stutzer, who had recently become director, invited Hans Danuser, who was just over thirty and still little known, to present his first solo exhibition. This exhibition, held in 1985 and titled *Drei Fotoserien* (Three Photo Series), marked the beginning of the photographer Danuser's career as an artist.[1] It also contributed to reopening the doors of the art world to the medium of photography, which, as an applied art, had long been moving in the shadows of the great genres since those doors were closed after a brief phase of exchange in the period of the classical avant-gardes. And, thanks to the meeting of Danuser and Peter Zumthor, it marked the beginning of a new type of architectural photography that would shape the image of Swiss architecture in the years that followed. Danuser had set himself the task—these days it would be called "artistic research"—of creating within ten years a kind of visual encyclopedia of themes that polarized the public at the time: namely, nuclear energy, gene technology, and money. The project, entitled *Wirtschaft, Industrie, Wissenschaft und Forschung* (Economy, Industry, Science, and Research), took him through Switzerland and to France and the United States, with support from scholarships.[2] In 1989, he concluded the project with an extensive exhibition at the Aargauer Kunsthaus in Aarau entitled *In Vivo*, and a monograph.[3]

Among the visitors to the exhibition *Drei Fotoserien* were Annalisa and Peter Zumthor, who had been running their own architectural firm in Haldenstein since 1980. Danuser's quasi-forensic look at the details of nuclear power plants and laboratories for genetic research presumably spoke to Zumthor's experience working in the cantonal historical preservation department in Chur in the 1970s, where he had conducted inventories of villages and recorded fragments of former buildings. Danuser's sensitivity to atmospheric interiors and eye for the textures and surfaces of concrete walls, tile floors, and metal surely aroused the interest of an architect who designs buildings from the inside out, and whose projects aim to make the invisible visible and to bring the latent to light. Danuser's method of not reducing the complexity of phenomena to an image but rather breaking it down into a wealth of fragments resembled his own analytical understanding of design and his view of space as something discontinuous. And, finally, as an architect who was pursuing the goal of architectonic autonomy he surely had respect for this young photographer who had chosen to set himself an ambitious task, rather than just to perform tasks for others.

A little later, when Zumthor was invited by the director of the Architekturgalerie Luzern to present his own first solo exhibition, he asked Danuser to photograph three of his buildings. The architectural photography common at the time did not conform to his idea of what constituted adequate representation. In his own words: "The illustrations of architecture in journals were repellent to us—as if the camera with its wide-angle lens was opening its jaws wide in order to record as much information as possible. The whole character of the building was lost in the process."[4] Zumthor gave Danuser a free hand and guaranteed him autonomy. Danuser accepted the invitation and in 1987 and 1988 he photographed the buildings with a medium-format camera and black-and-white film: the Zumthor studio in Haldenstein (1986), two protective structures for the excavations of Roman finds in Chur (1986), and the nearly finished Sogn Benedetg Chapel in Sumvitg (consecrated in September 1988). This resulted in three series of square, black-and-white photographs. They were shown in October 1988 in the exhibition *Partituren und Bilder: Architektonische Arbeiten aus dem Atelier Peter Zumthor, 1985–1988* (Scores and Images: Architectonic Works

from the Atelier of Peter Zumthor) at the Architekturgalerie Luzern and then in the summer of 1989 at the Architekturgalerie Graz, and published in catalog form.[5] They were published in November 1989 in the journal *Domus*, in *Ottagono* in 1990, and in *Du* in 1992.[6] Twenty years later, they were reprinted in the book *Seeing Zumthor: Images by Hans Danuser*.[7]

Zumthor had decided to exhibit the photographs in Lucerne in parallel with the project drawings of his buildings, which he compared to musical scores: "With their high degree of abstraction, they are the most precise depiction of the architectonic composition and the binding basis for its execution. Except that what is not in this score is left open to performance practice and to the interpretation of the performer." He understood the photographs to be "images of works performed according to these scores," formulated in the "artistic language of the photographer Hans Danuser." Thus he did not understand them as documentation, but rather as a kind of interpretation or commentary. In his words: "He speaks in this language about our performances."[8]

Knowing that his photographs would be presented together with the drawings and would therefore not have to shoulder the burden of representation in and of themselves expanded Danuser's latitude. Whereas his earlier works had been carried out, as he put it, "in the laboratory," now he could conduct an "experiment in the field" and "expose them to life."[9] The methodology that had already been vaguely outlined in *Drei Fotoserien*—namely, the representation of abstract themes by means of architecture—was now made concrete with reference to three specific edifices. In essence, the photographs of Zumthor's buildings continue on from the images of the laboratories and power plants and are thus closely related to the *In Vivo* cycle. Just as Danuser—when photographing the nuclear power plants—deliberately ignored the cliché of the iconic cooling tower, instead photographing a sequence of diverse interiors in the plants, here he dispensed with the then-common reduction of architecture to a single photograph showing the building together with its surroundings. Instead, he concentrated primarily on the interiors and made a series of photographs of each of the three buildings.[10]

For example, no one looking at the photographs of the Zumthor studio can tell what the building looks like from outside, where it is located, how large it is, or of what material it is made. No photograph shows its now famous facade with its characteristic slat structure. The images do, however, enable viewers to visualize the thought processes of the architects, to follow the play of light and shadows on the floor, and to admire a wall decorated by Matias Spescha. Viewers can put themselves in the place of the architects and sense that perhaps some ideas are found not when working at the drafting table but rather when standing on the stair landing, looking out the window, or daydreaming in front of a wall.

Danuser took two exterior photographs of the protective structures, but they are so far removed from the conventions of architectural photography that viewers cannot determine their urban context or their dimensions. The volumes of the buildings stand out against the meadow, which appears white because of overexposure, and a bright background, as if they were floating between heaven and earth like a fata morgana. The bridge connecting two buildings in another photograph recalls, in turn, an oversized camera bellows. It almost looks as if the camera itself is reflected in the architecture. The photograph of the space that rises up above the barely perceptible remains of the excavation resembles the image of a giant camera obscura into which daylight is penetrating, and which projects images of the outside world. And the photograph of the

pitch-black corridor leading across a bridge to the front door looks like the interior of a camera: a mechanism with a mysterious black rectangle lying in its area of focus.

In the Sogn Benedetg Chapel, too, the camera traces a photographic space within the architecture, for example in the image which shows where the bearing structure connects with the outer shell. Without the caption, it would be impossible to identify this as part of the chapel. Danuser's photograph shows the metal pins connecting the wooden supports to the wooden shell. They are what makes the interior seem like a sound box, since the viewer gets the impression that the outer spatial membrane has almost been suspended in the air. This makes manifest a theme that characterizes Zumthor's oeuvre: a space created entirely from surfaces. Zumthor painted the inside of the shell silver because he wanted to create, as he put it, a "silver wall."[11] This has the effect of dematerializing, in a sense, the surface of the wood and making the space seem deeper. (Several years earlier Herzog & de Meuron had employed a comparable method for their Blaues Haus [Blue House], in which the blue seems to plunge the viewers into a color space.) With regard to the relationship between architecture and photography, this shot is central because it functions like a hinge between the two genres. The silver surface of the wooden membrane corresponds to the silver surface of the photographic paper. Just as the silver paint causes the wood to shine, produces an illusion of depth, and reinforces the atmospheric spatial effect, the silver surface of the photographic paper lends depth to the photographic image. Danuser used black-and-white negatives, not color, yet the silver surface of the black-and-white paper is not completely planar but rather forms a kind of highly delicate relief from the structure of the silver crystals. It takes on an almost infinite gradation of shades of gray and to the viewers appears multicolored, because the facets of the silver crystals reflect the natural light.

Danuser treats the exterior photographs of Sogn Benedetg as if the building stood within an interior space. He turns his back on the view onto the Surselva. A layer of fog closes the space, and the placement of the chapel in the upper part of the image makes the pictorial space seem planar. The steep meadow is punctuated by boulders, which testify to the rawness of the natural forces in the mountains and remind us that the previous building, located just a stone's throw away, was destroyed by an avalanche in 1984. But the chapel, too, looks like a foreign body in its surroundings. It fits with its surroundings neither typologically (most chapels in the mountains are stone) nor formally (its tube-like shape, viewed from below, more closely resembles a tower than a sacred building). It is therefore unsurprising that the monastery remained skeptical and granted the building permission "without conviction" after the competition had been won, as Zumthor remarks in retrospect.[12]

Another exterior photograph makes it clear that the building is not round, but neither does it fully reveal the teardrop ground plan. It shows a pasture fence and gives the viewers a sense of the sparseness of the resources available in the mountain region. By showing a detail of the new building next to the fence and allowing its concrete foundation to loom up into the image, Danuser not only prevents any nostalgic evocation of a supposedly ideal, preindustrial world but also shines a light on the leitmotif of work—whether industrially organized or preindustrial. He relates the built concrete to the way the fence and chapel were produced. The unfinished branches rammed in and the pieces of bark inserted between them are waste products of the lumber industry, from the production of boards or shingles, for example, like those that protect the chapel's exterior wall from weathering.

A similarly subtle look at production is also provided by the details of the floor, which Danuser photographed before and after the pews were installed. They reveal that although small, inexpensive boards are used, their ornamental grain and variation improve the aesthetic effect of the interior. Danuser puts materials and work processes center stage—and for that reason, with a few photographs he is able to say more about Zumthor's method as an architect than any text that makes hasty mention of his training as a carpenter. In addition, he thus reinforces the impression that the landscape in which the chapel is located is at least in part made by human beings. Danuser's analytical approach brings together the economic conditions of agriculture and the building on the same level of representation. Both photographs show the building not against the backdrop of an aesthetic *landscape* but rather as part of the concrete surroundings of the *rural*.

The camera brings the surfaces very close, as if it wanted to draw a connection between the space of the architecture and the space of the camera, and as if it conceived of the architecture not as a closed-off space, but rather as a starting point from which the camera can expand into the imaginary realm, thus extending the architecture further. The pictorial space and the built space collide on the surface of the photograph. The meeting between Danuser and Zumthor brings out a potential in both that had not been clearly perceivable previously. The architectonic quality that is made manifest in Danuser's sequences of photographs is not a mere motif, but rather an embodiment of his method of creating spaces with the camera. The photographic quality in Zumthor's buildings, in turn, is not limited to the theme of the camera obscura but also pertains to the way light falls on surfaces and how the outside is transferred to the inside. Danuser's camera discovers its mirror image wherever it turns, or rather, it projects elements of photography onto Zumthor's architecture. In Danuser's photographs, Zumthor sees elements of architecture in a form he was unable to perceive previously. That may explain why the architect was moved by looking at the photographs in Danuser's studio "spread out on the floor and hung on the walls." That is to say, organized in space. In his words: "The photographs were … powerful. It was so beautiful that I had tears in my eyes. These beautiful, deep-black-and-white photographs in these bright and dark shades of gray not only met my expectations but exceeded them."[13]

Their collaboration on the 1988 exhibition was deliberately planned by Zumthor and Danuser as a one-time experiment, and Danuser has not taken pictures commissioned by Zumthor since. But their encounter led to a fundamental change in the conventions of architectural photography. Danuser's way of depicting Zumthor's architecture influenced its reception. Just as anyone who has ever seen the photographs that Hans Namuth took in 1950 of Jackson Pollock painting in his studio will almost involuntarily associate his paintings with the images of their production, so too are Danuser's photographs interwoven with Zumthor's work. He chose a personal interpretation rather than a neutral documentation. And rather than reducing phenomena to a photograph, he broke them down perspectively into their individual parts, as if in a short film that subdivides the object into sequences and shows it from different angles. These fragments permit the viewers to construct the architecture in their imagination. This fruitful relationship between architecture and photography had been made possible because the borders between the two genres had been temporarily relaxed. Zumthor, who was trying to make the move from landmark preservation to architecture, temporarily put responsibility in the hands of an artist. Danuser, in

turn, who had just turned from a photographer into an artist, agreed to do commissioned work for a time.

A decade later, however, Danuser would again engage with Zumthor's work, this time at the invitation of Fritz Hauser. The musician had composed *Sounding Stones* for Therme Vals: a sound composition played on sounding stones that is heard on infinite loop in the spa's relaxation rooms. Hauser asked Danuser to take photographs for the CD. Hélène Binet had already photographed the spa, which opened in 1996, and her photographs contributed to Zumthor's international breakthrough. Danuser was therefore not the first to approach the building from the perspective of photography. But as had already been the case with the three buildings ten years earlier, he used the opportunity to experiment with photography's ability to show the invisible— this time, sound and music. Zumthor's metaphor of the "score" echoes in this new project, but in contrast to the 1988 exhibition, the photographs were displayed on their own, with no project drawings placed next to them.

The nine-part series *Peter Zumthor: Thermal spring Vals* (1998) is methodologically linked to the series produced ten years earlier. As already in that first encounter, Danuser approached his object with a series of photographs of the interior—including one group of five photographs—and once again the exterior was left out. He visited the spa several times in different seasons. One of the visits coincided with a modification to the pool, during which the water was drained. In order to obtain the most uniform interior lighting possible, the skylights were also covered with tarps.[14] Danuser did not photograph the room where *Sounding Stones* is heard. Instead, he presents the entire main room of the spa as a hermetically closed space or as a labyrinth of rooms. Just as visitors to the spa can never get a view of the entire space and can sometimes get lost, Danuser offers no overview or orientation but instead fragments the building into numerous spatial impressions. And just as the visitors to the bath are always surrounded by the gurgling, splashing, and dripping of the water and of course by the sounds they make themselves, and can give themselves over to the illusion that they can hear the echo of the water gurgling inside the mountain, Danuser interprets the interior as a kind of sound box in stone.

In several photographs we see the traces of water left behind on the floor by bathers. In the photograph of the stairs, small puddles have been left behind on one step. The viewers imagine filling the empty pool. The absence of water is not perceived as a flaw but rather further underscores the scenographic effect of the building. The series inevitably recalls the stage sets of Adolphe Appia from the early twentieth century, with their steps and landings, or the light installations of James Turrell undertaken since the 1960s. As in the photograph sequences from 1988, the camera seeks out an affinity with the interior in the spa, for example, in the form of the light that penetrates the gap in the concrete ceiling and shines on the gneiss slabs that serve as wall panels. The role played by the silver wall in the photographs of the chapel—that of an interface between the architectonic and the photographic space—is here played by this gneiss surface. The grayish blue, slightly sparkling color of the stone is translated by Danuser into many nuances of gray.

Danuser continued this theme after 2000 in the three *Erosion* cycles. The surface of the rocks corresponds to the surface of the photographs placed on the floor like objects. The images fix the ever-changing surface of the rocks in the topology of the photograph surfaces, but at the same

time they themselves become objects that can be experienced spatially as the viewers move around them in the room. With *Schiefertafel Beverin* (Beverin Slate Slab) of 2001, Danuser risked the move into the medium of architecture. A plaza made of slate slabs serves as a platform and a meeting place for the Beverin psychiatric clinic. Whereas the photographs function as a continuation of the built space, the built space now extends the imaginary spaces of photography. The silver surfaces and deep images have produced a concrete, built entity.

1
Hans Danuser, *Drei Fotoserien*, exh. cat. (Chur: Bündner Kunstmuseum, 1985).

2
In 1980, 1983, and 1985, Danuser received the Eidgenössisches Kunststipendium (Federal Art Scholarship); in 1979, 1983, and 1985, the Kunststipendium des Kantons Zürich (Art Scholarship of the Canton of Zurich); and in 1983, 1984, and 1985, the Kunststipendium der Stadt Zürich (Art Scholarship of the City of Zurich). In 1984, he was the first photographer to receive an Atelierstipendium der Stadt Zürich (Studio Scholarship of the City of Zurich) in New York.

3
See Hans Danuser, *In vivo: 93 Fotografien*, exh. cat. (Aarau: Aargauer Kunsthaus, 1989).

4
Hans Danuser, in Hans Danuser and Peter Zumthor, "Ateliergespräch," in Hans Danuser und Bettina Gockel, eds., *Neuerfindung der Fotografie: Hans Danuser; Gespräche, Materialien, Analysen* (Berlin: De Gruyter, 2014), 149–66, esp. 152.

5
Partituren und Bilder: Architektonische Arbeiten aus dem Atelier Peter Zumthor, 1985–1988; Fotos: Hans Danuser, 2nd ed. (Lucerne: Architekturgalerie, 1994).

6
See Martin Steinmann, "Peter e Annalisa Zumthor: Cappella a Sogn Benedetg, Svizzera," *Domus* 710 (November 1989), 44–45; Wilfried Wang, "An Architecture of Silent Articulations: On the Work of Peter Zumthor," in "Domestico / Antidomestico = Domesticity / Counter-Domesticity," special issue of *Ottagono* 97 (December 1990): 48–80; and "Pendenzen: Neuere Architektur in der Deutschen Schweiz," special issue of *Du: Die Zeitschrift für Kunst und Kultur* 5 (1992): 49–67.

7
Zumthor sehen: Bilder von Hans Danuser = Seeing Zumthor: Images by Hans Danuser (Zurich: Edition Hochparterre bei Scheidegger & Spiess, 2009).

8
Peter Zumthor, "Partituren und Bilder," in *Partituren und Bilder* (see note 5), 9–10, esp. 10.

9
Hans Danuser, in Danuser and Zumthor, "Ateliergespräch" (see note 4), 156.

10
The photographs of interiors and of the cooling tower of the nuclear power plant were taken at the beginning of the cycle. According to Danuser, they were taken in Gösgen in 1979. Hans Danuser in conversation with Philip Ursprung, June 11, 2008.

11
Peter Zumthor: "Yes, I had decided on a silver wall. Then I sought the advice of the color planner Jean Pfaff anyway. He taped color strips to the back of the supports, which the light then reflected onto the silver wall. The colors appeared and disappeared with the sun. Then we both decided to paint the wall white, since we had convinced ourselves that that would have the desired effect. But white is too similar to the natural color of the wooden supports, so the result was really … nothing … or almost nothing." Hans Danuser, in Danuser and Zumthor, "Ateliergespräch" (see note 4), 156.

12
Peter Zumthor, in *Peter Zumthor: Bauten und Projekte, 1985–2013*, ed. Thomas Durisch, vol. 1 (1985–1989) (Zurich: Scheidegger & Spiess, 2014), 63.

13
Hans Danuser, in Danuser and Zumthor, "Ateliergespräch" (see note 4), 153.

14
Hans Danuser in conversation with Philip Ursprung, June 11, 2008.

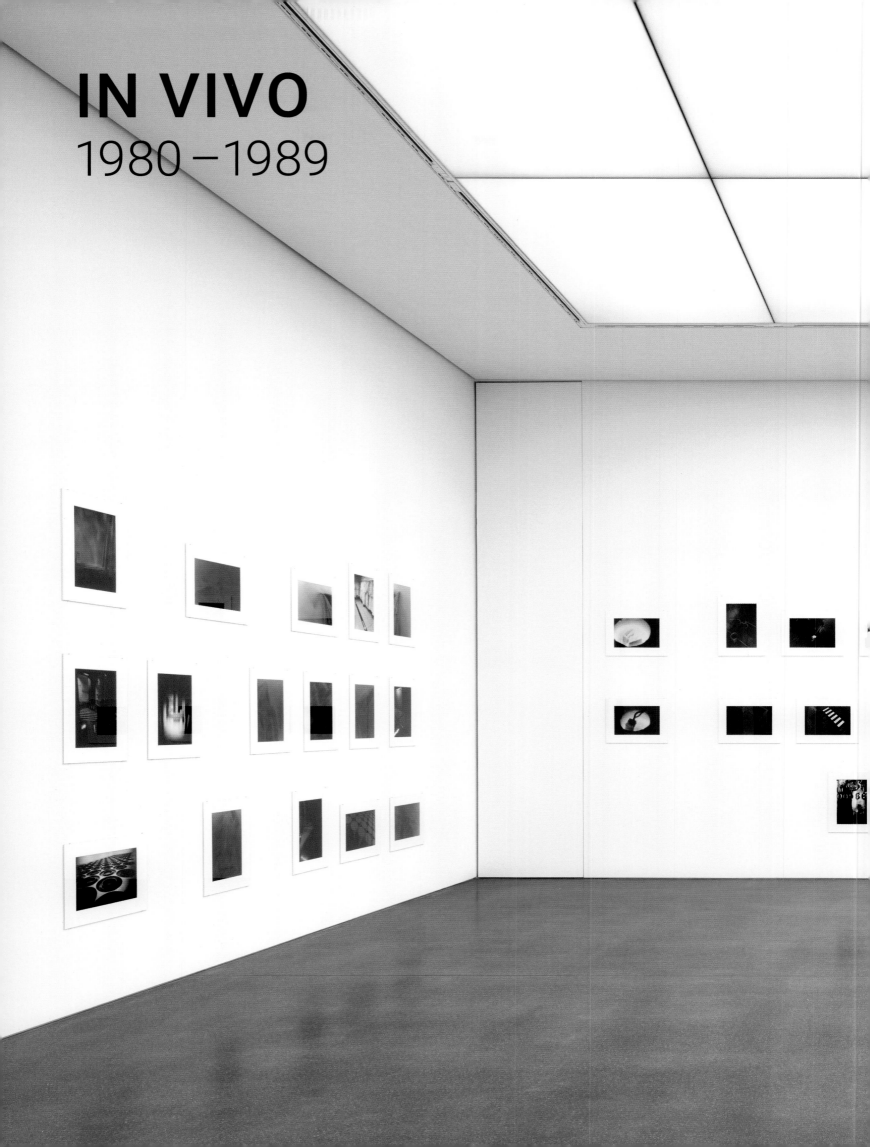

IN VIVO
1980 – 1989

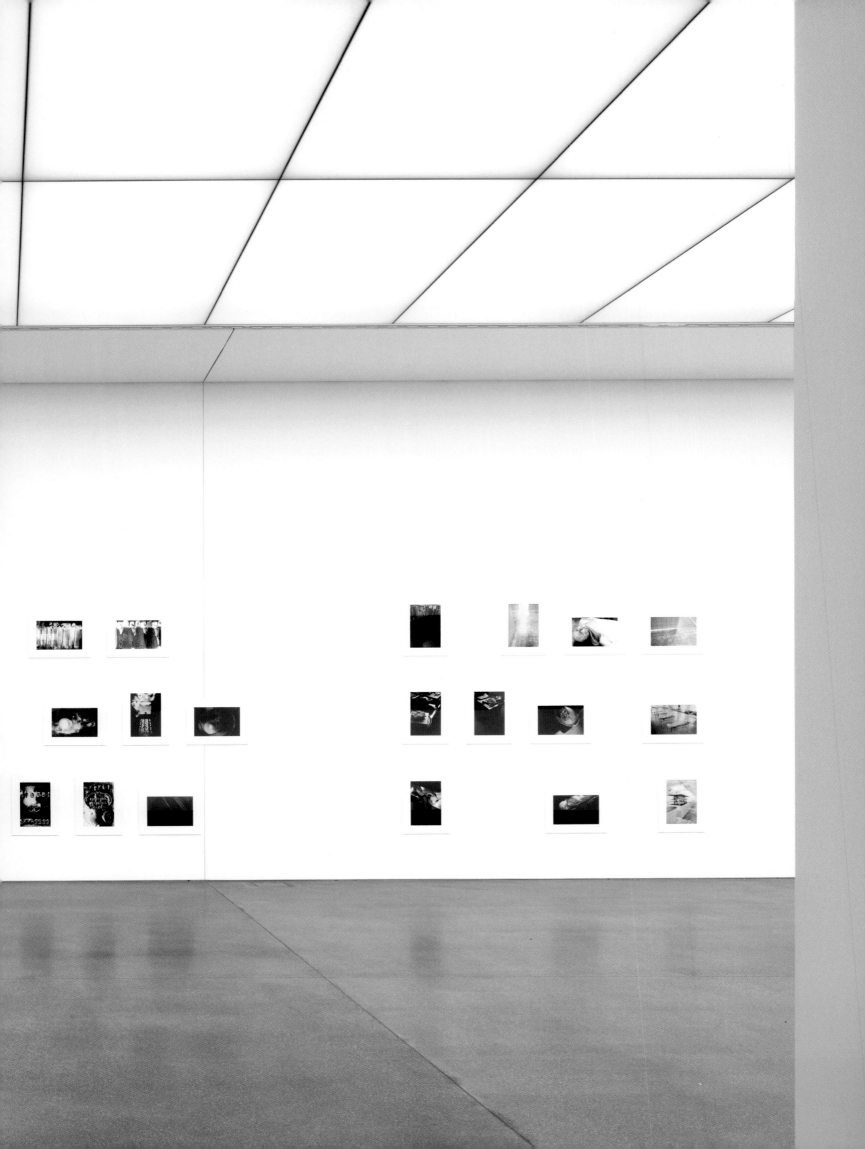

A-ENERGIE

Photographed in atomic power plants, reactor
research facilities, and in interim storage facilities
for highly radioactive waste

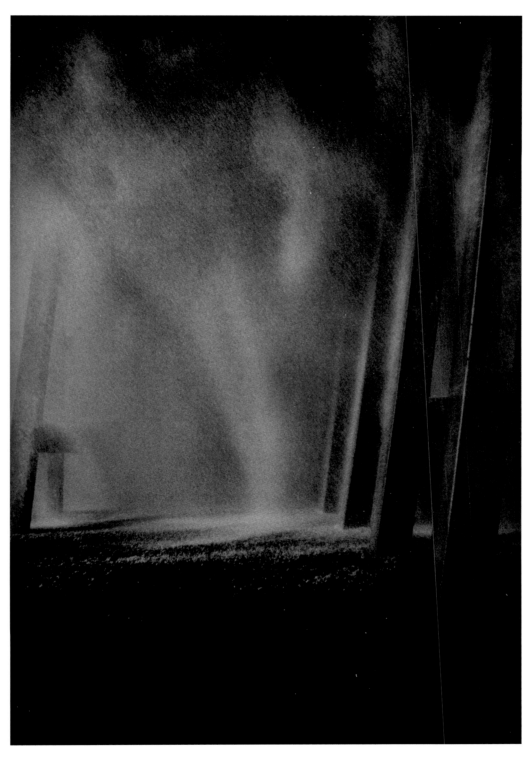

I 1

15

I 11

GOLD

Photographed in a gold foundry,
a gold refinery, and in bank vaults

II 1	Gold ingot
II 2	Pallets
II 3	Scratches
II 4	Crucible
II 5	Gold bullion
II 6	Pure gold
II 7	Casting molds
II 8	Die casting
II 9	Standard bars
II 10	Casting molds
II 11	Casting
II 12	Casting
II 13	Granules
II 14	Standard bars
II 15	Security grid
II 16	Standard bars
II 17	Standard bars
II 18	Security grid

II 16

II 10

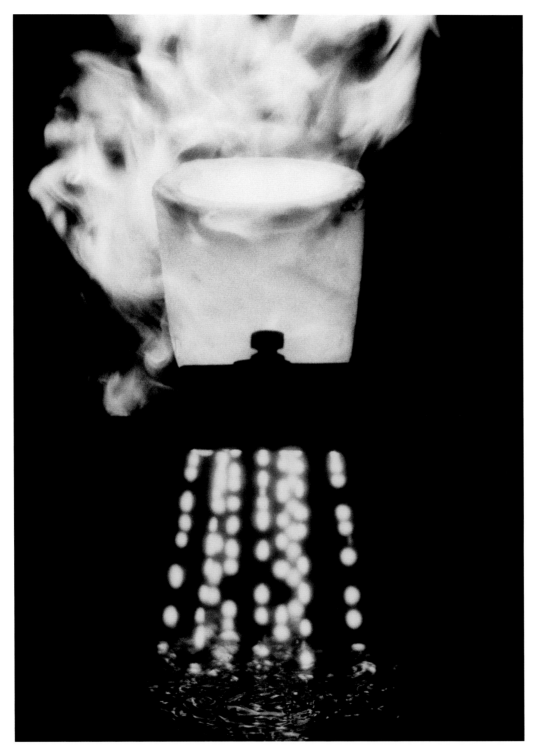

II 12

MEDICINE I

Photographed in anatomy and pathology
instruction and research laboratories

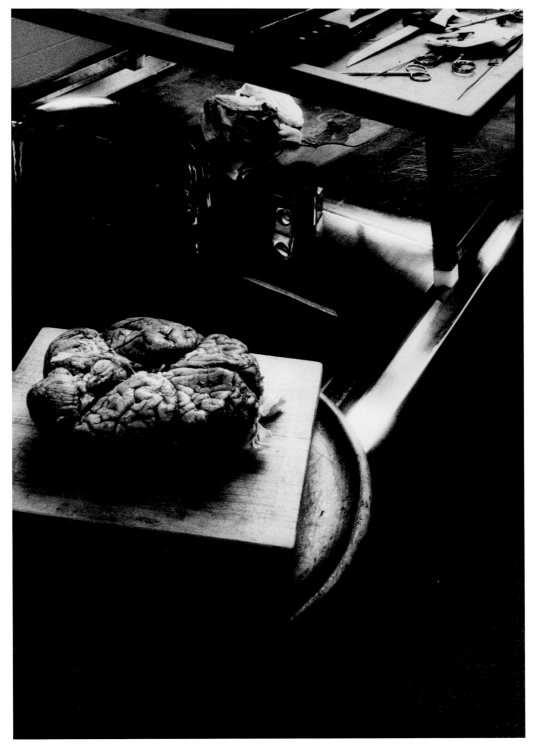

III 5

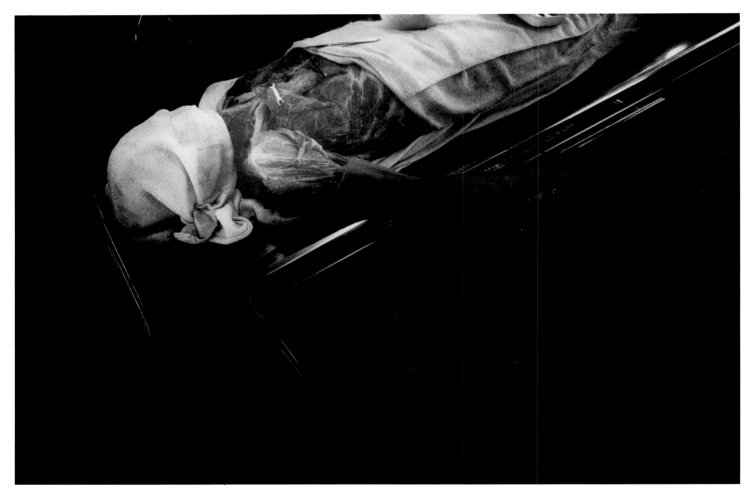

III 10

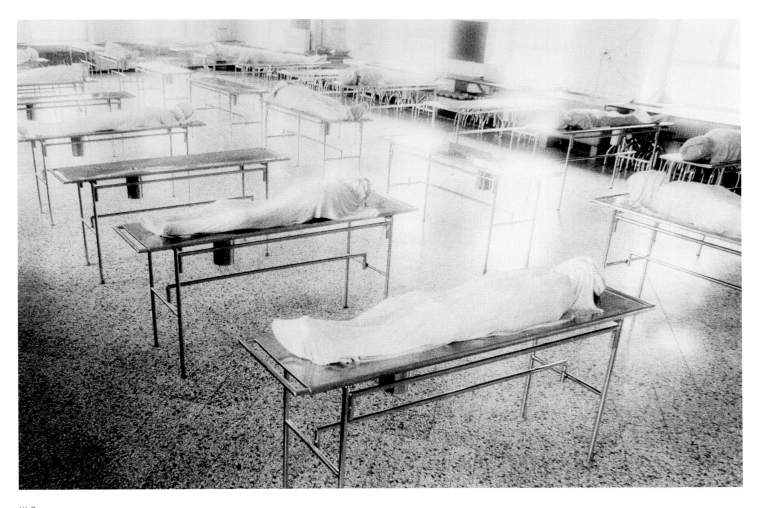

III 8

LOS ALAMOS

Photographed in nuclear fusion and
laser research laboratories

IV 9

IV 11

IV 12

MEDICINE II

Photographed in ophthalmology
and otorhinolaryngology clinics and
research laboratories

V 1

V 5

V 3

CHEMISTRY I

Photographed in pharmacology
and chemistry research laboratories,
analysis, and production

VI 1

VI 13

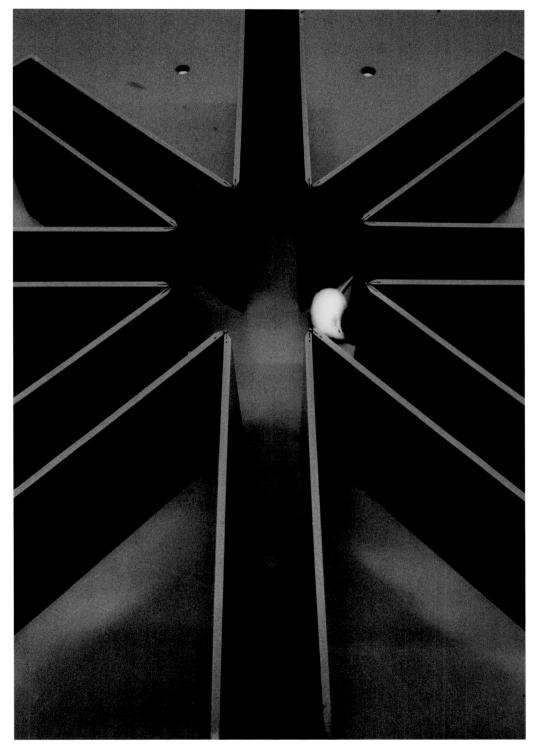

VI 14

CHEMISTRY II

Photographed in life science laboratories
and in pharmacology and agronomy genetic
engineering and biotechnology laboratories

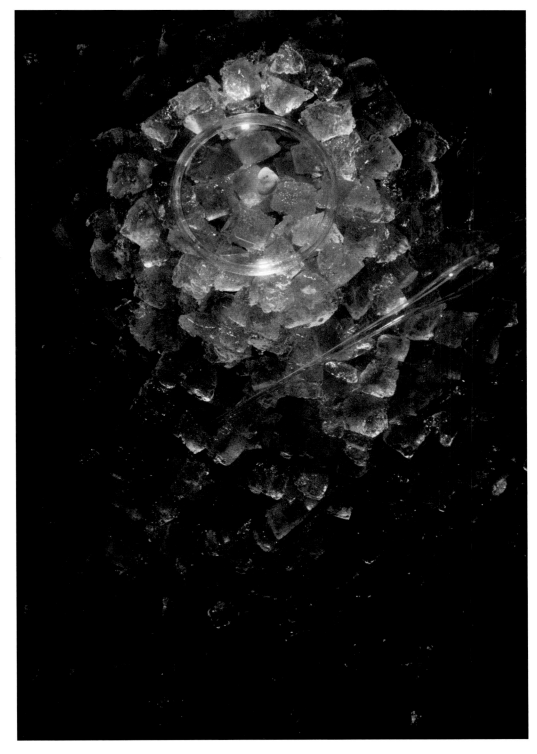

VII 4

VII 6

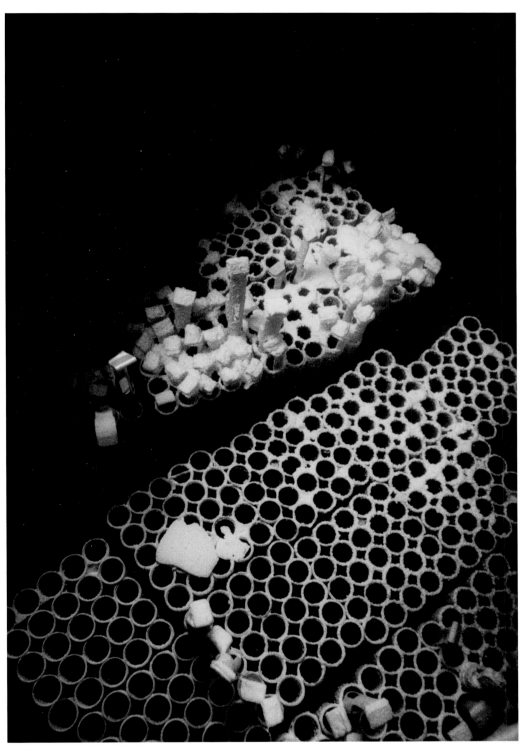

VII 3

In vivo— in vitro

Urs Stahel

The book was exceptional when it was published in 1989 and in the meantime has not lost any of its uniqueness. It has a slightly elongated, upright format, measuring 37 cm, with a breadth of 29.5 cm—that is, it is a format that at most allows semi-automatic processing. The book jacket is white, a warm white tending slightly toward off-white, an almost warm tone. Thick, firm paper has been chosen for it, with a matt laminate or finish, and typography alone decorates the front and the spine with the words: Hans Danuser—IN VIVO—Verlag Lars Müller. The back cover features a small-format photograph in the upper center, a quote of sorts from the book; following the numbering of the book it is figure III 10 as the key photograph in the *Medicine I* series, that is, it is the tenth photograph in the third section that was "photographed in anatomy and pathology instruction and research laboratories." An autopsied corpse lies on a gurney, partly visible, partly concealed, partly intact, partially dissected. The gurney is presumably the draw of a mortuary refrigerator, thrust into the picture from the upper right to the lower left, as if someone had opened up a modern grave in a metal refrigerator and shone a dim light on a frozen body. It is a tiny reference, a symbolic image for the project in its entirety, a displaced frontispiece. The book has been bound in light gray linen with "IN VIVO" impressed on the cover. The endpapers are deep red, the only color in the whole book. The title page is the same as the book jacket.

Then the book begins with the ninety-three tritone prints, dividing them into seven sections, with only the minimal addition of the numbering by the graphic artist and publisher Lars Müller: the Roman numerals are for the series and the Arabic numerals for the individual prints. The vertical and horizontal formats of the images have been arranged as if Lars Müller had, with a slight movement of his hand, shifted them from the center, pushing the horizontal formats slightly upward, the upright formats either to the left or the right, so that the images better harmonize with the large format of the paper. Throughout the entire book we find a cleverly calculated system of pages with images interspersed with empty pages, sequences that follow the exhibition arrangement and vice versa. An insert lists all the technical details as well as the titles of the series and the individual photographs, from I to VII, with series sizes comprising 9, 11, 12, 13, 14, 16, and 18 photographs. The lithographs in the book are from Straumann AG in Dielsdorf and among the very first to be produced digitally, which Waser Druck in Buchs did not print in the usual duotone but in three colors, called tritone. The bookbindery put the sheets together and bound them. The combination of lithography, printing, and art paper is remarkable, and even today still superb. In many of the photographs black tones are so predominant that the grayscale does not exceed ten to twenty percent. The other printers and publishers could not take on the job. Photographs, graphic art, lithography, printing, and binding here produce a coherency that is extremely rare. Accordingly the book won a number of awards.

The special formal, graphic, and technical characteristics of the book correspond with Hans Danuser's ninety-three photographs—exceptional on account of their overall artistic qualities and content. When first presented to the public they were immediately a sensation, and even today they fascinate and have a unique significance. *In vivo*—the world in terms of flesh, both of the dead and the living. *In vivo* and *in vitro*—the visualization of power, knowledge, capital, and violence in disturbing imagery that visualizes in an increasingly abstract world. Before we proceed to the particulars of the project, however, I would like to unroll like a rug the topography of photography and art, the chapters they went through and the situation at the time when the individual series for *In vivo* were produced in the period from 1980 to 1989, to be finally published as a single cohesive project and mounted for the first time as an exhibition at the Aargauer Kunsthaus in Aarau.

In the 1950s the penchant for certainties began to totter. The horrors of World War II had been incommensurably great. It was impossible to proceed as usual, as if nothing had occurred, to dabble around with the same old devices as before—even if society, its institutions, and even our innate indolence attempted with all their might to return to life as normal, to reintroduce and reestablish themselves and the values of yesteryear. World War II had made individuals too much aware that they were henceforth left to their own devices, at least in those countries that had been hardest hit by it. Faith in the state, its institutions, the Church, in the diverse moral and legal means of regulation was shaken severely, the Freudian superego left deeply disturbed.

Correspondingly, a succession of sweeping changes shaped the paths pursued by art and photography in the 1970s. For example, documentary photography became increasingly subjective. The parameters gradually changed. Objective presentation of the world morphed into a subjective perception of it; photographic truth shifted clearly toward authenticity, objective truth to the authenticity of the subject, to the authenticity of the photographer. Visual exploration, knowledge, and representation of the world shifted to a dialog, to reflecting on media or self. The photographers became visible in the image, so to speak. They came out of cover and bared themselves, discarded the general's vantage and joined the action in the field, took part. They became part of the image, and the world part of them. Documentary photography changed, growing more radical in stages, evolving into a subjective, artistic statement.

We can discern this trend to subjectivity in art too, in which art becomes embodied, defined in spatial and temporal relations, in happenings and performance, the movements that gained in momentum since the end of the 1950s. These were the first steps toward the dissolution of stringent pictorial conceptions, negating notions of art as synonymous with painting on square or rectangular canvases—framed or unframed—and united with the idea of the sublime, eternal, ecstatic, such as last found in abstract expressionism. And we can discern the trend to subjectivity in the crucial questions of identity of the time: Who am I? What is my role in life? What roles am I forced to adopt? Crucial questions that acquired a new urgency in face of the loss of faith in the authorities of the outside world, in outer absolutes. In post-war feminism we find the basic model for many debates on identity. The oppression of women is socially controlled by ascribing an allegedly natural, but in fact a socially controlled, unequal role to women, which is a key factor in shaping their identities already at a very young age. Women now question identification with traditional models and seek a new identity, combined with a transvaluation of values. Prescribing and assigning identities began to be viewed as a key means of exerting power within society, while inventing own identities became a form of resistance and opposition. Manifestations of this model could be more or less radical. All the other groups involved in identity discussions, such as the gay scene and POC (people of color), pursued this model.

Happenings and performance not only led to the identity movement of the 1960s and '70s but also to art and photography gradually becoming conceptual, to the dissolution of traditional notions of art and images in their various manifestations. For many artists this was a decade of radical departures—from the abstract, pure modes of design seeking objectivity and their conceptual superstructure; from the artwork as a closed, absolute entity; from the precept of the material-specificity of art; and from categories of style. It was also the time for the negation of greatness in form, narrative, or universal truths. They were being replaced by insight, thoughtfulness, probing and plumbing, questioning, trying out, searching, by conceptual reflection on

perception, on the terms under which we act, research of the media used by the artist. Photography is mostly used "industrially" in conceptual art, to quote Ed Ruscha with this term. Not the fine arts of photography, not the great powers of design in a square frame, but instead photography utilized as scraps of reality.

We can illustrate the conceptual turn in photography by tracing the evolution of landscape photography in the United States—the shift from notions of landscape as sacred, other-worldly, as a pantheistic notion of nature, to viewing landscape as real, factual, and an economic factor in the 1960s and '70s. Photographers turned about 180 degrees. They no longer went out to look at nature, but looked back into the suburbs, the rampantly growing urban environments that were eating up the countryside. Suburbia was born again, now in images. New Topographics no longer sees the world through the eyes of a subject, nurtured by the spirit of adventure of its author and his ideas of utopia. Instead it discards utopian ideas and scrutinizes, investigates what is happening to urban, suburban, and rural environments. Its photographs are investigations of new urbanism as an inner and outer reality. Its photographers and artists prioritize the purity of images and the congruence of form and content as critical instruments, replacing the illusion of artistic proficiency in photography with the illusion of mechanistic description. By this means they force us, the viewers of the photographs and the viewing subjects, to adopt a fundamentally new role—to look uncompromisingly and unsentimentally at the world before our eyes, at the world around us as it is now.

However, many photographers experienced the 1970s as a decade of great uncertainty, a time of identity crisis and radical change in photography. Conventional notions and uses of photography were now, for the first time, under extreme pressure. For the outside world photography was in the process of losing its role at the forefront in reporting about the world to live television. Internally it was in danger of being eclipsed by the first great wave of commercial photography, and art, too, began to explore photography, claim it for itself. Additionally the truth claim of photography was rapidly losing ground. Structuralist theories proclaimed the "death of the author." This contested the notion of an autonomous subject that is sovereign and determines its actions and instead put forward that a whole system is involved, and that we move in and with this system, are dependent on it, and are neither autonomous nor independent.

Seen in this light, the three major characteristics of photographic design at the time (black negative frame, push processing to obtain printable negatives in low-light conditions, extreme wide angle) seem to evidence a strong reaction, appear to participate in a visual counter strategy, a kind of photographic counterreformation. It was expected that photography appear as authentic and real as possible. Proximity, immediacy, and no frills were expected of it, and it was by no means allowed that one distort the original intention in the post-processing. This became the credo of a visual counterreformation. Reality and authenticity were suggested by making the grain visible, imbuing the medium with a rough, hands-on quality, and enlarging the image in a way so that it was detailed and crisp. The black edge underscored the aspect of the personal view of an autonomous subject. This appears to have been a new way of expressing a certain helplessness or refusal in coming to terms with the increasing complexity of the world and a systemic world view.

Against this backdrop, Hans Danuser began with his major project, which he concluded nine years later in 1989 with the book and the exhibition at the Aargauer Kunsthaus in Aarau. Initially in a searching, probing, experimental way towards the end of the 1970s, in the 1980s finally he

began with the *A-Energy* project, "photographed in atomic power plants, reactor research facilities and interim storage of highly radioactive waste." He thus started out with a highly controversial, heatedly debated topic. As we can well remember, the planned Kaiseraugst nuclear power plant in the Canton of Aargau fell through in face of the intense opposition among the local population and highly political environmentalists. The municipality of Kaiseraugst was long under discussion as the site for a nuclear power plant. According to Wikipedia, the most spectacular part of the controversy was an occupation of the site for eleven weeks in 1975 with some 15,000 people at the start. In 1989, the project was finally abandoned after twenty years of planning that cost 1.3 billion Swiss francs in the end. As the controversy was at its peak, the photographs often showed the same thing over and over: demonstrators, protest signs, raised fists, and cooling towers, alone or with cows grazing in the foreground. Hans Danuser adopted a different approach. He worked hard, he fought adamantly for the right to take close up pictures on location in the heart of nuclear energy research and production, of nuclear reactors, nuclear reactor research, and interim storage of nuclear waste. Through his own efforts he succeeded in reclaiming, at least partially, sovereignty of visual interpretation, which in this case Motor-Columbus, as the company that was to potentially run the nuclear reactor, held the exclusive rights. He distanced his photographs from the others in two ways: firstly he fragmented the symbol of the cooling tower into three parts. And, secondly, he presented the nuclear reactor and the places where nuclear research was being carried out devoid of people. We experience these places in his photographs as empty, tightly regulated rooms, with many signs and signals. We enter them as if we were on our way to our workplace, we are led through them, to the changing room, the double-door systems, the fog in the cooling tower. We look into the nuclear reactor, follow the nuclear waste to its interim storage place—metal containers stapled one over the other with labels and simply covered with plastic. Perhaps we can still remember that in the 1970s Switzerland dumped its nuclear waste in the Mediterranean Sea offshore from Portugal. We speak of a "permanent disposal site," but suspect or know that there is no such thing as a permanent disposal site for nuclear waste, because it must be permanently monitored and safe-kept under the strictest measures for the next 50,000 years.

Danuser's very first photographs are very different to the press photography that was common at the time, which was inevitably descriptive and documentary by nature. He avoids using ideological symbols and references and, instead of using the camera to emphatically present descriptive facts, provides room for beholders to immerse themselves in his photographs. They engulf their beholders, allow them to scout around; make them view in a way that triggers emotions, leaving latitude to the sensations of taste and smell, paradoxically addressing several senses concurrently. The very first picture of the project, taken in the collection basin of the cooling tower, brings to mind Fritz Lang's *Metropolis* or Andrei Tarkovsky's *Stalker*, a kind of apocalyptic vision, a visual Sodom and Gomorrah.

In his second project, the *Gold* series, "photographed in a gold foundry, a gold refinery and bank vaults," a deep, light-absorbing black predominates in the photographs, which is interrupted by the glowing, blazing light produced by melting down and then pouring the glowing molten gold into the ingot casts. The effect is that of dramatic, industrial chiaroscuro, as we know in painting since Caravaggio, with an inner light source and not shining in from some outer source, where the lighting is purely and simply the product of a process captured on film. In the prints and the reproductions, the saturation and darkness of the black values are between eighty to one

hundred percent, and the brightness is equally extreme, which now and again appears as if Danuser had scratched away the gelatin silver layer on the paper substrate. The impression of alchemy coincides with the mute and brilliant transformation of raw gold into its pure form, from one of the earth's elements into an abstract dimension, into the world of monetary abstractions, values, and capital.

In *Medicine I* the white of the tiles predominates. The rooms "photographed in anatomy and pathology instruction and research laboratories" are all tiled. It is a cold white, washed out in parts and bleached from much cleaning, into which human corpses and limbs are brought for dissection. Heads, brains, hearts, stomachs, organs. Here photography revitalizes anatomy as the classical interface between science and art. We follow the investigative, dissecting gaze, look on as the skin is removed, as the corpses and limbs are fragmented in the search of knowledge, of certainty. Danuser here again, as in the *A-Energy* series, maintains a remarkable balance between events and place of occurrence. The photographs give the environment, the space, the site, the condition of the floors, and metal dissecting tables the status of fellow actors. They are as eloquent as what we can perceive in them, they create the ambience, pictorial space, visual atmosphere. They are the covers of a book, paper, and text in one. United, their gentle muttering is the accompaniment for the visual words spelled in capitals "Energy!, "Gold!," "Values!," "Existence!," "Knowledge!" The intensity of the images and the subject matter demands the use of exclamation marks.

Just as in the nuclear energy series, this series begins with a photograph of skins, of protective clothing. Emptied, washed, hanging on hooks, they reference the activities of people while refusing to show them in action, actively engaging with their work. People are present in each and every picture, with their knowledge, their volition, their power, their goals, wishes, perhaps even their neuroses, while at the same time they disappear behind their machines and technology, in their rooms and spaces, in the world they have created. However, in *Medicine II*, "photographed in ophthalmology and otorhinolarynology clinics and research laboratories," humanity is present as the subject of investigation in a special way during operations on eyes, noses, ears, the human senses, the instruments of humankind with which bodies are in touch with the world. We know how to manipulate them so we have longer use of them, so they offer heightened precision, to enhance their performance. And the voice issuing from the larynx, the organ with which we breathe and speak, is our means of keeping in touch and communicating with the rest of the world. It is the powerhouse of our existence and social life. The organs that are to be operated on are laid bare for the purpose and the rest covered up, wiped away, wiped out with disinfection. Here medicine superbly mirrors humanity's capacity to act. We are excellent mechanics. We can repair precisely and accurately, but still do not understand much of the greater context. Within the scope of the latter, in its complex, interdependent, multilayered connections we are, above all, almost incapable of acting. Tubes and wires connect the patient to machines. The "cases" humbly submit to the world of substitutes, which, for the time of the operation, monitor the patients' condition, breathing, and circulation—or do for them. The early stages of the cyborization of humanity, the union of nature and the prosthesis, the original replaced by a substitute or enhanced by artificial means and support. We penetrate through the outer layer, the outward appearance of things, into the body, into its machinery. Monitoring a patient undergoing endoscopy on a screen means to look into the innermost recesses of the body, docking the body onto the big machine. This is a totally new form of being humbled, an encroachment on the physical integrity or the

intimacy of the body, a new kind of power that makes a necessity of an individual body submitting to the power and potency of organized knowledge.

Los Alamos, the fourth series, "photographed in laboratories for nuclear fusion and laser research," is essentially architectural scenes. On the one hand, the series strives to apprehend the space around the earth as a real and an imaginary architectural structure, a network of laser canons. They have everything under control, always and everywhere. On the other, Hans Danuser took photos in Los Alamos, New Mexico, where the United States government under Ronald Reagan was developing laser technology, still very new and uncharted territory at the time. We see dark rooms, workplaces that "speak" of cold brilliance when light hits metal, of fast-paced and intensive research, of a military bunker, disrupted by sharp beams of light, warning signs, and a robot-like laser canon, a metal octopus with an orb that can shoot in all directions, that is, 360 x 360 degrees. The project was ultimately discarded, shelved for the meantime—at least nothing new has been reported since. At the time, however, it was touted as the weapon that would give the United States the lead in the Cold War, turning the tide in the quest for global dominance. This was the reason why Hans Danuser decided to give up his first military project, which involved photographs of the anti-aircraft development company named Contraves in Switzerland, among others, and began with the Los Alamos project.

As stated above, in the series on the whole, it is largely the photographs of the surroundings that determine the overall picture. They are the photographs that frame, shape the spatial context in which the pictures unfold the subject matter—resembling crime-scene photographs, providing a survey of the situation, defining the location of the motifs and theme. They are remarkably compelling in the *Los Alamos* series. In *Chemistry I*, "photographed in pharmacology and chemistry research laboratories, analysis and production," such pictures convey an atmosphere that is cramped, claustrophobic, even suffocating. Together, pictures 2 and 3 of this series are reminiscent of Alcatraz or Guantánamo, like a hopeless prison for animals, for the rats bred "for the benefit of humanity," for research and analyses, often simply receiving injections of substances until pathological symptoms begin to show, until they develop behavioral disorders, until cancer manifests. To give the beholder the same feeling of hopelessness, Hans Danuser turned one of the photographs so that the two images interlock in a way that optically bars the way, terminating it, to become a dead end. There is a marked contrast between the physically palpable dark and gloomy barred-in spaces and the brilliant white of the writing boards, on which scientific formulas, production formulas (not yet profit estimations) have been scribbled, jotted down, for us an incoherent sketch. They are the flashes of inspiration, the formalization of the investigated material, abstractions of the flesh, the physical, are the precipitate of staged "natural" accidents. On the boards is the wording "brain sections in vitro test arrangement," "open brain in vivo test arrangement." The first image, the *Magnetic Resonance Scan*, appears to stage nature visually in terms of abstraction and geometry through science. This examination of a rat, at the time only carried out annually, experiences a geometrical transformation in the image, it has become an abstract entity explained in terms of squares, triangles, and circles. Every series contains several key images. However, if you want to pick out just one of these photographs, it is almost the only one that can stand for the whole, for the project, the thoughts, its hidden values.

With only one exception, all the subjects Hans Danuser tackled were controversial, intensively debated, and sometimes excited protest. But he only first stumbled on the topic of genetic research in the last chapter of *In vivo*, while taking the photographs for the series, in the process

of realizing the project. The *Chemistry 2* series, "photographed in life science laboratories and in pharmacology and agronomy genetic engineering and biotechnology laboratories," marks the conclusion of his large project. One of its photographs, an ultrasound image of an embryo, is the very first picture that refers beyond the directly visible world. It is the visual expression of a technology that goes deep below the surface, a technology that can manipulate the very roots of our world, that is, the genes. Danuser shows us the very first tobacco plant that was genetically modified. He visualized analog DNA-RNA determination. This series makes especially the great differences in temperature visible, from the minus 197 degrees of the ice where genetic material is stored to 37 degrees in a kind of "life" incubator. The individual photographs in this series are named *Tobacco Plant*, *Container*, *Embryo*, *Incubator*, *Deoxyribonucleic Acid/DNA*, *Ice*, *Ice*, *Ice*, *Glass Ampoules*, *Ultrasound Image*, *Ice*. The "ice" proved prescient for the following project, the *Frozen Embryo Series*.

The first picture in the series and the book and the last resemble one another like brother and sister. Fog determines the visual atmosphere in both of them, both formulate the transition from simple visibility—"in front of us stands a house on level ground"—to complex perceptions of reality and interventions in it: "What has been dribbled onto film here visualizes the inner structure of life, it visualizes DNA."

At the start I wrote that Hans Danuser's photographs were very different to the reportage, documentary photography typical for the time. This holds true for both the subject matter and the visual vocabulary. Danuser's domain are socially relevant areas, such as research and energy production, finance, knowledge, control, power, and violence. They are taboo areas, where access is controlled or blocked and communication channeled. As a rule, information in general and sovereignty of interpretation both over research results and the visual language illustrating these increasingly abstract issues lies in the hands of companies and institutions, and they guard it like the Holy Grail. Danuser's patience, his insistence and persistence, the way he hones and breaks this pictorial project down into something artistic, deliberating, and complex, opened doors for him, doors that are impassable now.

Hans Danuser's visual vocabulary was, at the time, new, different, and nevertheless highly photographic. In the first one hundred or so years in the history of this medium, motifs so engrossed our vision, held us spellbound to such a degree, that, hungry for visual sustenance, gazing in hope of visual insight, we for the most part could not see beyond this. Tunnel vision focusing on optics was the generally accepted mode. Although the views and insights of this kind of photography improved from decade to decade, the photographers who mastered the rules of the game for photography and the square frame with ever greater virtuosity, gradually came to realize how strongly the photographic image depended on technological innovations in cameras, optics, in films and photographic paper. Filled with curiosity and their passion and partiality for motifs, together with their enthusiasm and a sense for business, they scarcely looked to the left or the right, above or below, to the edge of the frame and beyond. They never turned around and asked who was taking the pictures and under what sociopolitical, economic, and media-specific conditions.

Only Japanese photography around 1970 adopted a different approach of "are, buke, boke" in *Provoke* magazine and in the pictures of the Provoke era photographers such as Takuma Nakahira, Yutaka Takanashi, and Daidō Moriyama, to name a few. "Are, buke, boke" means grainy, blurry, and out of focus. The effect of their photographs makes it clear that they are not attempting

to be "beautiful, attractive pictures" or "committed, coherent photographs," that they are not attempting to capture things with utmost documentary precision. Instead they strive to show that photographers were on the move, that photography was the confrontation between life in motion and the photographer in motion. Thus the picture was more or less the precipitate of this encounter, the result of slowly sweeping past one another or sudden collision. If you leaf through the only three issues that were ever published of *Provoke* magazine, they excite the impression that "something" is being broken open; that something is perhaps life, the situation, the location, the picture itself has become unhinged for the first time, that black-and-white are sometimes an aggressive means of attacking the classical world of representation and of sweeping it away. In these pictures we can discern a certain affinity to Hans Danuser's approach.

Hans Danuser's ninety-three photographs for *In Vivo* seek to take the best of what photography has to offer and at the same time reinvent it anew. His modus operandi was explicitly photographic, with him traveling to many different places for the seven themes of his series and taking his pictures there. In these areas he was painstaking and moved about slowly and deliberately, and brought the films home afterwards to his own darkroom. This is the classical strategy of the photographer and at the same time a characteristic only the medium of photography allows. He developed and enlarged the photographs in a way so that the black edges of the negatives are visible, that at a push the edge can serve as the "evidence" that Danuser "really had been there." However, the edges don't appear in the finished work, neither in the book nor in the exhibitions. He always covers them up or cuts them off for the lithographic print. After all, he wanted to get away from photography as documentary survey and proof of the situation at a specific location and specific time. He wanted to pursue a different path, to do something new. He wanted to find a photographic image that shows the fundamentals, that records structures, that strives to comprehend abstract knowledge in pictures. He wanted to find visual forms that represent the essential characteristics of human behavior, of research, investigation, development, and production of the 1980s, visual forms in which both information and emotion have their place, as do also objective facts and connotations, description and visual imagery, crispness and fuzziness. Indeed, his photographs have a fuzzy appearance, like velvet, giving you the feeling you want to touch them because of their wealth of tonalities, because of the extreme richness and density of their silver content. Information is submerged in black tones or pales in the brightness of white and nevertheless persists, it is there, gives food for thought and emotions. Danuser persisted in a photographic way of proceeding, but sought to produce pictures that bring photography a step further, away from its motif orientation. He did not want to be confined by the tenet of evidential proof while at the same time not wishing to become one of the fine art photographers who were flourishing at the time. He continued working with the classical format of photography and did not bend to the rage of ever-larger formats in painting and photography, in billboards, in recent large-format painting, large-format photography. Instead he explored a third avenue leading between the existing categories and chronicled the world with the photographic visual imagery of a painter, a filmmaker, an Andrei Tarkovsky or a Fritz Lang.

Neither the themes nor the images have outlived their relevance over the past thirty years, and if they belong to another time, they are still meaningful today. Consequently this body of work is addressed again and again, even internationally. Genetic research has progressed a great deal since, *Star Wars* been discontinued, but the principles of knowledge and power, power and violence remain, and Danuser's visual vocabulary befits all those in the present who probe in

depth the images and themes of the profoundly real. However, the overlap between the book and the exhibition and the way in which the visual themes in their various forms are developed analogously (almost like in music) remain unique. Danuser later braved the plunge into the monumental, into the physical confrontation with the image, as we can see in his oversized four landscape and four upright large format photographs of *Strangled Body* with iron frames from the mid-1990s, to name just one example. This direction also lent his work a distinct installation quality.

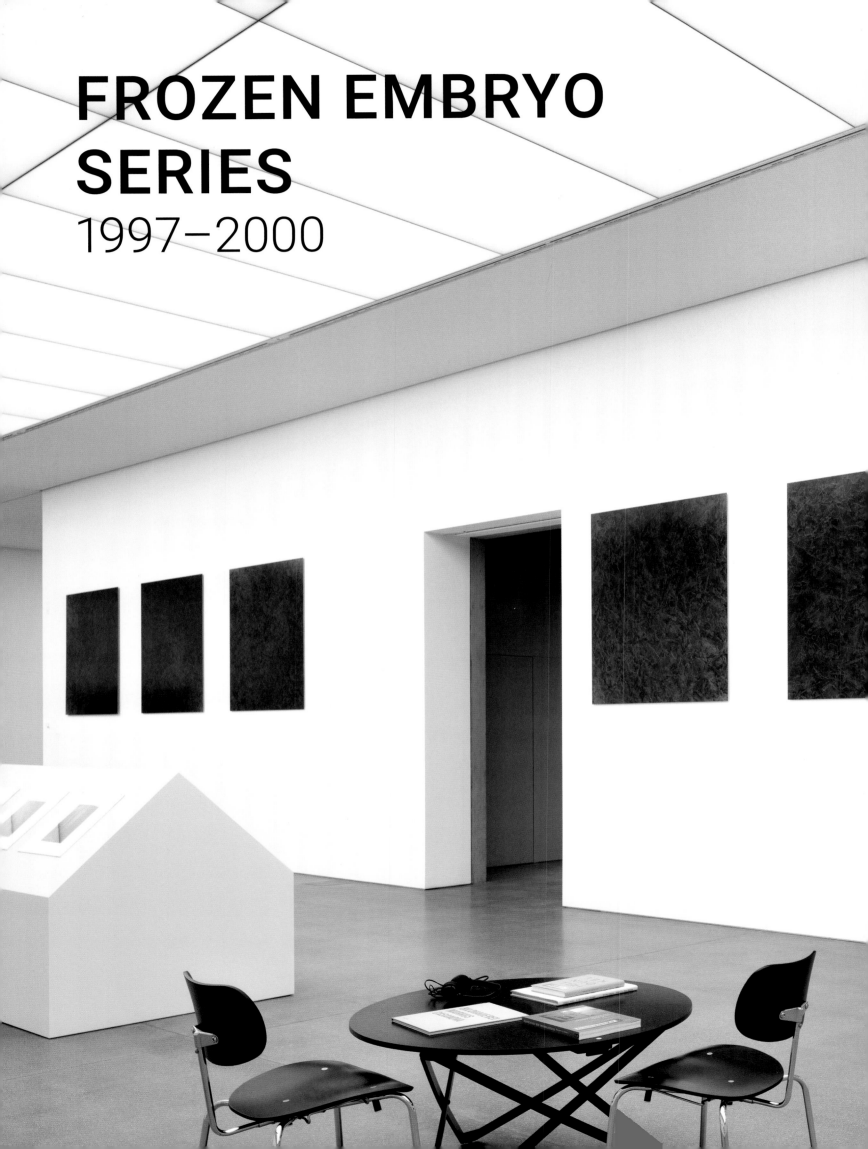

FROZEN EMBRYO
SERIES

1997–2000

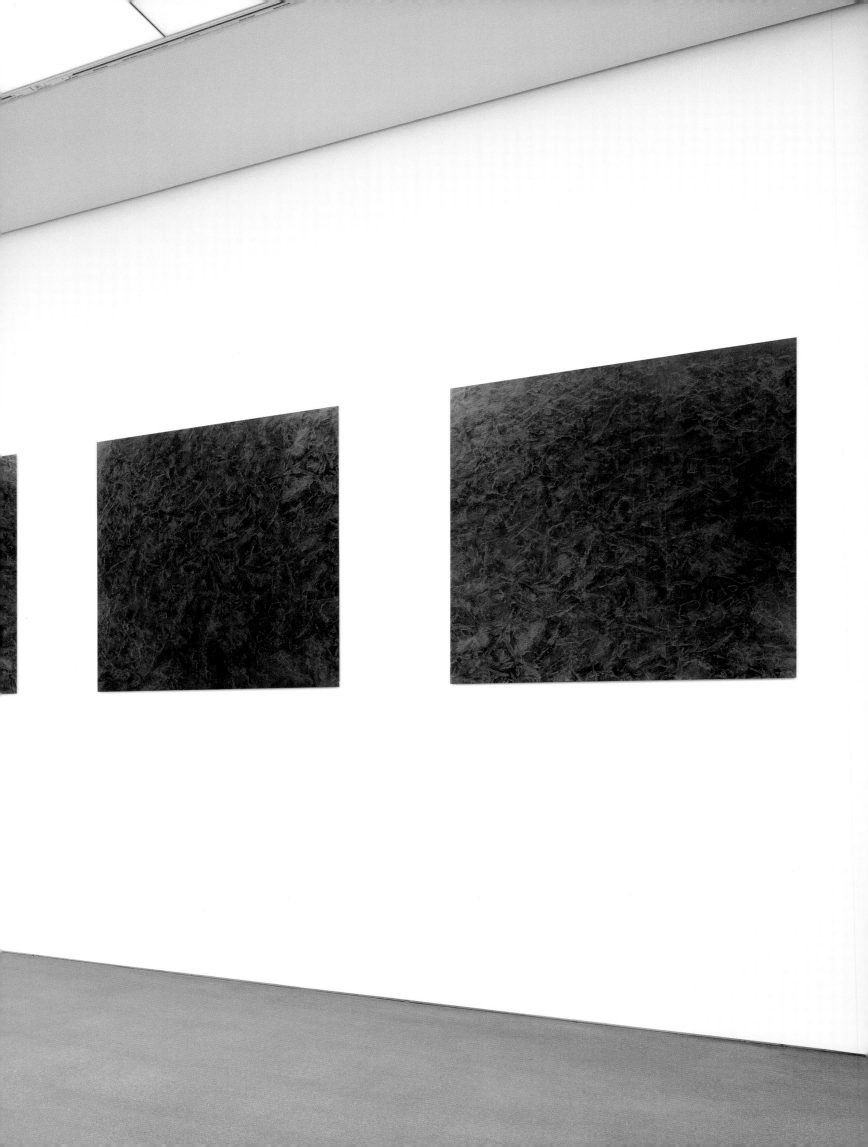

FROZEN EMBRYO SERIES III

III 1

III 4

III 2

III 3

III 5

III 6

III 7

III 8

III 9

III 10

FROZEN EMBRYO SERIES II

II 1

II 2

II 5

II 6

II 4

II 8

FROZEN EMBRYO SERIES I

| 1

| 2

| 3

| 4

FROZEN EMBRYO SERIES VIII

VIII 1

VIII 2

VIII 3

VIII 4

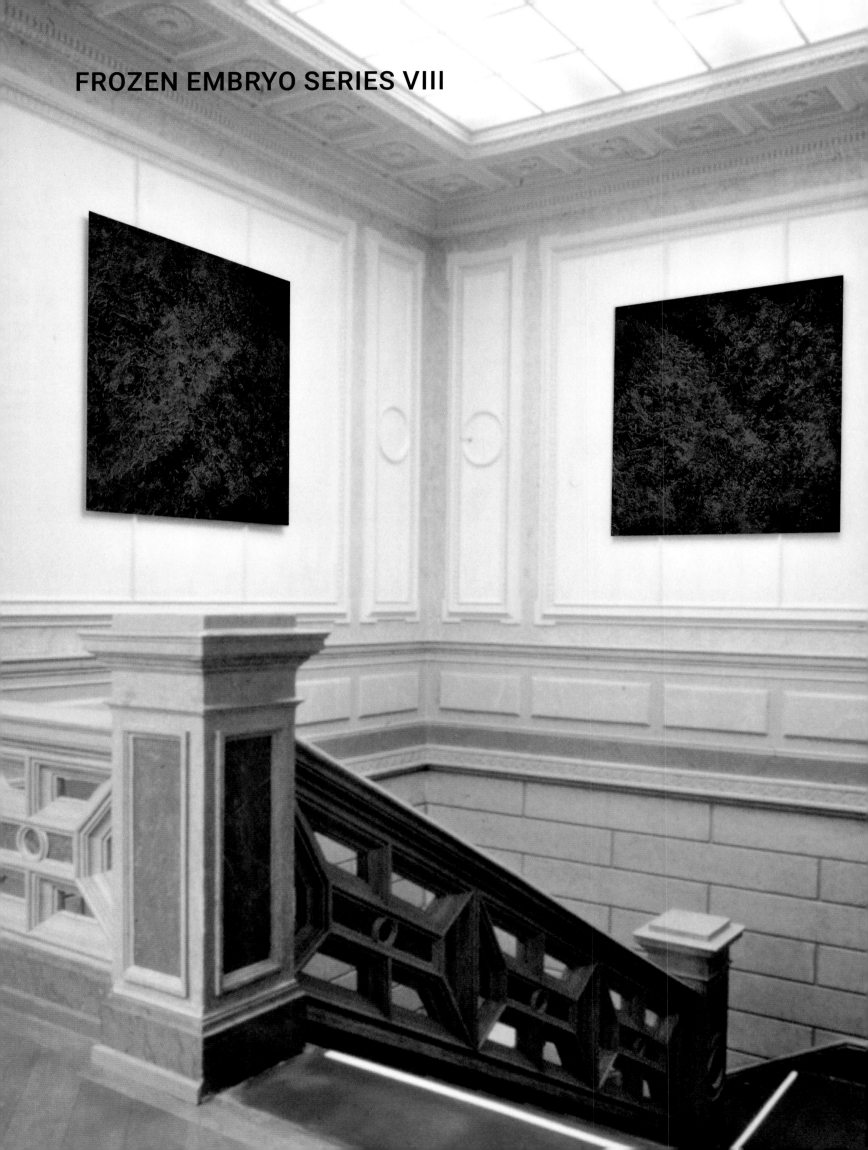

FROZEN EMBRYO SERIES VIII

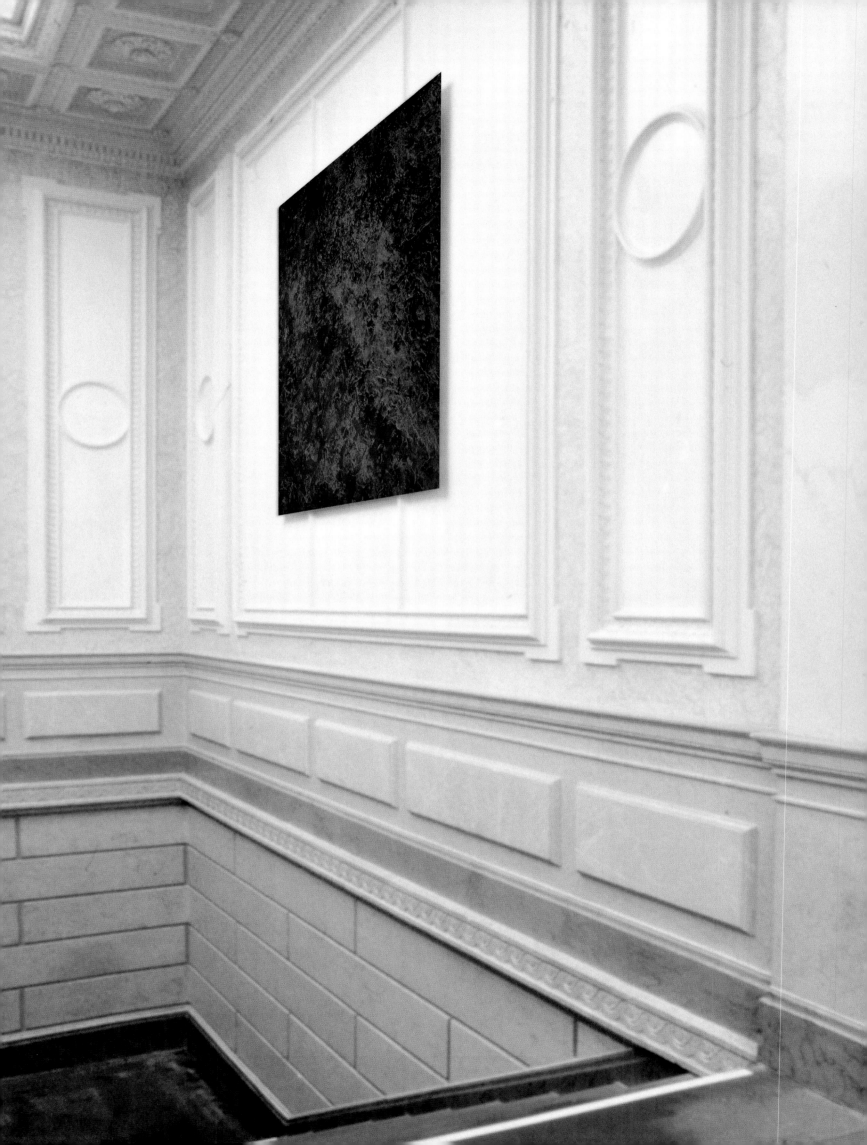

From Painting to Photography and Object

Lynn Kost

Prior to the invention of photography, we used to think primarily of paintings when it came to pictures. They were utilized for representation and visual narration, compressing time onto the canvas. Events and story lines are depicted side-by-side, overlapping, and taking on an abstract form.[1] Photography put an abrupt end to the long reign of this traditional conception of the image. It introduced the present tense into visual tradition and eclipsed the past tense of painting. In a subtractive process, photography selects from a current situation and creates an image of a reality. At both a narrative and an objective level, photography shifts the focus to the presence, immediacy, authenticity, and reality of the moment. With a little imagination and fantasy, viewers can participate and share in the reality the photograph depicts, whereas in paintings it cannot be shared and instead must be passed down to us.[2] The invention of photography atomized the traditional understanding of pictures. With painting only recently having arrived at naturalism, the visual arts were confronted with a fundamentally broadened concept of the image.

Shaken to its foundations, painting began to question its validity and purpose, and embarked upon the deconstruction and dissolution of representation and narration (the two essential characteristics that it had now lost to photography). Finally, in the early twentieth century, avant-garde movements began centering their efforts on abstraction, moving to nonobjective and monochrome paintings. They sought to liberate painting from the chains of illusionism. This evolution was a response to the inflexible and constrictive structures of society, which—in the field of art—manifested themselves in the form of strict institutionalization and conformity to rules. As happened at societal level, painting too began to free itself of these restrictions.[3] It gave free rein to color, abandoned its reliance on proportion and the structures of perspective, experimented with multi-perspectives and found objects, and began exploring the medium of collage. In the end, Marcel Duchamp and dada gave up the canvas. Suprematism demanded a new system of thought that tolerated neither resemblances nor representation and saw painting as a purely spiritual form of expression. Piet Mondrian reduced his pictures to the geometric essentials of space and primary colors, prescient of developments in the 1960s. All modernist avant-garde movements shared in a dissection of naturalistic perception.[4] Painting still persisted as paint on a canvas, but the familiar pictorial traditions that represented and upheld the old orders of society were subverted. Manifestos openly called for social change and a break with the conservative, institutional values of the press, art criticism, authorities, institutions, and the state. This took place at a time when photography was experiencing its first efflorescence.

The cornerstone for a new tradition in visual imagery was laid in the 1910s and 1920s. While photography may have played a decisive part in triggering this development, for its part it remained trapped in its infancy.[5] Abstract and nonobjective painting, however, entered into the canon, although it was still too early for the radical departures from tradition that Duchamp propagated.[6] Instead, the cult of genius prevailed once again, in the development of abstract expressionism and art informel. Poetic narrative supplanted the epic, and the blow of losing naturalism to photography was soothed by an excursion into the metaphysical. Finally, in the 1950s, there was a radical break with the narrative image. The logical consequence was the liberation of materials (such as paint) from their bondage to illusion and narration. Paints, stretcher frames, canvas, painting utensils, amongst other materials, became themselves the subject of representation.[7] This departure from the function of the image is representative of the attack on the dominant, conservative art discourse that continued to uphold painting as its paradigm. The one-way

relationship between artwork and viewer was no more. Materiality was to be felt, spaces and interactions experienced, and meaning imbued on a participatory basis. Viewers were now to become an active part of the works: they could choose their own point of view both spatially and mentally, and could no longer act as mere passive consumers.

Frank Stella provided the impetus for such processes with his conceptual approach, and by radically "de-skilling" artistic activity. Subsequently, Donald Judd, along with several other artists we classify as purveyors of minimalism and conceptual art in its nascent stage, sought to systematically deconstruct the painting. It was dissected into its separate parts, released from the canvas, and its individual components showcased.[8] The subject evolved into an object—it became the opposite of what it had been before. Now the viewer could engage actively with a counterpart, with an object. Narratives became a thing of the past. Instead, the objects themselves addressed the themes of perception, physicality, and space, and referred to their own materiality—questions which viewers could then explore for themselves. As a result, paintings creating a spatial illusion (within the boundaries of the frame) in order to stage stories or historic episodes largely disappeared. It is remarkable that in the conceptual scheme of thought of the 1960s, hardly any photographic experiments pursued a deconstructive approach toward the picture or the "reality of pictures."[9] In the late 1980s, Hans Danuser took up this thread in his work and was one of the first to apply it systematically to photography.

While a complete change in paradigms took place in painting within just sixty years, building on a pictorial tradition of many centuries,[10] photography was only assimilated into art discourse in the 1980s. There is an element of irony in the fact that photography first acquired enduring relevance in art discourse at the moment it submitted to the outdated notion of representation in painting. Painting for its part turned emphatically towards the world of art again. The "Junge Wilde" (Wild Youth), however, was a movement that neither sought a comeback of the figurative, linear narration of classical notions of painting nor the nonobjective traditions of the 1960s, but rather undermined the prevailing codes, the intellectual discourse of the time, and social rules in general, in the tradition of the Punk movement. Breaking taboos, throwing rules overboard, provocation, pop culture, posters, and street art were characteristic of this movement. Photography, on the other hand, filled the vacuum left by the disappearance of classical painting. A major genre within photography emerged with staged scenes (sometimes whole series), constructed pictures, montages, monumental formats etc.[11] Its basis was the pictorial tradition of painting and its principles of composition. Danuser clearly distanced himself from trends such as these right from the start of his artistic career. He had no intention of being a classical narrator or agitator. In his self-understanding as a free photographer, that is, not working on commission, but also free of the categories of applied and artistic photography, he made the most of the attention enjoyed by the medium at the time and worked with the camera on a different kind of image—to be presented in an art context. Both in terms of form and content, his pictures assimilated important elements from the abstract movements of the 1910s and 1960s, which were radically apparent in his *Frozen Embryo* and *Erosion* series. The point of departure was the series *In Vivo* (1980–1989), for which he took pictures of places that had played a key role in developing the innovations which benefited affluent societies (energy, medicine, animal testing, space research). These places—situated between life and death—are represented by the system. In archetypal images, Danuser captured those forbidden zones where the rules of power and morality do not

apply. He has a Kafkaesque way of playing with gray values and perspectives, leaving the viewer feeling uncertain. But the realism of his images does not stem from their naturalism, rather, it is induced by the high degree of abstraction in the pictures, which is in turn the product of the lighting and of the medium of black-and-white photography that often tends towards the monochromatic. In this way, the artist deconstructs our preconception of the image. By undermining our expectations of what an image is, of what the motifs of photography are, and of what techniques are involved, the artist challenges viewers to think for themselves, instead of adhering blindly to narrative readings.

His unique approach to photography also finds expression in his fascination with being able, by means of a series of images, to create a syntax that facilitates a non-linear interpretation of themes. In his images, he consciously deviates from familiar pictorial traditions. His photography neither describes circumstances nor narrates in the past continuous tense. His pictures neither depict a moment in time, nor do they narrate in the present tense. Likewise, they do not replicate reality nor do they make us feel secure in our beliefs and preconceptions. Instead, Danuser uses the camera to create pictures that converse with their viewers not only by means of pictorial motifs, but by means of their material, spatial, and physical presence as well as their serial syntax. He makes the viewer the focal point of his series of images. While the pictures of the *In Vivo* series still present recognizable motifs, they anticipate the concept of the *Frozen Embryo* and *Erosion* series.

Active in the youth unrest of 1980s Zurich, to which he paid homage with his work *Harlequin's Death* (1982), Danuser's interests included political and social conflicts, as well as forms of opposition to the prevailing system. Early on, he began his search for imagery as an artistic means of responding to social conditions and times of change, looking for visual means through which to adequately address system-related violence, or to alienate it in order to illustrate his take on the issue. It is not only his choice of motifs that reveals his distance from—and opposition to—the system, but also the technical and formal ways in which he realizes the pictures. This triad of motif, form, and technique is greater than the sum of its parts. Their reciprocative impact defines Danuser's artistic strategy as much as his commitment to maintaining a clear distance from the prevailing political and artistic discourses does.

Hans Danuser hones in on intrinsic systems, those structures that influence people and their actions. *The Party is Over* series still employs the documentary format in order to address this. With the *In Vivo* series, he established his formal independence and found his thematic leitmotifs. The image of a frozen embryo is featured towards the end of the series. It marks the pivotal moment in his work and heralds the beginning of the *Frozen Embryo* series, as well as his transition to the systematic deconstruction of photography's established visual tradition.

Neither visible perspective nor vanishing points are present in these photographs, and their motifs are displayed frontally in full-bleed images. As a consequence, the motif of ice—destined to conserve embryos—is stripped of its context and is scarcely identifiable. While working on *In Vivo*, Danuser discovered that the different structures and colors of ice that has been frozen by nitrogen to -191 degrees centigrade correspond optimally with the color values of photographic paper coated with silver bromide. The colors and specific structure of the ice fascinated him. Ultimately, the work is not concerned with the ice, the object, but rather with our perception of this material, its color, and its structure. With this in mind, Danuser probes the interplay between

black-and-white photography and the corresponding photographic paper in a quest for an equivalent to the materiality and color of the objects. He attempts to produce an image by means of photography, but extending beyond the usual naturalism of photography. That which existed only rudimentarily in *In Vivo* becomes concrete in this series. Only abstraction can enhance realism for the viewer. Realism must become manifest in the mind, not on the retina.[12] Danuser strives to display dimensions in such a way that they become detached from the object. One of his ways of achieving this is to present the pictures so that their center lies at a height of 2.2 meters. The artist wishes to represent a material aspect, to make the paper the object. He describes it in terms of millions of tiny sculptures: particles of light-sensitive silver bromide emulsion on the photographic paper which produce the image. The image varies according to the angle at which light hits the surface, and the angle at which the viewers are positioned as they move around it.[13] This materialization of photography can only be achieved with analog photography. When creating the series, Danuser switched between 24 x 36 mm and the medium format of the Hasselblad camera (6 x 6 cm). The alternation of formats highlights the elimination of the axes and undermines the expectation of a horizon line in a landscape format.[14] Furthermore, Danuser dispenses with a frame and mounts his full-bleed images directly on aluminum in a 150 x 140 cm format. The slightly distorted square format enhances the overall effect, giving the illusion that the image flows into the exhibition space. All these factors enable the viewers to concentrate fully on their perception, without disturbance. The fact that the work is photographic is secondary. All the connotations that are echoed in traditional discourse and in the interpretation of photography disappear into the background. The viewer is submersed directly in the material. Danuser planned every last detail of his approach, and it was at this point that he abandoned the hitherto accepted classical tradition of visual imagery. He emphasizes the objecthood of his pictures and therefore also defines them as distinct from photography and paintings in the way he presents them. During the same period, photographers such as Andreas Gursky and Thomas Struth subscribed to the tradition of painting by framing their monumental formats classically.[15] The *Frozen Embryo* series is exhibited without frames and consistently suspended several centimeters away from the wall. By choosing a square photographic format, the artist defines each negative as the original of eight possible prints: rotated four times around its center and again upon a mirrored axis. Hence eight originals can be reproduced from one negative. These pictures, although identical, have been rotated or are mirror images. Shown in series,[16] they reveal how deceptive our faculty of sight can be, since we primarily perceive differences. These quasi monochrome and serial "pictorial objects" question the viewer's perception and morph into a physical counterpart through which the viewer negotiates the issues of uniqueness, difference, interchangeability, series, and individuality. The work's complexity resides in the fact that these questions correspond to the topics implied in the title, such as genetic research, genetic engineering, mutation, and cloning. The extensive abstraction and, in this case, the fact that the object of the image—the embryo—is missing, have a decisive impact on the intensity of these pictures and the way they function.[17]

The point of departure for Hans Danuser's pictures is his social engagement, which finds formal parallels in his work. The *Frozen Embryos* series is based on embryonic research as well as the complex and controversial issues of reproductive medicine and genetic modification. In an abstract sense, the series present subject matters such as the body as object, reproduction—in the

form of cloning—, and the uniqueness of the individual. Society's ethical stance towards these issues is faltering, and our perception is infected with the same sense of uncertainty when we view these pictures. The *Erosion* series was Danuser's reaction to the crumbling of the Cold War balance of power at the end of the 1980s, when the demarcations between the Eastern and Western blocs began to dissolve. A general feeling of instability became a constant feature of Hans Danuser's work. Building on the *Frozen Embryo* series (the investigation of color and materials, all-over composition, and objecthood), the erosion of slate lent itself perfectly to displaying the materiality and color in analog photographic processes, and to expressing a concrete feeling in a concretely visual way. But this time Danuser goes a step further. He firmly rejects the insistence of the Western pictorial tradition on horizontal pictures and their presentation on a wall—as well as the mode of reading from the top left-hand corner to the bottom right. He continues to develop the objecthood of his photographs by transposing them from the wall to the floor as an installation. He grouped the series into areas. Viewers can move along these areas or traverse them. Making the transition to installations assimilates fundamental trends of the 1960s.[18] The artist no longer determines what is the top, the bottom, or the sides of a picture, as in the *Frozen Embryo* series, and leaves that up to the viewer. Viewers no longer stand face-to-face with the works in order to read them in the conventional manner, but rather do so according to their own position and perspective in relation to the works. They are free to change their position as they please. On the other hand, they fall victim to this freedom. They are forced to take a stance and choose a perspective, both of which change with every movement. Danuser strives to show that traditional values have been rendered uncertain, creating a sense of disorientation. He further demonstrates that there can never be a single correct position or perspective. He addresses gray areas, figuratively speaking: those zones in which obscurity dominates, in which suddenness and accident are concealed, in which opinions and emotions are generated and continue to evolve. Hence we are not only looking at sand in these images—we feel as if we are mired in quicksand, an impression which is heightened by the color of the photographs, the shimmering shades of gray that have been produced by the technical implementation. To an extent, Danuser wrenches the images into a gray area between photography, object, sculpture, and installation.

The notion of the image has changed radically since photography was first discovered. Over time, photography had appropriated all the most important facets of painting for itself, and today it is no longer the painting but the photograph that we equate with pictures. On the other hand, painting expanded the notion of pictures beyond their narrative and representational function to encompass the monochromatic and the non-representational, and thus found a new relevance within art discourse, with many repercussions. This led, as described above, to new forms of painting, sculpture, installations, and an orientation towards performance. The interaction between viewer and artwork, as well as the focus on materiality and space, became the motor for these changes. Hans Danuser sees analog photography as a means of working with—and on—material. The artist's exhibition at the Bündner Kunstmuseum Chur in the summer of 2017 is titled *Darkrooms of Photography*. The photographic material is developed and processed in two darkrooms: that of the analog camera and of the photo lab. Danuser's reference to the physical metal particles of the silver bromide emulsion on the baryta paper is significant. He sees these particles as a sculptural surface that reflects the light falling on it in ever new ways, in this way also influencing the colors we see when viewing the images. The importance which he attaches to materials is

shown by his penchant for researching emulsions and even developing his own.[19] In the 1980s, when photography acquired a major role in art discourse and in the tradition of classical painting, Danuser resorted to widening the scope of photography, taking it in new directions. In his eyes, the silver bromide emulsion does not just fulfil the function of print-making. It has a materiality of its own and additional functions that are independent of the reproductions it produces. It is exactly at this point that he adopts the principles of the 1910s and especially those of the 1960s, rejecting illusionism and concentrating instead on materiality, on liberating pictures from their place on the canvas, and moving towards objecthood, spatial development, and transformation into installations. In short, he removed his pictures from the wall and brought them into the room to interact physically with the viewer.

Hans Danuser thus departs from accepted notions of the photographic image. Since he employs the classical techniques of analog photography and only carries out marginal retouching on the images, they remain strictly objective. Formally, however, they do not correspond with the criteria of the classical notions of painting and photography. With his various series *Frozen Embryo*, *Erosion*, and *Landscape in Motion*, he creates images that have powerful, sensuous qualities. But their effect can only unfold fully when they are confronted with a physical and intellectual counterpart. His photographs do not narrate stories; they invite us into dialog. The resulting image is multi-layered. But these layers do not necessarily fit together neatly like the pieces of a puzzle. Complex thoughts and their many repercussions are the subject of the viewing process—thoughts and repercussions that concern our society today, and that greatly concerned Hans Danuser.

1
The past continuous is the tense used for objective, visual narratives. Examples include the oral tradition of fairy tales (beginning with "once upon a time," and ending with "and they lived happily ever after"), as well as to legends, sagas, and epic narratives such as *The Iliad* and *The Odyssey*, or standard religious texts. Stories such as these connote universal validity.

2
However, whether or not the pictures have been manipulated is irrelevant. The important thing is for the event of the photograph to be authentic.

3
Expressionism, cubism, futurism, constructivism, suprematism, and dada, each in their own way, invalidated pictorial traditions in ever more radical ways.

4
The fact that painters discarded the use of perspective and proportion (one of the fundamental characteristics that painting relinquished to photography), that is, naturalistic representation in three-dimensional space, is interesting to examine with reference to the emergence of photography as an art form. It appears logical that photography becoming a widespread medium was an important factor in the crisis of painting as an illusionistic and narrative form of expression; the way in which the two events coincide, at least, is remarkable.

5
Photography did play a role in surrealism and in constructivism, and the first photographic movements—straight photography and new vision (*Neues Sehen*)—were underway by this point, these developments remained straws in the wind to the world of art discourse. Furthermore, it was not until much later that the impact was felt of Alfred Stieglitz's cloud pictures, which explored the idea of abstraction very early on. The influence Malevich had on Stieglitz is worth a mention.

6
Duchamp did not seek to break with painting. Instead, he wanted art to be established on a new foundation. Painting, regardless of the extent to which it developed the above-mentioned pictorial traditions, was still painting: still paint on a canvas and thus dependent on the eye or (retinal) perception. It was therefore necessary to abandon the canvas entirely, rather than using it to try out new things. Duchamp's invention of readymades laid the cornerstone for conceptual art. Duchamp's friendship with and artistic affinity to the photographer Man Ray highlights, in the broad sense, the potential of the relationship between the concepts and approaches of the two artists, and between the readymade and photography.

7
Exemplarily in the work of Jackson Pollock and characteristic of the art of Frank Stella, Morris Louis, Helen Frankenthaler, Kenneth Noland, etc.

8
As a result, the art world saw the development of shaped canvases, specific objects, minimalist sculptures, installations, conceptual art, and performance art. All these developments undermined the predominance of the square or rectangular-painted surface as the focal point of art discourse. According to the critic Michael Fried, the weak point in the term "specific object"—as coined by Donald Judd and which became the buzzword for minimal art—was that specific objects (mostly presented in series and groups) declined into theatrical settings and were no longer art, because they were no more than simple objects. Michael Fried, "Art and Objecthood," *Artforum* 5 (June 1967), 12–23.

9
John Baldessari was the exception. His *Cremation Project* (1970) programmatically represents his artistic engagement with the representational function of paintings and its deconstruction. For his artworks, which often address this subject matter, he used various media, especially photography, for instance in the piece *Throwing Three Balls in the Air to Get a Straight Line* (1973).

10
This shift in paradigms is however only valid for the minority of painting at the time. But looking back, it is justified to speak of a decisive development in art history.

11
With the work of Cindy Sherman, Andreas Gursky, Wolfgang Tillmans, Jeff Wall, Gregory Crewdson, etc., this genre became very important from the 1980s onwards in visual arts discourse and paved the way for the recognition of photography as a medium of the visual arts.

12
The principle that reality—or the completion of the work—first takes place in the viewer's brain is visible in the art of Marcel Duchamp in a radical form. Basing his work on this concept, and discarding what he dismissed as retinal art, Duchamp was incredibly influential for the following generations of artists.

13
Hans Danuser in conversation with the author at his studio on February 20, 2017.

14
This presentation can likewise be viewed as a reference to Kazimir Malevich's *Black Square*. When the latter was first mounted in an exhibition it was hung very high up, in an allusion to the classical presentation of icons.

15
Since the 1950s, the old pictorial traditions of painting had been rejected, especially that of the frame. The painting was no longer to be a restricted illusionary space. Pictures no longer told stories and because they were without a plot or action, they no longer needed a frame. Thus the frame became a backward-looking reference to old pictorial traditions.

16
The series are each made up of a different number of pictures (from three to ten).

17
The *Frozen Embryo II* series (see pp. 172–173) is the only exception in this regard. In reference to and in connection with *In Vivo*, the point of departure for the entire *Frozen Embryo* series, an embryo is featured in three of the eight pictures.

18
Carl Andre's floor installations address this aspect from 1967 onwards, and Les Levine presented photographs in his work *Systems Burn-Off X Residual Software* (1969) as an installation that viewers could actually walk through.

19
On the relevance of material and Hans Danuser's research in this area, see the contribution by Kelley Wilder in this publication, pp. 48–55.

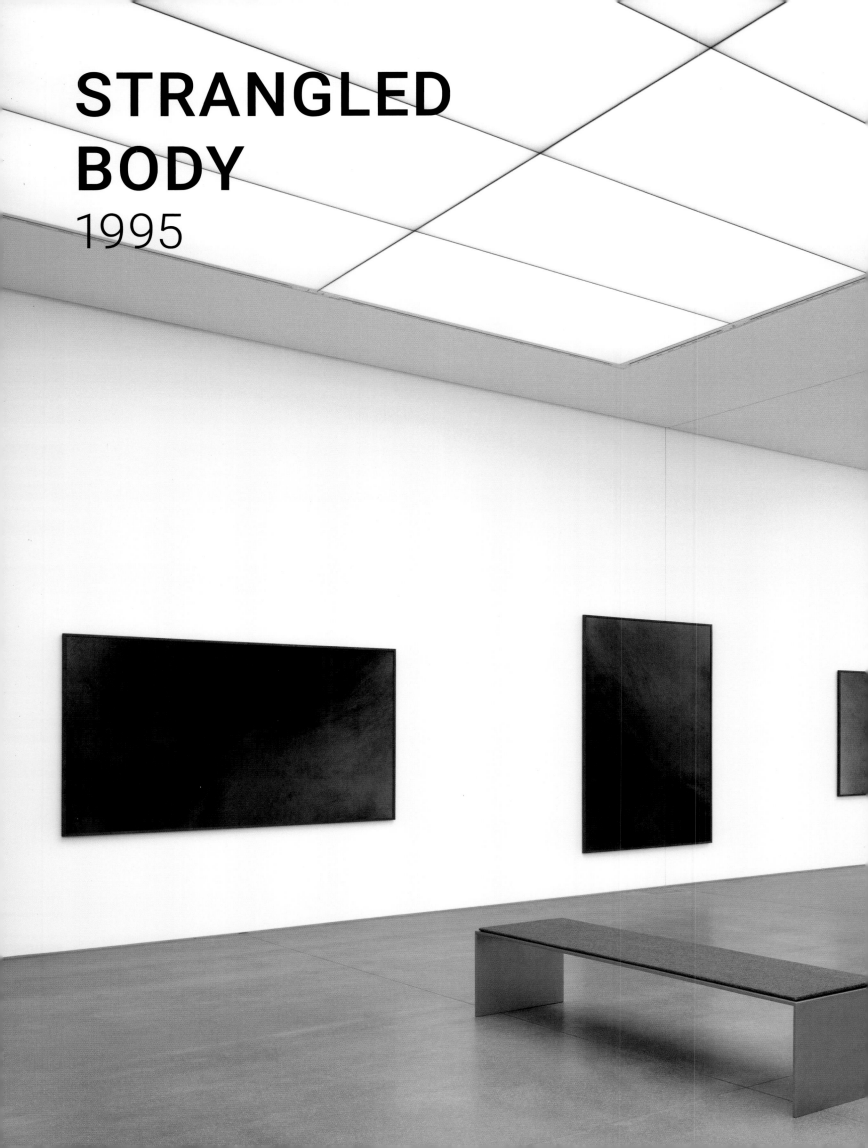

STRANGLED
BODY

1995

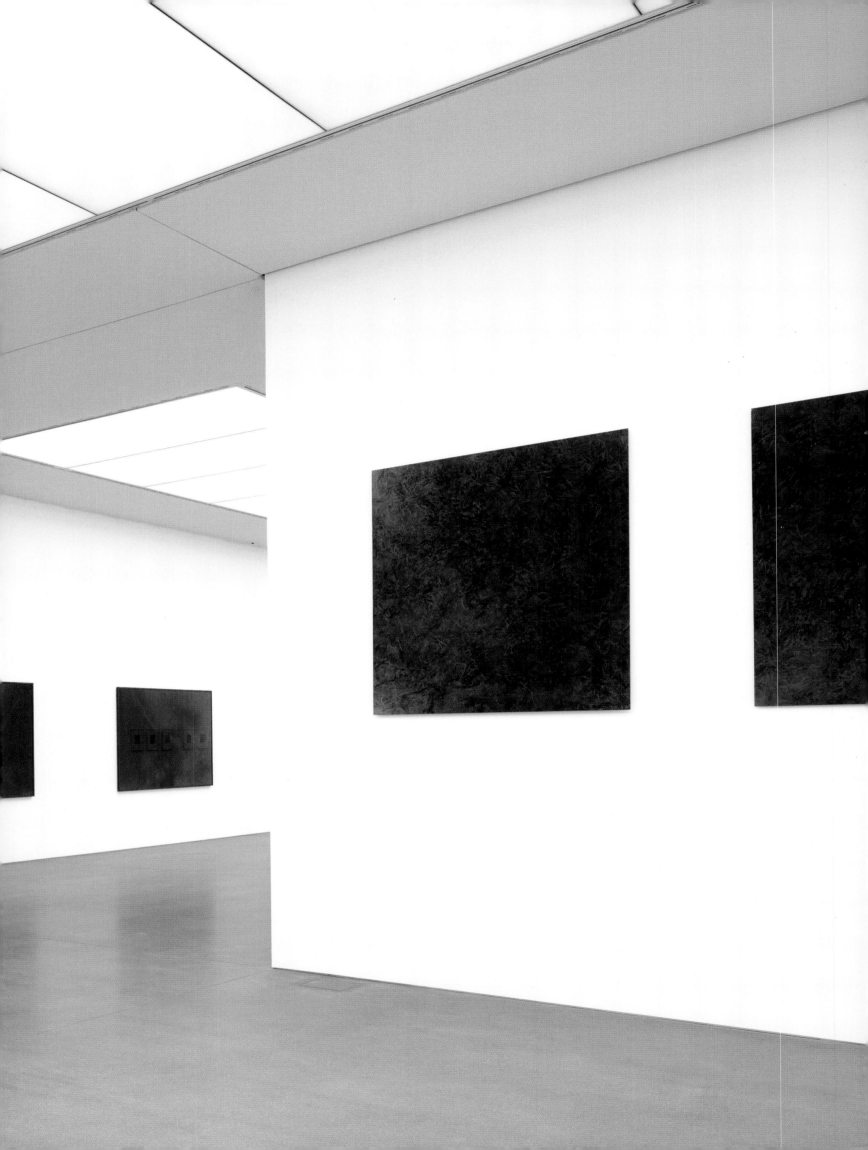

Under the Spell of the Black Sun

Stefan Zweifel

I. The Light Trails of Nothingness

Step by step, bit by bit, you become immersed in the mining pit that is the museum in Chur, sinking deeper down into the segments of your own history. Without knowing it, you feel your way through the sediments, reaching the zones in which the sun's analog counterpart—photography—entices every visitor with warped layers of stone and slate, images of slate that remind us *in vivo* of that which we suppress: death.

We enter into an enclosed space, but the photographs on the walls blow the confines of our minds, they free us of restraint and lead us into a fascinating counterworld, where, at the center of the museum darkroom, a truth flares up in white, suggesting that we never have been and never will be any different from the light trails of nothingness.

And immediately we see our mirror image in a pane of glass, our own image intermeshed with the body of a rat, trapped in the machinery which discovered instrumental reason and tortured nature. Image and mirror image hold the self and the rat captive in an involuntary dance, almost Dionysian despite the cold and impersonal backdrop. And despairing, too, because the after-images of these photographs evolve, night by night, anew; new images crystallize, photographs capture our unconscious, photographs that were celebrated as the divine image of the sun's Apollonian glow when the art of photography was first discovered. Now, however, the self dissolves amongst the Dionysian tumult of dreams.

When romanticism discovered the sublime, painting solitary figures against the expansive horizons of the ocean, whose breaking waves mirrored the color of the sky, when the first tourists discovered the daunting power of the Alps: it was then that the experience of the sublime was unleashed from within the secure confines of the Enlightenment, from the domain of those "lumières" which wished to throw light on everything with the burning torch of sun-like reason.

The occidental subject had only just been assured that it existed between the a priori of transcendental ideas and the a posteriori of the moral imperative, when Immanuel Kant himself, presumably unintentionally but through the pure enthusiasm of a wild imagination, dispensed with the limits of the subject: in the growing storm of sublime images in which the abysses of nature's primal forces yawned, the self was torn from itself and flung into the wilderness of the unknown, into the murmuring space of art.

Terror and shock soon expanded the sublime alphabet of William Turner and Herman Melville, emerging from our unconscious as a whale or as madness, finally blending with the fountains of spume, mixed with its own blood, as the white whale breathed his last breath, this darkly romantic arc between alpha and omega, birth and death, reaching now into new realms. Space-engulfing surfaces, large and black, and cracked; here we find images of erosion—dunes with trickling sand, frozen embryos, the folds in the skin of people, strangled and now choking us, enticing us into those depths that can only be plumbed if we, like the ancient Greeks, stoically remain at the surface, at the divide where every self has its origins, the first cell division. This duality evolves continuously until the subject closes itself once again beneath the staggering blow of the hammer of death. Death does not hit us like the gold ingot that smoothes and glows radiantly from the black ground of the image. Instead it leaves us lying there in shatters, distorting the corpse's mouth into a thin crack, a crack that Hans Danuser had already shown his viewers in his first work, in the form of a crack in a marble panel.

Suspended over it is the emblem and symbol of eternity, a tetrahedron. On each of its sides is an intense shadow like on a negative film. It is as if the main function of this three-sided pyramid

is less as an ancient burial monument whose gold-plated peak greets the light of the sun each morning, and more as the force which harnesses the barque of the sun in its deepest chambers during the twelve hours of the night, to reach Osiris, the god of the underworld, and raise him from the dead to live among their shadows. No, it appears as if it were torn from Albrecht Dürer's *Melancholia I*, in which the self sits between the insignia of the eternal values of knowledge and the eternal forms of geometry, forlorn and lost in thought.

In this way we see our own self breaking, slipping and sliding over layers of erosion. We wander aimlessly between visual worlds and realize: my self is not a torch of enlightenment, no—it is rather a body of light that traverses the lives of images, recording their trails of light on its skin, inscribing them on its retina like a living photogram. My self is the light of a corpse.

II. Sol/eil

Long ago, in the ninth and tenth centuries, the Sinaite and hermit Philotheos exposed his body to the sun on the slopes of Mount Sinai, and invented, half-starved and half-blind, the primal term for this kind of vision of God: "God inscribes himself here through light, *photeinographeistai* (photographs himself)." For Philotheos, his own emaciated body thus became a light support, a photographic plate. A momentous primal scene.

The self: an entity that is issued out of the *sol*, out of the earth, out of broken stone, perhaps out of marble, into which the eye of the sun, *l'oeil du soleil*, burns, uniting the highest with the lowest, the ground with the heavens. In this alchemy of the analog, a countersun has, from the very beginning, always flashed its light, dissolving the boundaries of the Platonic sunlight of truth, righteousness, and beauty while opening the doors to an inner truth where the radiant and glaring solar light morphs into the glittering saturnine countersun, where the sun turns into a "solar anus"—as Georges Bataille might have put it.

If you look at the sun for a good while and then close your eyes, spots will dance behind your eyelids, red and black. Sunspots burnt into our retinas. Red like blood and black as death. They betoken a third, suppressed eye, the solar eye that grows on the foreheads of all great actors, and perhaps not only on their brows—after all, every solar eye refers to a dark spot, the anal of the analog.

The world, according to Bataille, is bombarded by the sun's excrement, by the radiation it discharges. The earth answers with volcanoes: inner earth, "vulvanus" and glowing red, is hurled back in the direction of the sun, a desperate attempt to reply, communicated by Vincent van Gogh in the burning of his paintings, and by Friedrich Nietzsche in his philosophy.

Nietzsche experienced this countersun in Engadine: again and again he looked into the light of the sun in order to experience the nothingness of the self. His eyes overflowed with the salt of his tears like salt compounds forming an emulsion on film negatives, and afterwards the dark spots of the countersun danced as "mouches volantes," the spots of winged flies, over his retina. The sun of enlightenment was transformed, in the darkroom of his skull, into an obscure counterimage.

Just like Zarathustra, Nietzsche let the sun shine on him and reward him—to then take its light down to the cities and to tell them of the Übermensch—mankind was waiting only for the last human to arrive. Those last human beings who, as Nietzsche said, blink into the sun and cry:

"We have invented happiness." A little poison now and then: that makes pleasant dreams. And, at the last, much more poison for a pleasant death. So they sat on the terrace of the Maloja Grand Hotel which belonged to a Belgian count and blinked at the sun. They were convinced—like us, as consumers and guests in the brief moment of happiness on the sun terrace of what is now Engadine—that "we have invented happiness."

The occidental subject, bathing in self-aggrandizement and the truth of enlightenment, morphs, in the counterworld of Nietzsche and Bataille, into an "abject," into the emanations of the sun, which not only illuminates the world but also draws attention to the intense shadows of enlightenment.

The self-aggrandizement of the "sub-ject" sought to enslave the world of "ob-jects." But in Nietzsche its structure crumbles, only a "-ject" remains, the pure "flow" of our desires, the "excrement" of suppression, a ray of the present, which—after the twilight of the gods, after the sweeping away of all our fixed values—then sweeps itself away like a wave, like a wave of light veering into the infinity of outer space, where rectangular panels levitate, reflecting light off their black surfaces like the block monoliths in the film *A Space Odyssey*. The images in the museum strike our consciousness in this way, light lithographs from a future in which our lives leave no more imprint than bullet holes and scratches on eroded slate slabs.

In the art magazine *Documents*, Bataille presented photographs by Eli Lotar and Jacques-André Boiffard, both assistants to Man Ray. However, they did not pay tribute to surrealism—but to a *subsurrealism*. They explored, with their lenses, the urban peripheries, the peripheries of consciousness: sawn-off cow hooves outside of Paris's abattoirs, their skins wrapped up and lying in the gutters, with trails of blood on the street, strewn with wet and gleaming offal. The last temples of death, banished to Paris's banlieues, but which made a comeback through the photographs, emerging through Picasso's pictures and Alberto Giacometti's figures—whose work was first presented to the public in *Documents* in 1929. Because Giacometti, of all people, had an acute sense of formlessness, of that which engrossed Bataille in his philosophy of the *informe*: the formlessness on which our lives are based and into which it will return.

The formless has that kind of heterogeneity that cannot be assimilated by the homogenizing nature of reason. In it the limits of understanding become apparent, and in it too the trail of Eros entices us, the Eros/ions. After all, as Bataille would see it, eroticism involves the mutual dissolution of the self, but only if one wound touches another and the abundance of blood flows to excess, where each is no longer anything more than the beating heart of the other.

We hold our heads up high in the sky of ideas, acknowledging our role as the planet of enlightenment within the solar system, upholding our notions of truth, righteousness, and beauty—but our feet remain stuck in primal mud. And therefore Bataille, alongside the photographs of the abattoirs, alongside the myriads of crawling flies dying on a piece of adhesive tape, alongside screaming mouths and SM masks, also shows, enlarged twelvefold, the big toes of his friends, an entire page of the magazine devoted to each of them.

Excessively shocking, because Bataille presents the toes as if amputated, set against the Apollonian radiance of Karl Blossfeldt's primal plant forms, the architecture of nature. But Bataille wrote: the flowers and the queen of flowers, the orchid, these symbols of love, they flower and decay and stink like old prostitutes in brothels, the magnificence of their reproductive parts with which they reach into the skies will ultimately be burnt by the sun and land on the manure pile of history, where all our humanistic ideals are rotting.

III. Pan

Didn't this ancient ascetic once lie there, exposing the body he wanted to be rid of, wanted to surmount, to the sun, as if he were a film negative on which the light of the sun left her imprint? Weren't humans from the very beginning the photogram of their own desires and yearning, didn't the sun always burn the light trails of our yearnings into our bodies, into our skins, into our retinas, transforming the glaring light into the black spots of fear like those behind Nietzsche's eyelids? Is not each and every one of us a darkroom where our innermost desires and fears unfold, where pleasure turns into fear, and Eros into Thanatos?

Isn't every body *in vivo* a rat of death, a white patch of light with the blacks of pupils peeping out in sheer panic, but not seeking to find a way out of the labyrinth of knowledge, the labyrinth of the laboratory—because Pan points only to the pleasures of the here and now, when the sun stands at its zenith and the shadows are shortest.

Only too gladly would we too like to be beings that cast no shadow, completely bathed in light, living totally in the presence of the sun, in joyful brightness, and this for all eternity. But the shadows that our bodies cast grow longer and longer, and when the twilight of Pan arrives, panic and death lie waiting in the dark.

Just as each of us now stands in the Bündner Kunstmuseum, he too stands there: the aged author Bergotte in Marcel Proust's novel *In Search of Lost Time*. He wrote for his whole life, trying in vain to articulate the origins of his sentences, and now he stands in front of a yellow section of wall, "un petit pan de mur jaune," as Proust wrote, and is so blinded by the shapeless spot that he, reeling, falls to his death—condemned by Jan Vermeer's pallid yellow section of wall, the dusky surface of the wall of being from which we rebound, blinded by cadaverous light, only to survive, at most, as shadows cast by the victims onto the walls of Hiroshima by the radioactive glare of the atomic bomb.

Strangled Bodies cast shadows such as these onto the walls of the museum. On exploring Hans Danuser's world of imagery we, again and again, feel drawn into the mutilated chasms of skin, where wrinkles, like sand dunes, drift towards the rupture in which the nothingness of the dead skin resides. And these images are, despite everything, a veritable celebration of life, of that Dionysian life that so adamantly proclaims "yes" to the present moment, that so wants these pleasures to last for an eternity and thus affirms with passion the eternal recurrence of one's own death. *In vivo*.

This life was, undeniably, an excursion into unknown realms. It slipped and slid over layers of slate, it saw how in New York, like the cave paintings of Lascaux, symbols and drawings covered gutted houses in which sinister forces had found a home, only to be exorcized by the sheer love of life and the garish green figures of the imagination in a Dionysian dance on the edge of the crater, covered by Maja's veil like the ashen Twin Towers of New York, at a time when we could never have imagined that they were as unsound as the wooden supports of Brooklyn Bridge.

An article in *Documents* by Michel Leiris entitled "The Ethnographer's Eye" searches not only in the other, but also in our civilization's suppressed temples of death for the traces left by the self. This self hatches itself into every word, into the game paths of words whose light trails are followed by the ethnographer's eyes. He does not hunt the wild animals but rather hunts himself. He kills himself.

Yes, we bear our skin for the term of our lives, through time, a skin on which the sunlight leaves small black dots, trails that pave the way toward the blackness of the nothingness into which we are sinking, without being able to cling to the geometric cast of our intellect.

The nature of the interplay between punctum and study is dialectic: while we complacently delight in our knowledge and consider ourselves as belonging to the educated classes, a minute detail, a small dot, penetrates into the midst of our passion, captivating it, not exposing us to *plaisir* but to *jouissance*. Hans Danuser now augments the two spots of our eyes, which bring order into the world with their geometric knowledge, with a punctum that is itself a study, an investigating eye that is ensnared by our unconscious.

The third eye of the lens presents us with new formations of the *pan de mur*.

The eyes are stripped resolutely of their powers as the means of *theorein*, of looking intensely at outward appearance, and technology and reason's horizontal conquest of the world is humbled. A mythical "solar eye" dethrones them, which, as an *oeil pinéal*, vertically sets its sights on the impossible—just like the lens of the camera, as a third visual point, penetrates the unknown. Here, *pinéal* no longer references René Descartes's conception of the pineal gland as the seat of the soul. Instead, it refers to a third eye under the brow, one that can look directly into the blinding light of the sun, and that lets Bataille plunge into the "starry firmament under his feet."

Analogous to the visual points of both reason and theory, which always refer to a third eye— that of the impossible and of the nonrational—the two dots in Bataille's novels are augmented, by a third, to form the three points of punctuation "…", which are not just incidentally called "points de suspension" in French. According to the French dictionary *Le Littré*, this form of punctuation involves the "suspension of sense." Bataille lets classical discourse flow into the silence of the "…", and Hans Danuser lets modernist pictorial invention flow into the blackness of erosion. There, the three points of silence flit about, seducing us to follow their trail into the suppressed center of our own self: …

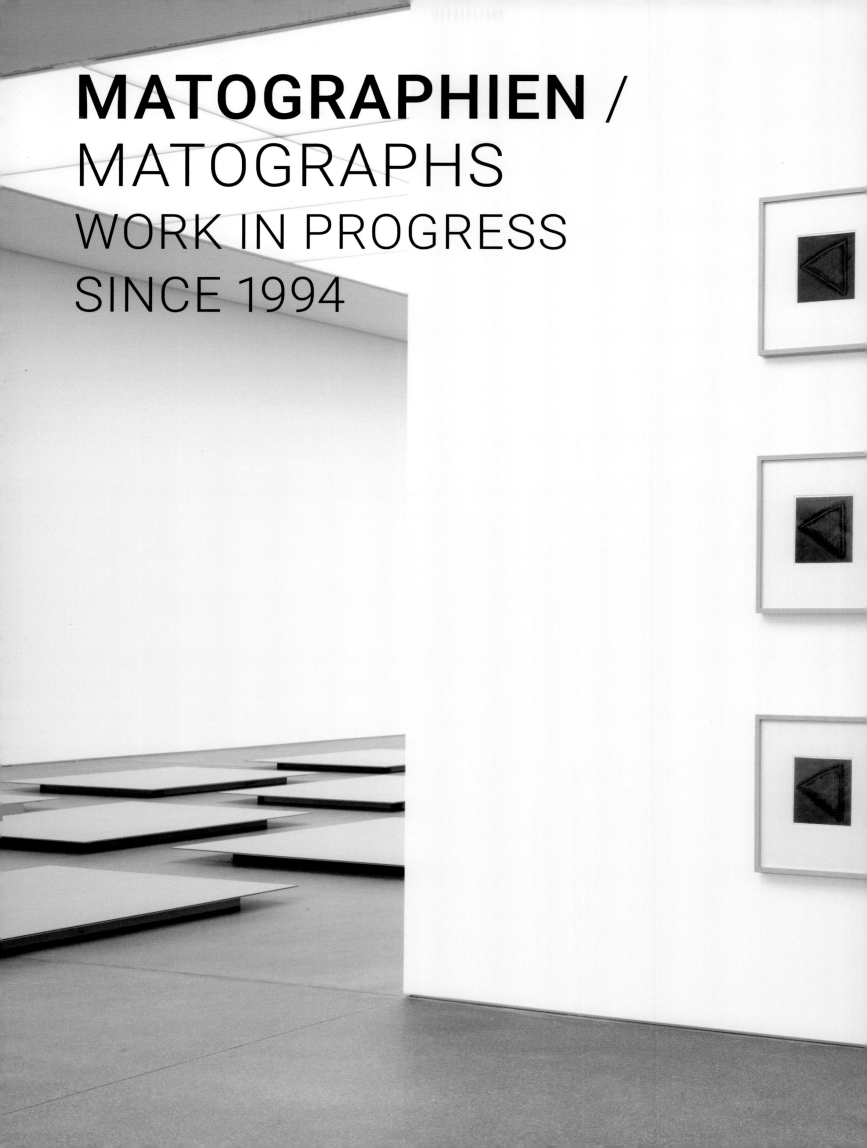

MATOGRAPHIEN /
MATOGRAPHS
WORK IN PROGRESS
SINCE 1994

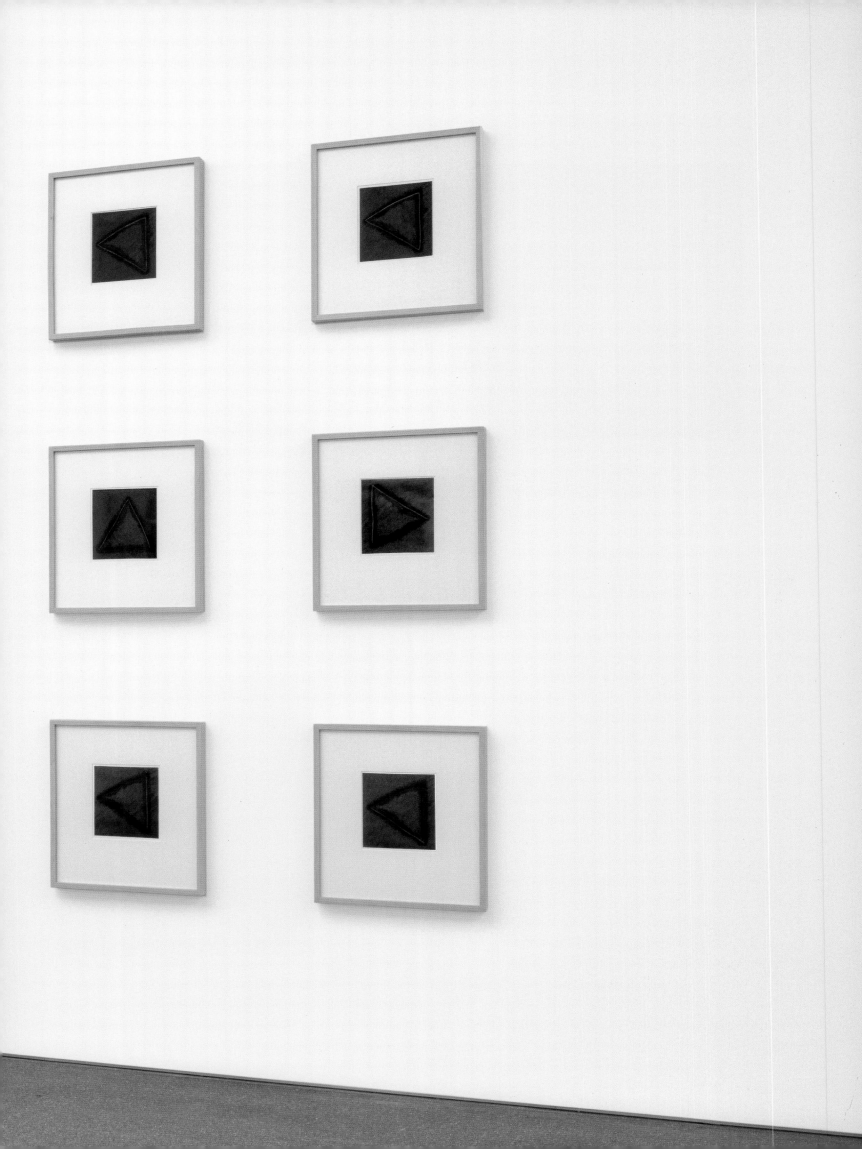

SUNSET / SUNRISE

I

II

ROTATION SHOT FROM DELTA TO MOUNTAIN

I

III

II

III

205

Contra Gnosis: A Con-Text on the Role of Research in Hans Danuser's Work

Jörg Scheller

Artistic research is a twenty-first century buzzword. In artistic discourse and debates on education policy, it has become almost a battle cry. Accordingly, Henk Borgdorff's definitive work on artistic research has borrowed its title from Immanuel Kant: *The Conflict of the Faculties*. It can be said, simplifying somewhat, that one side in the conflict is fighting for the autonomy of the (fine) arts—that is to say, is insisting on having its own rules distinct from those of science, politics, and society. The philosopher Christoph Menke summed up this attitude as follows: art typifies a "freedom not in the social, but from the social."[1] The other side stands for artistic research as a genuinely interactive, collaborative, dialogical, socially rooted, and ultimately *useful* way of making art: embedded art, so to speak. Art-as-research understood in this way is part of a growing reculturalization of the arts and sees the freedom of making art as analogous to the freedom of the sciences. It regards the autonomy of art as a well-meaning myth or a bourgeois fetish.

In the often heated debate over artistic research, it can sometimes seem as if this research were something entirely new. The flurry of activity surrounding education policy skirmishes that are ultimately concerned with sources of funding, accreditation, legitimization, or power relationships conceals the fact that artists have always (also) done research—long before they were imprinted with a seal of recognition for this work, with their projects being awarded European Credit Transfer and Accumulation System points. The philosopher of culture Dieter Lesage put it pointedly: "Art that does not operate with research is bad art. [...] The institutions that now offer courses of study in artistic research *alongside* courses of study in art are making an enormous mistake."[2] Because, taking up Lesage's point, when advanced art sets out for new shores, when it takes an interest in knowledge and expands horizons, when it addresses questions, problems, and challenges of more than just (auto)biographical relevance, and communicates its results (by means of art), it necessarily becomes research. This form of artistic research *avant la lettre* characterizes Hans Danuser's oeuvre.

It is not (or not just) that Danuser advocates a dialogical approach, cooperates with natural and social scientists, and was a visiting professor at the Collegium Helveticum of the Swiss Federal Institute of Technology in Zurich (ETH). Artistic research does not depend on scientific support; nor does it necessarily have to involve working in or with a collective obligatory. On the occasion of this retrospective, it is appropriate to recall the early phase of Danuser's artistic career in the 1980s, since both his own personal approach to research and the general features of a brand of artistic research that truly emphasized the *artistic* were crystallized during that period. Or, as Danuser remarks in an interview: "I have always believed in the image."

Research is inseparable from the concept of the new or of the implicit that has not yet been made explicit. Research unearthing the known and familiar would be a contradiction in terms. The new, in turn, is closely related to the taboo. Wherever the truly new is being explored, controversies almost inevitably ignite—not only of a scholarly, but also above all of an ethical and moral nature. When Hans Danuser was working on his cycle *In Vivo* (1980–89), as a photographer scouting out the inner lives of nuclear power plants and chemistry laboratories, he touched on such taboos. Nuclear energy, genetic research, and the chemical industry, along with the usually unspoken-of areas of pathology and anatomy, are phenomena that most of his contemporaries knew only from the consumer side: electricity, medicines, therapies.

Danuser did not just call *attention* to these highly inaccessible yet omnipresent areas of modern societies. Newspaper articles or television reporting could do a better job of that. Danuser

presented the indexically grounded (through analog photography) and subjectively interpreted *atmospheres* of these places, and offered new perspectives on them. Even more than that—or, more precisely, even less than that—his photographs show that some things cannot be shown, that something cannot be represented in the representation, that the photographs always conceal as well as reveal. As Urs Stahel wrote of *In Vivo* in 1989, it is striking "that in several […] photographs *one hardly sees anything at all*," that Danuser "fades the so-called factual into the white" or allows it "to sink into the black."[3] Negation hardly ever plays a role in traditional documentaries or reportages. Danuser, by contrast, produces images that call themselves into question. But not only themselves.

Looking at the photographs of *In Vivo*, it is almost impossible to understand oneself as a sovereign subject that exercises control and mastery over that which it has created or that which was created by others. This is by no means a self-evident realization. Pictures, especially those created using single-point perspective, play an important role in the secular story of the self-empowerment of humanity, according to Martin Heidegger: "The fundamental event of modernity is the conquest of the world as picture. From now on the word 'picture' means: the collective image of representing production […] the unlimited process of calculation, planning, and breeding."[4] Danuser's photographs can be understood as a critique of such pictorial practices. Whereas, on the one hand, he opens up difficult-to-access spaces to the public eye, on the other hand, in his photographs he closes off the proverbial *unlimited possibilities* and the expansion of areas of control that people in the secular West have expected of the new since the beginning of the modern era. In his photographs, the supposed overcoming of taboos never completely emerges from the shadow of the taboo. Whether it is the production of gold, laser research, or temporary storage of nuclear waste, the photographs of *In Vivo* are dominated by the un-thought, the unavailable, the imponderable.

We might draw a parallel at this point with Danuser's most recent works: his *Type Images*. Superficially, the two have nothing to do with one another. But, for example, when Danuser writes counting-out rhymes in colorful letters on the walls of the administration building of the Department of Health of the Canton of Zurich, he points, albeit in a more playful and more cheerful way, but nevertheless with comparable force, to the tension between control and imponderability, the open and the closed. Counting-out rhymes are, on the one hand, children's games and, on the other, basic techniques of control, which can never truly conceal their own inadequacy and provisional nature.

Here, artistic research comes into *play*, in the truest sense of the word. In essence, it is distinguished by the fact that it shows the limits of (supposedly) sovereign, controlled and controlling, informed and informing, exhaustively explaining and intersubjectively verifying science. It points out the blind spots but does not pretend, in the manner of a miracle healer, to make the blind see—fading into the white, sinking into the black …

In short, modern science was the discipline of the *sovereign* individual who subjugated nature and transformed it into a white cube that promised a completely transparent view over the phenomena assembled within it. Artistic research properly understood, by contrast, is the in- or interdiscipline of the skeptical individual who dreams not of the conquest of the world and of total transparency, but rather lifts the veil of his or her surroundings in order to discover additional veils beneath it. In doing so, it never overlooks the makeup of the veils themselves but rather relates

them to the unveiled. Because much of modern art is inherently drawn to acts of deconstruction, such art can be understood as a corrective to those systems of thinking or, rather, "systems of opinion," that do not question their own premises and transform into formalized "schools of thought." Ludwik Fleck, who coined both terms in his classic *Entstehung und Entwicklung einer wissenschaftlichen Tatsache* of 1935 (translated as *Genesis and Development of a Scientific Fact*), spoke of "a closed, harmonious system within which the logical origin of individual elements can no longer be traced. [...] They are not mere aggregates of partial propositions but as harmonious holistic units exhibit those particular stylistic properties which determine and condition every single function of cognition."[5] Innovation needs vexation. Modern art specializes in this role. That vexation has become convention in liberal societies is another story.

If one considers against this backdrop the ideas that circulate about, for example, genetic research—clinically clean, professionally organized, strictly controlled laboratories, on the one hand, and menacing chimeras, monsters, and spectacular accidents on the other—it becomes clear what essentially distinguishes Danuser's photographs. In works that are as unspectacular as they are portentous and atmospheric—including *Strangled Body* (1995) and *Frozen Embryo* (1998–2000)—he hybridizes two kinds of "schools of thought" and "systems of opinion": on the one hand, the common self-image and self-perception of scientists and institutions and, on the other, the popular imagination about what might be going on behind closed doors. He opens up a space between these two poles—a space that will be discussed later. This hybridization of the established, this opening of spaces, is a basic impulse not only of the modern arts but also of research. Not coincidentally and with some justification, the curator of *documenta 13* (2012), Carolyn Christov-Bakargiev, once called (advanced) art basic research.[6]

Art as research or artistic research proves that a changed *representation* of the world is already an integral part of research, since each new representation is preceded by a new *perception* of the world. Anyone who is at one with the world, anyone to whom it seems entirely familiar, will not research it. Only those who perceive it afresh will do so. The work of the photographer, which Vilém Flusser once compared to the gesture of philosophizing, since in both cases the goal is to analyze and interpret a detail of the world,[7] is by no means limited to a *representation* of the world.

Consequently, artistic research can be understood as research in the original and proper sense: not as a walk through a brightly lit white cube, in which fully developed photographs are presented, but rather as experimentation in a darkroom full of imponderables. The scholar of science Bruno Latour remarks in this context: "While Science had certainty, coldness, aloofness, objectivity, distance and necessity, Research appears to have all the opposite characteristics: it is uncertain; open-ended; immersed in many lowly problems of money, instruments, and know-how; unable to differentiate as yet between hot and cold, subjective and objective, human and nonhuman."[8] For Latour, therefore, research *precedes* science. Science is the formalization and standardization of that which idiosyncratic, unconventional research unearths.

Research Is a Jungle, Science Is a Park

Long before artistic research became a watchword, when Hans Danuser was gaining access as a layman to the aforementioned institutions and companies and transforming his impressions

not in a documentary or scientific way but in a decidedly *artistic* fashion, both his methods and his results corresponded to Latour's understanding of research, and also to the more formal, normative criteria that Borgdorff cites as the *conditio sine qua non* of artistic research: expansion of knowledge, new research in and through works of art, addressing important questions, documentation, and dissemination.[9] It was artists such as Danuser who paved the way for artistic research, without really trying to do so. They were guided by curiosity and a thirst for knowledge, not by ready-made methods or "handbooks" published on artistic research. They entered the jungle before it had even been mapped.

Danuser began his career in advertising and fashion photography. He never studied art. Presumably for that very reason, he developed an independent, unprejudiced eye, and he has retained it. Research thrives on such *external* impulses and vexations. Educational institutions, in turn, tend towards over-structuring and over-organization: they strive for innovation and yet cannot help but conventionalize this striving. Danuser had the advantage that he did not first have to force his questions and concerns through the filter of a bureaucratic apparatus. Whether he was developing photographic techniques such as the so-called matograph, photographing corpses laid out in the pathology department, or cooperating with the architect Peter Zumthor and diverse scientific institutes, he did it as the photographer Hans Danuser, not as a representative of an institution. The slow, focused, concentrated, and independent work that is typical of Danuser is probably only conceivable under those conditions.

An exchange of letters between Danuser and Agfa-Gevaert AG from 1992 demonstrates how free artistic research on the one hand, and scientific and industrial research on the other hand, differ from each other, but also that it is this process of *exchange* that causes their differences to widen further. Danuser wanted to tint the coating of the photographic paper *before* it was covered with black-and-white emulsion. To develop such a complex process, he needed partners with adequate financial resources and technical infrastructure. He wrote in his request to Agfa that "this would open up new, fundamental possibilities for art photography." But the company rejected him: too expensive, too involved, too specialized. In addition, "an intervention in such an automatic and very critical procedure is absolutely unthinkable." At least since the boom in third-party funding, even research projects at universities usually have to prove their large-scale relevance and justify the expected benefits. Danuser, by contrast, gave himself the privilege of escaping this utilitarian logic—and ultimately convinced his partners in industry to join him in developing the matograph, which was included in the Swiss Trademark Register in 1996.[10]

Whereas artistic research at universities can have the reputation of applying art and making it useful—significantly this first became a political issue in Europe in the wake of the Bologna reforms, which sought to bring the universities closer to business—Danuser's works, or at least the finished ones, are all clearly located in the realm generally known as "free art." Naturally, this term is simplistic, problematic, and misleading, but it does signal a distinctly different direction, a different aspiration, to that of *embedded art*. Art is not free but rather the (utopian) embodiment of freedom—and freedom does not fall from the (revolutionary) sky. Its development is dependent on protected spaces and incubators. That, and only that, can guarantee "free" art.

In Danuser's works, the process of creation may play out in the applied field; it may be based on a number of technical, political, or social issues; it may depend on fundraising, sponsors,

clients, institutions, or partners from industry, but in the end it produces artefacts that are committed to the openness of the aesthetic experience. Danuser's oeuvre is thus exemplary of an artistic research that does not succumb to the temptation to pledge itself to science or fuse with its contexts, so to speak, and therefore of an artistic research that insists on its own laws precisely as it enters into contact and exchange with the sciences and other realms of life.

It is, however, also exemplary of the concept of research that Latour advocates: that research is, as it were, a nomad or a joker and cannot be pinned down to a discipline, an institution, or a milieu. While systematics may be a common denominator of all forms of research, systematics are not limited to science. Pop musicians do research when they systematically develop new sounds. Painters do research when they systematically explore new forms of representation. Beekeepers do research when they systematically experiment with new forms of beekeeping. Danuser's work, too, has all the ingredients of research: the searching, questioning, and scrutinizing, the planning, the organizing, the experimenting, the systematizing, the presenting, the commenting, and the documenting. However, Danuser deliberately stops short of the scientific program, the binding, intersubjective *conclusio*. Wherever he is making use of technical or scientific methods or working in their institutions, technology and science are always subordinated to a genuinely artistic expression. That is also true of his project *The Last Analog Photograph*, which he initiated with Reinhard Nesper at the Institute of Inorganic Chemistry at the ETH Zurich in 2007; photographs from it are published here for the first time.[11]

This self-confident juxtaposition of the (fine) arts with their scientific counterparts, which are supposedly superior because they can be quantified and implemented in non-symbolic areas, is especially important today, because the arts sometimes put themselves in the labyrinth of the practical necessity of art as science, art as activism, art as politics, art as therapy, art as investment, art as stimulus for the creative industry, without keeping a hold of the Ariadne's thread that would help them to emerge from the labyrinth again. The open—but non-arbitrary—quality of the aesthetic is always an important corrective and a particular challenge when discourses end, when that deceptive feeling of certainty arises that your aim and your methods are good, right, and unquestionable. Who would want to object to art benefiting society? The art historian Claire Bishop observes aptly in this context: "And so we slide into a sociological discourse—what happened to aesthetics? This word has been highly contentious for several decades now, since its status—at least in the Anglophone world—has been rendered untouchable through the academy's embrace of social history and identity politics, which have repeatedly drawn attention to the way in which the aesthetic masks inequalities, oppressions and exclusions (of race, gender, class, and so on)."[12] Yet the opposite is the case. In the fine arts, but also in pop culture and in the places where they overlap, it is *precisely* the openness of the aesthetic that permits different groups and individuals to formulate and communicate their concerns and interests.

With this in mind, it pays to look back to the eighteenth century. In 1795, Friedrich Schiller wrote in his *Briefe über die ästhetische Erziehung des Menschen* (On the Aesthetic Education of Man in a Series of Letters): "In the midst of the fearful kingdom of forces, and in the midst of the sacred kingdom of laws, the aesthetic impulse to form is at work, unnoticed, on the building of a third joyous kingdom of play and of semblance, in which man is relieved of the shackles of circumstance, and released from all that might be called constraint, alike in the physical and in the moral sphere."[13] Under pressure from the modern "differentiation of [...] spheres of value,"[14] from the

increasing division of labour, and from the excesses of the French Revolution, Schiller sought for a way to turn the "natural man" back into a man "*ennobled … as Idea.*" The true revolution of society cannot occur, in his view, if "egotism," "unbelief," "lethargy, and […] depravation of character" make total experience impossible.[15] Since religion no longer possesses its traditional influential powers, art is now in demand, he argues: it allows man to experience wholeness insofar as it makes the synthesis of imagination and reason possible, and illustrates to the self-determined person that the uninhibited development of his or her talents can also help bring about a development of society: "For, to mince matters no longer, man only plays when he is in the fullest sense of the word a human being, and *he is only fully a human being when he plays.*"[16]

And suddenly the circle closes, from Schiller by way of art, aesthetics, and artistic research, to the work of Hans Danuser. Schiller's synthesis of reason and imagination correlates to the synthesis of photographic objectivity—which, it goes without saying, is never absolute and is always relational—and open aesthetic interpretation in photographs like those of *In Vivo*. The tension that Schiller describes between the cruelty of nature and society, on the one hand, and free play, on the other, correlates to the Janus face of Danuser's *Type Images*, in which control and systematics are intertwined with the playful, childish, and even foolish—the last being understood to be a "fragile balancing on the seams of meaning."[17] If not in a semantic sense, at least in a structural one, research of the sort Danuser does represents an intermediate position between art and science, just as for Schiller, aesthetics represents an intermediate position between nature and society.

Danuser's five-part series *Harlequin's Death* (1982) can be interpreted as a key work in this context. The combination of a staged photograph showing a young man covered with blood lying on asphalt at night, photographs from *In Vivo*, and images of a squad of police in the city of Zurich during the youth unrest of 1980–82, points to the constitutive role of the fool in culture and society. Like (free) art and basic research, the fool occupies the position of a mediator who is potentially anarchic and self-referential. Cultures without fools are cruel cultures. They do not permit any non-identical, non-utilitarian spaces in which one can negotiate, explore, provoke, and play without concrete results. If the fool dies out, only the serious and a rigid logic of the either-or are left to reign. It is as if Danuser wanted the subtext of all his works to be: do not believe you have to choose folly *or* seriousness, art *or* science, critique *or* aesthetic, context *or* autonomy. They all have their times and their spaces, they condition each other, build each other up, permeate each other, replace each other. Oscillate between park and jungle! Have the courage to be ambivalent and ambiguous! Do not allow the gnostic in you to prevail! But do not forget that art, the court jester of free societies, is primarily what makes this simultaneity or succession possible.

1
Christoph Menke, *Die Kraft der Kunst* (Berlin: Suhrkamp, 2013), 14.

2
Dieter Lesage, "Akademisierung," in Jens Badura et al., ed., *Künstlerische Forschung: Ein Handbuch* (Zurich: Diaphanes, 2015), 221–23, esp. 223.

3
Urs Stahel, "In vivo," in *Hans Danuser: In vivo; 93 Fotografien*, exh. cat. (Aarau: Aargauer Kunsthaus, 1989), n.p.

4
Martin Heidegger, "The Age of the World Picture," in idem, *Off the Beaten Track*, ed. and trans. Julian Young and Kenneth Haynes (Cambridge, UK: Cambridge University Press, 2002), 57–73, esp. 71.

5
Ludwik Fleck, *Genesis and Development of a Scientific Fact*, ed. Thaddeus J. Treun and Robert K. Merton, trans. Fred Bradley and Thaddeus J. Trenn (Chicago: University of Chicago Press, 1979), 37–38.

6
Interview with Carolyn Christov-Bakargiev, http://www.sueddeutsche.de/kultur/documenta-leiterin-carolyn-christov-bakargiev-ueber-die-politische-intention-der-erdbeere-1.1370514 (accessed March 2, 2017).

7
Vilém Flusser, *Gestures*, trans. Nancy Ann Roth (Minneapolis: University of Minnesota Press, 2014), 106–07.

8
Bruno Latour, *Pandora's Hope: Essays on the Reality of Science Studies* (Cambridge, MA: Harvard University Press, 1999), 20.

9
Henk Borgdorff, *The Conflict of the Faculties: Perspectives on Artistic Research and Academia* (Leiden: Leiden University Press, 2012), 53.

10
Matography project, work in progress, part I, 1993–96, together with the research departments of Novartis Basel and Bayer Werke / Agfa-Gevaert, Leverkusen. See also Juri Steiner in *Hans Danuser: Delta*, exh. cat. Kunsthaus Zürich (Baden: Lars Müller, 1996); Ulrich Gerster in *Hans Danuser: AT*, Nidwaldner Hefte zur Kunst 1, exh. cat. (Stans: Nidwaldner Museum, 1997).

11
Project proposal *Hans Danuser—The Last Analog Photograph* at the Institute of Inorganic Chemistry at ETH Zurich, together with Prof. Reinhard Nesper, Max Broszio, Matthias Herrmann, Florian Wächter, et al., as part of the photo cycle *Hans Danuser: Landscape in Motion*, 2007–2016, part 3 of the *Erosion* project.

12
Claire Bishop, *Artificial Hells: Participatory Art and the Politics of Spectatorship* (London: Verso, 2012), 17.

13
Friedrich Schiller, *On the Aesthetic Education of Man in a Series of Letters*, ed. and trans. Elizabeth M. Wilkinson and L. A. Willoughby (New York: Oxford University Press, 1982), 215.

14
Uwe Schimank, *Theorien gesellschaftlicher Differenzierung* (Wiesbaden: Springer VS, 2007), 26; Schimank describes Weber's "view of social differentiation as a pluralization of 'spheres of value,' each with its own rationality." Cf. Max Weber, *Die protestantische Ethik und der "Geist" des Kapitalismus*, ed. Klaus Lichtblau (Weinheim: Beltz Athenäum, 2000).

15
Schiller, *On the Aesthetic Education of Man* (see note 13), 27.

16
Ibid., 107.

17
Michael Glasmeier and Lisa Steib, *Albernheit* (Hamburg: textem, 2011), 18.

LANDSCAPE

1993–1996

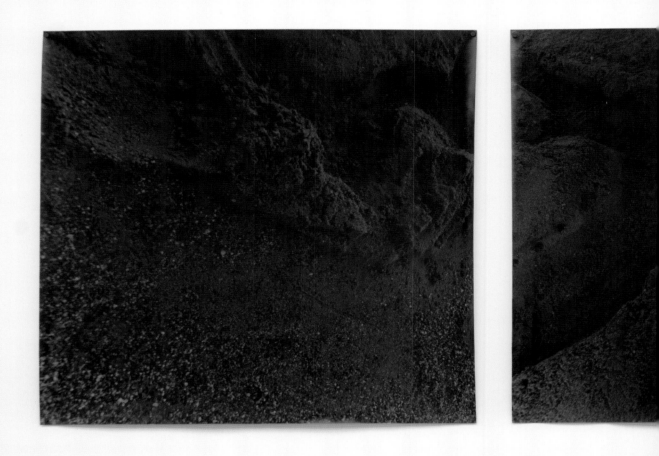

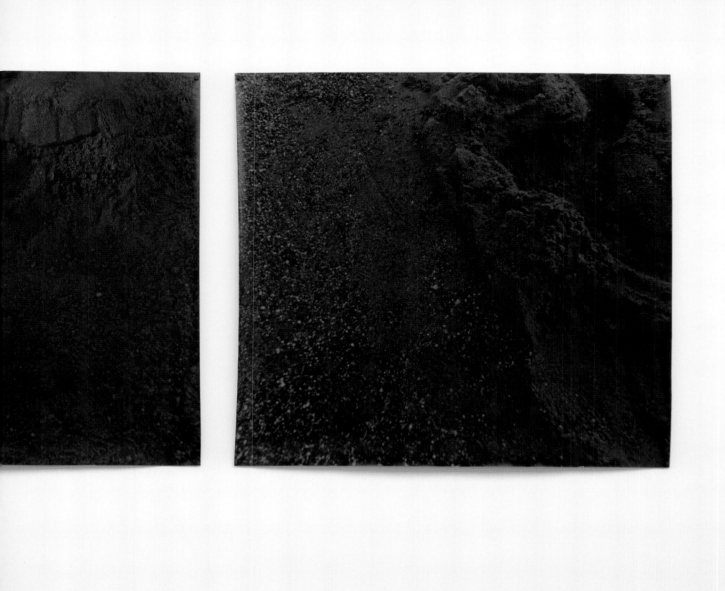

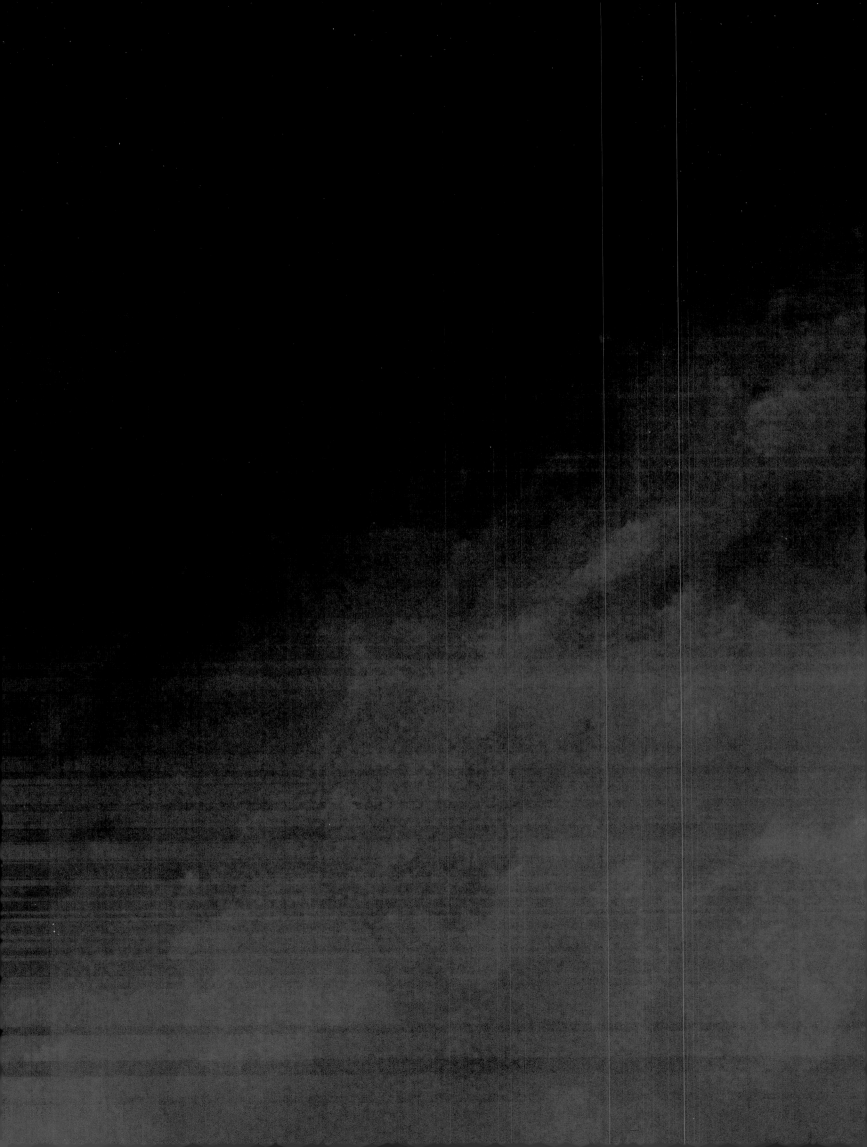

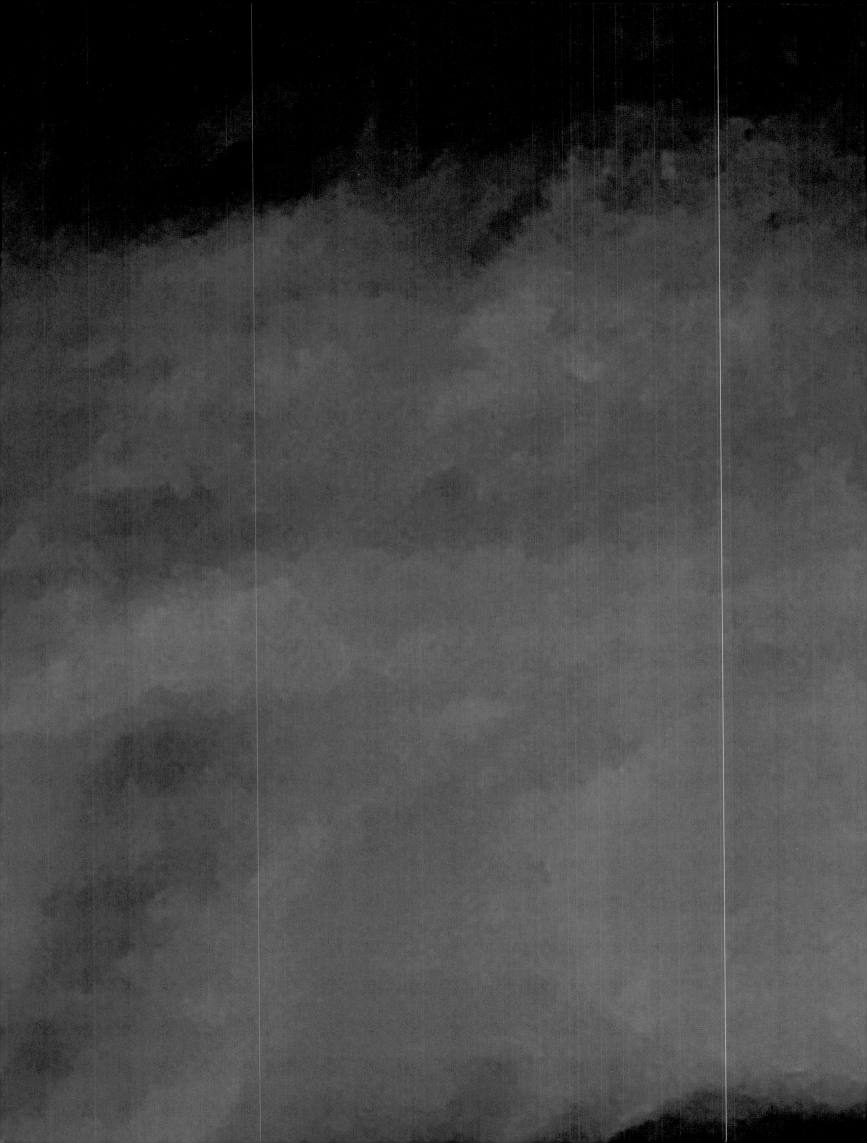

Catalog of works

MARMOGRAPHIEN / MARBLEGRAPHS, **1976**

Gelatin silver prints on marble
Several bodies of works
Plates pp. 6–7

Egg cup on a piece of sandstone, 1976
23 x 38 cm
Private collector, Zurich

TRILOGY CUCUMIS MELO, 1976
In 3 parts, I–III, each 62 x 75 cm
Image III
Private collector, Zurich

FISCH III (FISH III), 1976
50 x 65 cm
Private collector, Zurich

FISCH IV (FISH IV), 1976
50 x 65 cm
Private collector, Zurich

HARLEKINS TOD / HARLEQUIN'S DEATH, **1982**

Analog photographs, gelatin silver prints
on baryta paper, in 5 parts,
each 40 x 50 cm or 50 x 40 cm (image)
Private collector, Zurich
Plates pp. 98–99

ALPHABET CITY, 1984

Photographed in Alphabet City
(Lower East Side, Avenues A, B, and C),
Manhattan, New York
Analog photographs, gelatin silver prints
on baryta paper
2 bodies of works, in 10 parts,
each 40 x 50 cm or 50 x 40 cm (image)
Private collector, Zurich
Plates pp. 92–97

THE PARTY IS OVER, 1984 / 2016

Photographed at the derelict docks on
Hudson River in Chelsea, Manhattan and
on East River, Brooklyn, New York, 1984,
where art performances such as *pan art*
and *carneval* were presented.
Analog photographs, medium-format slide
(6 x 6 cm), 1984; digital prints on Hahnemühle
baryta paper, 2016
In 21 parts, I–XXI, each 91 x 90 cm (image)
In the artist's personal collection
Plates pp. 76–91

PARTITUREN UND BILDER /
SCORES AND IMAGES /
ZUMTHOR PROJECT, 1988–1999

Analog photographs, gelatin silver prints
on baryta paper, 4 bodies of works, in 30 parts,
each 50 x 40 cm (paper), 40 x 26 cm (image)
Private collector, Zurich
Plates pp. 100–117

ZUMTHOR STUDIO, HALDENSTEIN, 1988–1992

In 7 parts, I, II 1–3, III 1–2, IV
Plates pp. 102–105

SOGN BENEDETG CHAPEL, SUMVITG, 1988
In 6 parts, I, II 1–2, III, IV 1–2
Plates pp. 106–109

SHELTERS FOR THE ROMAN ARCHAEOLOGICAL
SITE, CHUR, 1988
In 8 parts, I, II 1–2, III, IV 1–3, V
Plates pp. 110–113

THERME VALS, 1999
In 9 parts, I, II 1–2, III, IV 1–5
Plates pp. 114–117

LANDSCAPE, 1993–1996

Analog photographs, gelatin silver prints
on baryta paper
Several bodies of works, each 142 x 150 cm
(image)
Plates pp. 216–219

LANDSCAPE VI, 1993–1996

In 3 parts
Kunsthaus Zürich, Prints and Drawings Collection
Plates pp. 216–217

LANDSCAPE VI, 1993–1996

Detail
Private collector, Zurich
Plates pp. 218–219

STRANGLED BODY, 1995

Analog photographs, gelatin silver prints
on baryta paper with iron frame behind glass
In 8 parts, I–VIII, each 141 x 222 cm
or 222 x 141 cm (image)
Fotomuseum Winterthur Collection,
Gift of George Reinhart
Plates pp. 188–197

MATOGRAPHIEN / MATOGRAPHS
work in progress since 1994

Oil paint under gelatin silver prints
on baryta paper
Several bodies of works, each 22 x 20 cm (frame),
19.2 x 18.3 cm (image)
Plates pp. 204–207

DELTA, 1996

In 9 parts
Private collector, Zurich
Plates pp. 204–205

SUNSET / SUNRISE, 1998

In 3 parts
Private collector, Zurich
Plates pp. 206–207

**ROTATION SHOT FROM DELTA TO
MOUNTAIN, 1996**

In 3 parts
Private collector, Zurich
Plates pp. 206–207

FROZEN EMBRYO SERIES, 1997–2000

Analog photographs, gelatin silver prints
on baryta paper on aluminum
Several bodies of works, each 150 x 140 cm
(image)
Plates pp. 168–179

FROZEN EMBRYO SERIES I, 1997–2000

In 4 parts
The Metropolitan Museum of Art, New York
Plates pp. 176

FROZEN EMBRYO SERIES II, 1997–2000

In 8 parts
Howard Stein Collection, New York
Plates pp. 174–175

FROZEN EMBRYO SERIES III, 1997–2000

In 10 parts
Fotomuseum Winterthur Collection,
Permanent loan from a private collector, Zurich
Plates pp. 170–172

FROZEN EMBRYO SERIES VIII, 1997–2000

In 4 parts
Bündner Kunstmuseum Chur
Plates p. 177

EROSION—floor installations with photography,
2000–2006

Analog photographs, gelatin silver prints
on baryta paper on aluminum
Several bodies of works, each 150 x 140 cm
(image)
Plates pp. 58–75

EROSION I, 2000–2006

In 18 parts, I 1–18
Fotomuseum Winterthur Collection,
Permanent loan from a private collector, Zurich
Plates pp. 64–71

EROSION II, 2000–2006

In 6 parts, II 1–6
Fotomuseum Winterthur Collection
Plates pp. 60–63

EROSION III, 2000–2005

In 9 parts, III 1–9
Kunsthaus Zürich, Photography Collection,
Permanent loan of the Walter A. Bechtler
Foundation
Plates pp. 72–75

THE LAST ANALOG PHOTOGRAPH, 2007–2017

LANDSCHAFT IN BEWEGUNG
(LANDSCAPE IN MOTION) / Moving Desert,
work in progress, part III of the EROSION project
Analog photographs based on gelatin
silver prints on baryta paper
Several bodies of works
Plates pp. 20–47

SANDSTORM, 2007–2017

In 3 parts, I–III, each 135.5 x 340 cm (image),
II, 135.5 x 315 cm (image)
Private collector, Zurich
Plates pp. 22–27

THE LAST ANALOG PHOTOGRAPH, 2007–2017
I–XXV, each 55 x 155 cm (paper),
49 x 149 cm (image)
Plates pp. 30–37

Image I (DÜNE IN BEWEGUNG /
DUNE IN MOTION), 2007–2017
Graubündner Kantonalbank, Chur
Plates pp. 30–31

Image V, 2007–2017
In the artist's personal collection
Plates pp. 32–33

Image VIII, 2007–2017
In the artist's personal collection
Plates pp. 34–35

Image XXII, 2007–2017
In the artist's personal collection
Plates pp. 36–37

THE LAST ANALOG PHOTOGRAPH, 2007–2017

In several parts, A, C, D, E, H, J,
each 40 x 50 cm (paper), 21 x 46 cm (image)
In the artist's personal collection
Plates pp. 22–26

IN VIVO, 1980–1989

Analog photographs, gelatin silver prints
on baryta paper
7 bodies of works, in 93 parts, 50 x 40 cm
or 50 x 40 cm (paper), and 27 x 40 cm
or 40 x 27 cm (image)
Realized in the US and Europe
Bündner Kunstmuseum Chur
Plates pp. 126–157

A-ENERGY, 1982
In 16 parts, I 1–16
Photographed in atomic power plants, reactor
research facilities, and in interim storage
facilities for highly radioactive waste

I 1 Cooling tower basin
I 2 Containment structure
I 3 Cooling tower
I 4 Overalls
I 5 Cooling tower
I 6 Double-door system

I 7 Nuclear reactor
I 8 Containment structure
I 9 Barrels
I 10 Containment structure
I 11 Passageway
I 12 Interim storage site
I 13 Containment structure
I 14 Passageway
I 15 Containment structure
I 16 Waste
Plates pp. 128–131

GOLD, 1983
In 18 parts, II 1–18
Photographed in a gold foundry,
a gold refinery, and in bank vaults

II 1 Gold ingot
II 2 Pallets
II 3 Scratches
II 4 Crucible
II 5 Gold bullion
II 6 Pure gold
II 7 Casting molds
II 8 Die casting
II 9 Standard bars
II 10 Casting molds
II 11 Casting
II 12 Casting
II 13 Granules
II 14 Standard bars
II 15 Security grid
II 16 Standard bars
II 17 Standard bars
II 18 Security grid
Plates pp. 132–135

MEDICINE I, 1984
In 11 parts, III 1–11
Photographed in anatomy and pathology
instruction and research laboratories

III 1 Aprons
III 2 Room
III 3 Head
III 4 Passageway
III 5 Brain
III 6 Table
III 7 Heart
III 8 Dissecting Room
III 9 Table
III 10 Torso
III 11 Embalming
Plates pp. 136–139

LOS ALAMOS, 1987
In 13 parts, IV 1–13
Photographed in nuclear fusion and
laser research laboratories

IV 1 Deflection mirror
IV 2 Protective screen
IV 3 Passageway
IV 4 Protective screen
IV 5 Krypton laser
IV 6 Worlds of steel
IV 7 Free electron laser
IV 8 Boresighter
IV 9 Laser beam
IV 10 Room
IV 11 Finishing area
IV 12 Beams
IV 13 Test setup
Plates pp. 140–143

MEDICINE II, 1986
In 9 parts, V 1–9
Photographed in ophthalmology and
otorhinolaryngology clinics and research
laboratories

V 1 Eye
V 2 Infusion
V 3 Ear
V 4 Operating theater
V 5 Cables
V 6 Operating field
V 7 Floor
V 8 Larynx
V 9 Nose
Plates pp. 144–147

CHEMISTRY I, 1988
In 14 parts, VI 1–14
Photographed in pharmacology and
chemistry research laboratories, analysis,
and production

VI 1 MRI scanner
VI 2 Food troughs
VI 3 Protective screen
VI 4 Mixing vessel
VI 5 In vitro test setup with brain sections
VI 6 Board
VI 7 Board
VI 8 In vivo test setup
VI 9 Board
VI 10 In vivo test setup for cranictomy
VI 11 Ampoules
VI 12 In vivo test setup
VI 13 Labyrinth
VI 14 Mouse
Plates pp. 148–151

CHEMISTRY II, 1989
In 12 parts, VII 1–12
Photographed in life science laboratories
and in pharmacology and agronomy genetic
engineering and biotechnology laboratories

VII 1 Tobacco plants
VII 2 Containers
VII 3 Gene bank
VII 4 Embryo
VII 5 Incubation room
VII 6 Deoxyribonucleic acid, DNA
VII 7 Ice
VII 8 Ice
VII 9 Ice
VII 10 Glass ampoules
VII 11 Ultrasound image
VII 12 Ice
Plates pp. 152–155

Biography

Born in Chur in 1953
Lives in Zurich and St. Antönien

Exhibitions

Solo Exhibitions

2018

Castasegna, Villa Garbald, *Hans Danuser: Blumen für Andrea* (Flowers for Andrea), Jul. 8, 2017 – Jun. 30, 2018, curated by Stephan Kunz.

2018

Chur, Bündner Kunstmuseum, *Hans Danuser: Dunkelkammern der Fotografie* (Darkrooms of Photography), Jun. 3 – Aug. 20, 2017, curated by Stephan Kunz and Lynn Kost.

2009

Zurich, Semper-Sternwarte of ETH Zurich, *Hans Danuser: Ein Colloquium der Dinge* (A Colloquium of Things), Sept. 14, 2009 – May 30, 2014, curated by Gerd Folkers.

Chur, Galerie Luciano Fasciati, *Zumthor sehen: Bilder von Hans Danuser* (Seeing Zumthor: Images by Hans Danuser), Apr. 29 – May 2, 2009.

2008

Chur, Galerie Luciano Fasciati, *Auszählen: The Counting Out Rhymes Project*, Nov. 1 – Nov. 29, 2008.

2006

Moscow, Central Exhibition Hall Manege, *Hans Danuser: Erosion*, Jul. 1 – Aug. 30, 2006, curated by Olga Sviblova and Urs Stahel.

2003

New York, Scalo Gallery, *Frozen*, Jun. 16 – Jul. 21, 2003, curated by Walter Keller.

2002

Chur, Galerie Luciano Fasciati, *Hans Danuser: Berg in Bewegung* (Mountain in Motion), Oct. 26 – Nov. 23, 2002.

2001

Winterthur, Fotomuseum, *Hans Danuser: Frost*, Nov. 9, 2001 – Jan. 6, 2002, curated by Urs Stahel.

2000

Ermatingen, Wolfsberg Executive Development Center, *Hans Danuser, Frozen Embryo Series: Eine Installation mit Fotografien im Wolfsberg* (A Photograph Installation in Wolfsberg), Oct. 17 – Dec. 16, 2000, curated by Juri Steiner.

1997

Zurich, Helmhaus, *amanfang: Carte Blanche von Hans Danuser* (At the Beginning: Carte blanche by Hans Danuser), Dec. 5, 1997 – Jan. 18, 1998, curated by Hans Danuser.

Stans, Nidwaldner Museum im Höfli, *Hans Danuser: AT*, Oct. 26 – Dec. 21, 1997, curated by Ulrich Gerster.

1996

Zurich, Kunsthaus Zürich, *Hans Danuser: Delta*, Apr. 12 – Jun. 23, 1996, curated by Guido Magnaguagno.

1993

Chur, Bündner Kunstmuseum, *Hans Danuser: Wildwechsel* (Game Paths), Sept. 30 – Nov. 14, 1993, curated by Beat Stutzer.

1991

Munich, Städtische Galerie im Lenbachhaus, *Hans Danuser: In Vivo*, Oct. 2 – Dec. 1, 1991, curated by Helmut Friedel.

1990

New York, Curt Marcus Gallery, *Hans Danuser*, Oct. 2 – Nov. 13, 1990.

Graz, Forum Stadtpark, *Hans Danuser: In Vivo*, May 23 – Jun. 22, 1990, curated by Manfred Willmann and Christine Frisinghelli.

1989

Aarau, Aargauer Kunsthaus, *Hans Danuser: In Vivo: 93 Fotografien* (93 Photographs), May 27 – Jul. 9, 1989, curated by Urs Stahel, Beat Wismer and Stephan Kunz.

Zurich, Galerie Folio, *Hans Danuser: In Vivo*, Oct. 28 – Nov. 29, 1989, curated by Barbara Haab, Walter Keller, and Dieter von Graffenried.

St. Gallen, Stadttheater, *Hans Danuser: Chemie II* (Chemistry II), Mar. 5, 1989.

New York, American Association for the Advancement of Science (AAAS), *Hans Danuser: Selections from the Series Physics I and Chemistry I*, Feb. 15 – Mar. 18, 1989, curated by Jeannette Murray.

1988

Lucerne, Architekturgalerie, *Partituren und Bilder: Architektonische Arbeiten aus dem Atelier Peter Zumthor 1985 – 1988* (Scores and Images: Architectonic Works from Peter Zumthor's Studio 1985 – 1988), Oct. 2 – 23, 1988, curated by Martin Steinmann.

1987

St. Gallen, Stadttheater St. Gallen, *Hans Danuser: A-Energie* (A-Energy), Apr. 23 – Jun. 25, 1987.

1986

Basel, Gewerbemuseum Basel, *Hans Danuser: Drei Fotoserien* (Three Photo Series), Feb. 25 – Apr. 13, 1986, curated by Bruno Haldner.

Biel, Photoforum Pasquart, *Hans Danuser*, Feb. 15 – Mar. 16, 1986, curated by Dolores Denaro.

1985

Chur, Bündner Kunstmuseum, *Hans Danuser: Drei Fotoserien* (Three Photo Series), Dec. 1, 1985 – Jan. 5, 1986, curated by Beat Stutzer.

Group Exhibitions

2016

Zurich, Museum Rietberg, *Gärten der Welt: Orte der Sehnsucht* (Gardens of the World: Places of Longing), May 13 – Oct. 9, 2016, curated by Albert Lutz.

2015

Mannheim / Ludwigshafen / Heidelberg, Fotofestival, *[7] Orte* (Places), *[7] prekäre Felder* (Precarious Issues), Sept. 18 – Nov. 15, 2015, curated by Urs Stahel.

2013

Winterthur, Fotomuseum Winterthur, *CrossOver: Fotografie der Wissenschaft + Wissenschaft der Fotografie* (CrossOver: Photography of Science + Science of Photography), Sept. 7 – Nov. 17, 2013, curated by Christin Müller and Thomas Seelig.

Basel, Schweizerisches Architekturmuseum, Basel, *Bildbau: Schweizer Architektur im Fokus der Fotografie* (Image Construction: Swiss Architecture in the Lens of Photography), Mar. 2 – May 20, 2013, curated by Hubertus Adam and Elena Kossovskaja.

Winterthur, Fotomuseum Winterthur, *Concrete: Fotografie und Architektur* (Photography and Architecture), Mar. 2 – May 20, 2013, curated by Thomas Seelig and Urs Stahel.

Chur, Bündner Kunstmuseum, *Ansichtssache: 150 Jahre Architekturfotografie in Graubünden* (Point of View: 150 Years of Architectural Photography in Grisons), Feb. 16 – May 12, 2013, curated by Stephan Kunz and Köbi Gantenbein.

Promontogno, *Arte Hotel Bregaglia*, 2010 – 2013, curated by Luciano Fasciati and Céline Gaillard.

2011

Winterthur, Fotostiftung Schweiz, *Schweizer Fotobücher 1927 bis heute: Eine andere Geschichte der Fotografie* (Swiss Photobooks from 1927 to the Present: A Different History of Photography), Oct. 22, 2011 – Feb. 19, 2012, curated by Martin Gasser.

2010

Winterthur, Oxyd Kunsträume, *Boogie Woogie: NY, NY; Schweizer Kunstschaffende in New York* (Swiss Artists in New York), Oct. 23 – Nov. 21, 2010, curated by Gabriele Lutz.

Bern, Kunstmuseum Bern / Zentrum Paul Klee, *Lust und Laster: Die 7 Todsünden von Dürer bis Nauman* (Lust and Vice: The 7 Deadly Sins from Dürer to Nauman), Oct. 15, 2010 – Feb. 20, 2011, curated by Matthias Frehner, Juri Steiner, Fabienne Eggelhöfer, Claudine Metzger, and Samuel Vitali.

Aarau, Aargauer Kunsthaus, *Yesterday will be better: Mit der Erinnerung in die Zukunft* (Taking Memory into the Future), Aug. 21 – Nov. 7, 2010, curated by Madeleine Schuppli and Marianne Wagner.

Chur, Bündner Kunstmuseum, *Fotoszene Graubünden: Albert Steiners Erben* (The Photography Scene in Grisons: The Heirs of Albert Steiner), Jun. 19 – Sept. 12, 2010, curated by Katharina Ammann.

Bern, Kunstmuseum Bern, *Don't Look Now: Die Sammlung Gegenwartskunst; Teil 1* (Collection of Contemporary Art, Part 1), Jun. 11, 2010 – Feb. 27, 2011, curated by Kathleen Bühler and Isabel Flury.

2009

Biel, Centre Pasquart, *Genipulation: Gentechnik und Manipulation in der zeitgenössischen Kunst* (Genipulation: Genetic Engineering and Manipulation in Contemporary Art), Sept. 13 – Nov. 22, 2009, curated by Dolores Denaro.

Winterthur, Fotomuseum Winterthur, *Darkside II: Fotografische Macht und fotografierte Gewalt* (Photographic Power and Photographed Violence), Sept. 5 – Nov. 15, 2009, curated by Urs Stahel and Daniela Janser.

Chur, Bündner Kunstmuseum, *Vermessen: Strategien zur Erfassung des Raums* (Mapping: Surveying Strategies), Apr. 11 – Jun. 7, 2009, curated by Katharina Ammann.

Mechelen, Cultuursite Onder de Toren, *Al het vaststaande verdampt* (All That Is Solid Melts Into Air), Mar. 21 – Jun. 21, 2009, curated by Roprecht Ghesquière, Edwin Carels, Bart De Baere, Liliane Wachter, Dieter Roelstraete, and Grand Watson.

2008

Zurich, Galerie Museum Baviera, *Kult Zürich Ausser Sihl: Das andere Gesicht* (The Other Face), Sept. 4, 2008 – Jan. 31, 2009, curated by Simon Maurer.

Aarau, Aargauer Kunsthaus, *Stilles Leben* (Still Life), Aug. 31 – Nov. 16, 2008, curated by Madeleine Schuppli.

Pfäffikon, Seedamm Kulturzentrum, *Die Neuerfindung der Alpen* (Reinventing the Alps), Mar. 2 – May 13, 2008, curated by Pius Freiburghaus.

2007

Dresden, Deutsches Hygiene-Museum, *Six Feet Under: Autopsie unseres Umgangs mit Toten* (Autopsy of How We Deal with the Dead), Sept. 22, 2007 – Mar. 30, 2008, curated by Ralf Beil and Bernhard Fibicher.

Chur, Bündner Kunstmuseum, *Fleischeslust oder die Lust an der Darstellung des Fleischlichen* (Carnal Lust or a Lust for Carnal Representation), Sept. 29 – Nov. 18, 2007, curated by Kathleen Bühler.

2006

Bern, Kunstmuseum Bern, *Six Feet Under: Autopsie unseres Umgangs mit Toten* (Autopsy of How We Deal with the Dead), Nov. 2, 2006 – Jan. 21, 2007, curated by Bernhard Fibicher.

Ascona, Museo d'arte moderna, *Photosuisse: Mostra di fotografie e filmportraits di 28 fotografi svizzeri* (Swiss Photography: Exhibition of Photographs and Film Portraits by 28 Swiss photographers), Apr. 9 – June 5, 2006, curated by Christian Eggenberger.

2005

Roma, Istituto Svizzero di Roma, *Photosuisse* (Swiss Photography), Oct. 22 – Dec. 24, 2005, curated by Christian Eggenberger.

2004

Altdorf, Haus für Kunst und Aussenraum, *Geschiebe: Landschaft als Denkraum* (Rubble: Landscape as a Space of Reflection), Jul. 30 – Oct 17, 2004, curated by Sibylle Omlin.

New York, International Center of Photography, *Imaging the Future: The Intersection of Science, Technology and Photography*, Sept. 13 – Dec. 29, 2004, curated by Carol Squiers, France Morin, and Peter Greenaway.

2003

Winterthur, Fotomuseum Winterthur, *Cold Play: Set 1 aus der Sammlung des Fotomuseums Winterthur* (Set 1 from the Collection of the Fotomuseum Winterthur), Nov. 15, 2003 – Jun. 13, 2004, curated by Thomas Seelig and Urs Stahel.

Zurich, Landesmuseum, *Wege zur Unsterblichkeit? Dialog mit Religion, Naturwissenschaft, Spiritualität* (Paths to Immortality? Dialog with Religion, Science, Spirituality), Sept. 19 – Nov. 30, 2003, curated by Urs Baumann, Christof Kübler, and Regula Zweifel.

Glarus, Kunsthaus Glarus, *Fink Forward: The Collection / Connection*, Jun. 29 – Aug. 24, 2003, curated by Matthias Kuhn, Christoph Lichtin, Georg Rutishauser, and Nadia Schneider.

New York, Grey Art Gallery, New York University, *Not Neutral: Contemporary Swiss Photography*, Apr. 15 – Jul. 19, 2003, curated by Urs Stahel.

Chur, Bündner Kunstmuseum, *Sternstunden: Von Angelika Kauffmann bis Hans Danuser* (Highlights: From Angelika Kauffmann to Hans Danuser), Apr. 12 – Jun. 1, 2003, curated by Beat Stutzer.

Chur, Stadttheater, *Was fällt Ihnen ein?* (What Comes to Mind?), Feb. 22 – Apr. 20, 2004, curated by Leza Dosch.

Madrid, Sala del Canal de Isabel II, *Nosotros y el mundo que nos rodea: Arte fotográfico contemporaneo de Suiza*, Feb. 7 – Mar. 23, 2003, curated by Urs Stahel.

2002

Villingen-Schwenningen, Städtische Galerie, *Zeitgenössische Fotokunst aus der Schweiz* (Contemporary Swiss Art Photography), Sept. 22 – Dec. 1, 2002, curated by Urs Stahel.

Biel, Photoforum Centre Pasquart, *Photographie "à la carte": Un festival et douze institutions photographiques suisses* ("À la carte" Photography: A Festival and Twelve Swiss Photographic Institutions), Jun. 1 – Sept. 29, 2002.

Bochum, Museum Bochum, *Zeitgenössische Fotokunst aus der Schweiz* (Contemporary Swiss Art Photography), May 29 – Jul. 7, 2002, curated by Urs Stahel.

Halle, Hallescher Kunstverein, *Zeitgenössische Fotokunst aus der Schweiz* (Contemporary Swiss Art Photography), Apr. 7 – May 19, 2002, curated by Urs Stahel.

Berlin, Neuer Berliner Kunstverein, *Zeitgenössische Fotokunst aus der Schweiz* (Contemporary Swiss Art Photography), Jan. 12 – Feb. 24, 2002, curated by Urs Stahel.

2001

Malmö, Konsthall, *Flying Over Water*, Sept. 16, 2000 – Jan. 14, 2001, curated by Peter Greenaway and Bera Nordal.

New York, Tang Museum, *Paradise Now: Picturing the Genetic Revolution*, Sept. 15, 2001 – Jan. 6, 2002, curated by Marvin Heiferman and Carole Kismaric.

2000

Lausanne, Musée de l'Elysée, *Le siècle du corps: 100 photographies 1900 – 2000* (The Century of the Body: 100 Photographs 1900 – 2000), Oct. 12, 2000 – Jan. 14, 2001, curated by William A. Ewing.

Zurich, Coninx Museum, *Beyond Borders: Kunst zu Grenzsituationen* (Art addressing Border Conflicts), Sept. 15, 2000 – Jan. 28, 2001, curated by Cynthia Gavranic, Zvjezdana Cimerman, and Daniel Ammann.

New York, Exit Art, *Paradise Now: Picturing the Genetic Revolution*, Sept. 9 – Oct. 28, 2000, curated by Marvin Heiferman and Carole Kismaric.

Bern, Kunstmuseum Bern, *Eiszeit: Kunst der Gegenwart aus Berner Sammlungen* (Ice Age: Contemporary Art from Bern Collections), Jul. 21 – Oct. 1, 2000, curated by Ralf Beil.

1999

Lugano, Museo Cantonale d'Arte, *Con la Coda dell'occhio: La Svizzera dal 1848 al 1998: Cronaca fotografica*, May 22 – Jul. 11, 1999, curated by Peter Pfrunder.

Basel, Bahnhof Ost, *Anfänge, Neubarock, Aussenwelten, Lichträume, Kunst-in-form-atik* (Beginnings, Neobaroque, Outside Worlds, Light Spaces, Art In-form-atics), Jan. – Mar. 1999.

Geneva, Maison Tavel, *Du coin de l'oeil: La Suisse de 1848 à 1998; Photochronique* (Sidelong Glance: Switzerland from 1848 to 1998, A Photographic Chronicle), Dec. 17, 1998 – Apr. 25, 1999, curated by Peter Pfrunder.

Lenzburg, Stapferhaus, *Last Minute: Eine Ausstellung zu Sterben und Tod* (An Exhibition on Death and Dying), Oct. 30, 1999 – Apr. 2, 2000, curated by Beat Hächler.

1998

Paris, Centre culturel suisse, *Du coin de l'oeil: La Suisse de 1848 à 1998; Photochronique* (Sidelong Glance: Switzerland from 1848 to 1998, A Photographic Chronicle), Sept. 25 – Nov. 22, 1998, curated by Peter Pfrunder.

Winterthur, Fotomuseum, *Fünf Komma fünf: Fünfeinhalb Jahre Fotomuseum Winterthur* (Five-and-a-half years of the Fotomuseum Winterthur), Aug. 29 – Oct. 25, 1998, curated by Urs Stahel.

Schwyz, Forum der Schweizer Geschichte, *Seitenblicke: Die Schweiz 1848 bis 1998; Eine Photochronik* (Sidelong Glance: Switzerland from 1848 to 1998, A Photographic Chronicle), May 21 – Sept. 13, 1998, curated by Peter Pfrunder.

Zurich, Galerie Rudolf Mangisch, *Transmutation*, May 7 – 24, 1998, curated by Daniel Ammann and Zvjezdana Cimerman.

Brünn, Kunsthaus der Stadt Brünn, *Foto Relations*, Jan. 13 – Mar. 1, 1998, curated by Maria Smolenicka.

1997

Vienna, Kunsthalle, *Alpenblick: Die zeitgenössische Kunst und das Alpine* (Alpine Views: Contemporary Art and Alpine Matters), Oct. 31, 1997 – Feb. 1, 1998, curated by Wolfgang Kos.

Zurich, Galerie Rudolf Mangisch, *Kunst und Gentechnologie* (Art and Genetic Engineering), Oct. 7 – 24, 1997, curated by Daniel Ammann and Zvjezdana Cimerman.

Krems, Kunsthalle, *Die Schwerkraft der Berge 1774 – 1997* (The Gravity of Mountains 1774 – 1997), Sept. 7 – Nov. 23, 1997, curated by Wolfgang Denk.

Lyon, Halle Tony Garnier, *L'autre. 4e biennale d'art contemporain de Lyon*, Jul. 9 – Sept. 24, 1997, curated by Harald Szeemann.

Aarau, Aargauer Kunsthaus, *Die Schwerkraft der Berge 1774 – 1997* (The Gravity of Mountains 1774 – 1997), Jun. 15 – Aug. 24, 1997, curated by Stephan Kunz and Beat Wismer.

Zurich, Museum für Gestaltung, *Frankensteins Kinder: Film und Medizin* (Frankenstein's Children: Film and Medicine), Mar. 8 – Apr. 20, 1997, curated by Cecilia Hausheer and Jutta Phillips-Krug.

Zurich, Galerie Semina rerum, *Im Dunkeln zum Licht* (In Darkness towards Light), Jan. 25 – Feb. 28, 1997, curated by Irène Preswerk.

1996

Zurich, Kunsthaus Zürich, *Im Kunstlicht: Photographie im 20. Jahrhundert aus den Sammlungen im Kunsthaus Zürich* (Artificial Illumination: Twentieth-century Photography from the Kunsthaus Zürich), Aug. 23 – Nov. 10, 1996, curated by Guido Magnaguagno.

Frankfurt, Steinernes Haus und Schirn Kunsthalle, *Prospect 96: Photographie in der Gegenwartskunst* (Prospect 96: Photography in Contemporary Art), Mar. 9 – May 12, 1996, curated by Peter Weiermair. New York, The Swiss Institute, *The Eye of the Beholder: Seven Contemporary Swiss Photographers*, Feb. 15 – Mar. 23, 1996, curated by Peter Pfrunder.

Bradford, National Museum of Photography, Film & Television, *The Dead*, Oct. 5, 1995 – Jan. 7, 1996, curated by Val Williams and Greg Hobson.

1995

Venice, Venice Biennale, *Identity and Alterity*, Jun. 12 – Oct. 15, 1995, curated by Jean Claire.

Bellinzona, Centro d'arte contemporanea, *La collezione fotografica svizzera della Banca del Gottardo*, Sept. 12 – Oct. 22, 1995, curated by Luca Patocchi and Alberto Bianda.

Lugano, Galleria Gottardo, *La collezione fotografica svizzera della Banca del Gottardo*, Sept. 12 – Nov. 18, 1995, curated by Luca Patocchi and Alberto Bianda.

Tenero, Galleria Matasci, *La collezione fotografica svizzera della Banca del Gottardo*, Sept. 12 – Oct. 22, 1995, curated by Luca Patocchi and Alberto Bianda.

Aarau, Aargauer Kunsthaus, *Ohne Titel: Eine Sammlung zeitgenössischer Schweizer Kunst* (Untitled: A Collection of Contemporary Swiss Art), Jan. 28 – Mar. 19, 1995, curated by Marianne Gerny, Jean-Luc Manz, Urs Stahel, and Theodora Vischer.

1991

New York, The Museum of Contemporary Art, *The Interrupted Life*, Sept. 12 – Dec. 29, 1991, curated by Marica Tucker, France Morin, and Peter Greenaway.

1990

Zurich, Museum für Gestaltung, *Wichtige Bilder: Fotografie in der Schweiz* (Momentous Images: Swiss Photography), Jun. 28 – Aug. 26, 1990, curated by Martin Heller and Urs Stahel.

1988

Chur, Bündner Kunstmuseum, *Konfrontationen: Von Angelika Kauffmann bis Miriam Cahn* (Confrontations: From Angelika Kauffmann to Miriam Cahn), Jun. 26 – Sept. 17, 1988, curated by Beat Stutzer.

1987

Nuremberg, Institut für Moderne Kunst, *Offenes Ende: Junge Schweizer Kunst* (Open End: Recent Swiss Art), May 31 – Jun. 17, 1987, curated by Manfred Rothenberger and Urs Stahel.

1983

Munich, Städtische Galerie im Lenbachhaus, *Aktuell '83: Kunst aus Mailand, München, Wien und Zürich* (Current Trends of '83: Art from Milan, Munich, Vienna, and Zurich), Sept. 21 – Nov. 20, 1983, curated by Helmut Friedel, Erika Billeter, Armin Zweite, Vittorio Fagone, and Dieter Ronte.

1982

Zurich, Städtische Galerie zum Strauhof, *Fotografien III* (Photographs III), Dec. 10, 1982 – Jan. 8, 1983, curated by Helen Bitterli.

1979

Baden, Galerie im Trudelhaus, *Klein-Skulpturen: Objekte* (Small-format Sculptures: Objects), May 5 – Jun. 30, 1979.

Collaborations

Collaboration In and With Science and Research

2007 – 2017

The Last Analog Photograph / Farbe und Fotografie (Color and Photography), project development at the Laboratory of Inorganic Chemistry (LAC), ETH Zurich, with Prof. Reinhard Nesper, Max Broszio, Matthias Herrmann, Florian Wächter, Dipan Kundu et al., section of the working group "Landschaft in Bewegung (Landscapes in motion) / Moving Desert," Part III of the *Erosion* project, work in progress.

Publications: "Chemische Färbung von s/w-Fotographien: Untersuchung kolorierter Fotopapiere" (Chemical color reproduction in black-and-white photographs: investigating color photographic paper). Research project of the master's degree study program for chemistry in collaboration with Hans Danuser, carried out by Max Broszio from Philipps-Universität, Marburg, Germany, at the ETH Zurich Laboratory of Inorganic Chemistry in the group headed by Prof. Reinhard Nesper, Zurich 2008; Wilder, Kelley. "Through the Looking-Glass: Hans Danuser's *Last Analogue Photograph*." In *Hans Danuser—The Darkrooms of Photography*. Göttingen: Steidl Verlag, 2017.

2009 – 2014

Hans Danuser "EIN COLLOQUIUM DER DINGE" (A colloquium of things). Art installation *Ein Colloquium der Dinge* in the foyer of the old Semper-Sternwarte of ETH Zurich and the Collegium Helveticum. The Laboratory for Transdisciplinarity of Universität Zürich / ETH Zurich) was established at the beginning of the fellows period 2009 – 2016 by Hans Danuser on the topic of reproducibility and commenced with his appointment as visiting professor at ETH Zurich: investigations from the perspective of art and applying its methodologies, a model and tool for identifying the potential of the topic for a proposed multidisciplinary dialogue. In collaboration with Prof. Dr. Gerd Folkers, director of Collegium Helveticum (2004 – 2016) and professor of pharmaceutical chemistry at ETH Zurich; Prof. Dr. Johannes Fehr, deputy director of Collegium Helveticum, responsible for the Culture and Humanities Department (2004 – 2014); Dr. Elvan Kut, member of the executive board of Collegium Helveticum and responsible for the Science Department (2012 – 2016); as well as the fellows of the period 2009 – 2016: Prof. Dr. K. W. Axhausen, professor of traffic planning and transport systems at ETH Zurich; Prof. Dr. jur. Andrea Büchler, chair of private law and comparative law at Universität Zürich; Prof. Dr. Alex N. Eberle, professor of pathological biology and vice rector of Universität Basel; Prof. Dr. Andreas Pospischil, director of the Veterinary Pathology Institute at Universität Zürich; Prof. W. Rössler, MD and MPsy, clinic director and director of the Medizinisches Direktorium of Zurich University Hospital of Psychiatry and Center of Social Psychiatry; Prof. Dr. August Schubiger, professor of radiopharmacy at ETH Zurich, head of the Institute of Pharmaceutical Sciences at ETH Zurich, the Paul Scherrer Institute (PSI), and the Clinic and Polyclinic for Nuclear Medicine of Zurich University Hospital; and Prof. Dr. Angelika Steger, professor of computer science at ETH Zurich. Architecture: The former eidgenössische Sternwarte, now ETH Zurich, built in the years from 1862 to 1864 by Gottfried Semper (1862–1864), modified with new design elements by the interior designers Gasser/Derungs. Publication: EIN COLLOQUIUM DER DINGE (A colloquium of things) with essays by Gerd Folkers, Johannes Fehr, Uta Hassler, an introduction by Martin Schmid, and photographs of the space by Ralph Feiner, 2010, as well as a complementary video: topic films zuerich / Eigenverlag CH-ETHZ-UZH, 2010.

2008

Entscheidungsfindung (Decision-making) in conjunction with the *Counting out Rhymes Project*, work in progress, Institute of Mathematics of Zurich University with Prof. Andrew D. Barbour.

2005 – 2008

Modeling Erosion, Institute for Geotechnical Engineering, ETH Zurich, with Dr. Jan Laue and Prof. Sarah Springman in conjunction with the *Erosion* series, 2000 – 2008.

1993

Matographien (Matographs), project development with the research divisions of Novartis Basel and Bayer Werke / Agfa Gevaert, Leverkusen; An essay by Jury Steiner "Die geritzte Venus schreiet laut" (The slashed Venus screameth out loud). In *Hans Danuser—Delta*. Exhibition catalogue, Kunsthaus Zürich, 1996; and Gerster, Ulrich. In *AT*, exhibition catalogue, Nidwaldner Museum, 1997; Jörg Scheller, "Contra Gnosis: A Con-Text on the Role of Research in Hans Danuser's Work." in *Hans Danuser—The Darkrooms of Photography*. Göttingen: Steidl Verlag, 2018.

1992

"Institutsbilder—Eine Schrift Bild Installation" (Institutional photographs—a text-image installation), in collaboration with the Institute of Mathematics, Institute of Pharmacology and Toxicology, and Institute of Physics at Universität Zürich (UZH) as well as the Institute of Pharmaceutical Sciences at ETH Zurich, with the cooperation of the architects Guido Doppler, Burkhart und Partner Architekten, Basel / Zurich; Martin Schmid, "Auf der Suche nach der gemeinsamen Sprache: Verkehrsbereiche der Transdisziplinarität" (Searching for a common language: contact areas of transdisciplinarity). Picture insert "Institutsbilder: Eine Schrift–Bild–Installation an der Universität Zürich-Irchel" (Institutional photographs: A text-image installation at Universität Zürich-Irchel) by Hans Danuser. In Martin Schmid and Elvan Kut, eds. *Heilen / Gesunden: Das andere Arzneibuch* (Healing / convalescence: an alternative pharmacopoeia). Zurich: Collegium Helveticum, 2013.

1986

Los Alamos, section of the *In Vivo* project, 1980 – 1989. Artist in Residence at the Los Alamos Laboratories, New Mexico, USA.

1976 – 1978

Marmographien (Marblegraphs), project development at the former Institute of Photographic Chemistry, ETH Zurich, with Prof. Dr. Franz Tomamichel and Prof. Dr. W. F. Berg and the former Ciba-Geigy AG Basel (Ilford).

Collaboration with Artists

2017

Schraffuren (Hatchings), three audio stations with Reto Hänny for Hans Danuser's *In Vivo* in the exhibition *Hans Danuser: Dunkelkammern der Fotografie* (Darkrooms of Photography) at the Bündner Kunstmuseum Chur.

1998

Klangraum Therme Vals (Acoustic space Therme Vals), sound installation with composer Fritz Hauser and publication of a CD with the same name including a booklet with photographs by Hans Danuser of Peter Zumthor's Therme Vals.

1997

Bildhauerei: Markus Casanova (Sculpture: Markus Casanova), with Markus Casanova and Beat Stutzer. Baden: Lars Müller, 1997.

1996

Maeander (Meander), music installation with Fritz Hauser for Hans Danuser's *Frozen Embryo* series in the *Delta* exhibition at the Kunsthaus Zürich. Baden: Lars Müller, 1996.

1994

Helldunkel: Ein Bilderbuch (Light and Shadow: A Book of Images), with Reto Hänny. Frankfurt am Main: Suhrkamp, 1994.

1993

Hans Danuser: Wildwechsel (Game Paths), with Reto Hänny and Beat Stutzer. Baden: Lars Müller, 1993.

1989 – 1999

Partituren und Bilder / Zumthor Project (Scores and Images) with the architect Peter Zumthor. Published in conjunction with the exhibition *Partituren und Bilder: Architektonische Arbeiten aus dem Atelier Peter Zumthor* (Scores and Images: Architectonic Works from Peter Zumthor's Studio), 1985–1988, at Architekturgalerie Luzern and Haus der Architektur in Graz and Acoustic space Therme Vals, 1988. Edition Hochparterre bei Scheidegger & Spiess for the exhibition *Zumthor sehen. Bilder von Hans Danuser* (Seeing Zumthor. Images by Hans Danuser) at Galerie Luciano Fasciati, Chur.

Bibliography

Monographs

2017

Hans Danuser: Darkrooms of Photography. Edited by Bündner Kunstmuseum Chur. With essays by Stephan Kunz, Kelley Wilder, Philip Ursprung, Urs Stahel et al. Exh. cat., *Bündner Kunstmuseum Chur*, Jun. 3 – Aug. 20, 2017. German edition: *Dunkelkammern der Fotografie.* Göttingen: Steidl, 2017.

Hans Danuser: Blumen für Andrea (Flowers for Andrea). With an essay by Stephan Kunz. Exhibition publication, Villa Garbald Castasegna, Jul. 8, 2017 – Jun. 30, 2018. Castasegna / Chur: Fondazione Garbald / Bündner Kunstmuseum Chur, 2017.

2016

"Uccelin: Ein Werk fliegt aus." Edited by Köbi Gantenbein, with essays by Stephan Kunz, Andreas Kley, Martin Beyeler, Jacqueline Burckhardt, Josef Estermann, Philip Ursprung et al. *Hochparterre* no. 5, special issue (2016).

2014

Gockel, Bettina and Hans Danuser, eds. *Neuerfindung der Fotografie: Hans Danuser—Gespräche, Materialien, Analysen.* With essays by Urs Stahel, Steffen Siegel, and Abigail Solomon-Godeau, as well as conversations between Hans Danuser and Reto Hänny, Philip Ursprung and Peter Zumthor. Berlin: De Gruyter, 2014.

2009

Danuser, Hans, Köbi Gantenbein, and Philip Ursprung. *Zumthor sehen: Bilder von Hans Danuser.* Zurich: Edition Hochparterre bei Scheidegger & Spiess, 2009.

2001

Hans Danuser: Frost. Edited by Urs Stahel, with essays by Hans Danuser and Urs Stahel. Exh. cat., Fotomuseum Winterthur, Nov. 9, 2001 – Jan. 6, 2002. Zurich: Scalo, 2001.

2000

Hans Danuser, Frozen Embryo Series: Eine Installation mit Fotografien im Wolfsberg. With an essay by Juri Steiner. Exh. cat., Wolfsberg Executive Development Centre, Ermatingen, Oct. 17 – Dec. 16, 2000. Ermatingen: Wolfsberg Konzerngesellschaft, 2000.

1997

Hans Danuser: AT. Edited by Nidwaldner Museum, with an essay by Ulrich Gerster. Exh. cat., Nidwaldner Museum im Höfli, Stans, Oct. 26 – Dec. 21, 1997. Stans: Nidwaldner Museum 1997.

1996

Hans Danuser: Delta. With essays by Juri Steiner, Günther Metken, and Guido Magnaguagno. Exh. cat., Kunsthaus Zürich, Apr. 12 – Jun. 23, 1996. Zurich / Baden: Kunsthaus Zürich / Lars Müller, 1996.

Hans Danuser, Delta. Special edition with a compact disc, Fritz Hauser, *Maeander*, music installation for the *Frozen Embryo* series by Hans Danuser, 30 min. Baden: Lars Müller, 1996.

1993

Hans Danuser: Wildwechsel. Edited by Bündner Kunstmuseum Chur, with essays by Reto Hänny and Beat Stutzer. Exh. cat., Bündner Kunstmuseum Chur, Sept. 30 – Nov. 14, 1993. Baden: Lars Müller, 1993.

Affolter, Claudio. *Hans Danuser: Institutsbilder; eine Schrift Bild Installation an der Universität Zürich.* Edited by Universität Zürich and the Hochbaudepartement of the Canton of Zurich, 1993.

1989

Hans Danuser: In vivo; 93 Fotografien. Edited by Aargauer Kunsthaus, with essays by Beat Wismer and Urs Stahel. Exh. cat., Aargauer Kunsthaus Aarau, May 27 – Jul. 9, 1989. Baden: Lars Müller, 1989.

Danuser, Hans. *In vivo.* Baden: Lars Müller, 1989.

1985

Hans Danuser: Drei Fotoserien. Edited by Beat Stutzer. Exhibition publication, Bündner Kunstmuseum Chur, Dec. 1, 1985 – Jan. 5, 1986. Chur / Zurich: Bündner Kunstmuseum / Hans Danuser, 1985.

Contributions to Publications

2017

Canonica, Finn. "Licht und Farbe." *Das Magazin* no. 22 (2017): 2 – 3.

Hinrichsen, Kristina. "Ästhetik als Protest: Arbeiten von Hans Danuser." *Das Magazin* no. 22 (2017): 18 – 27.

Ursprung, Philip. "Hans Danuser und Peter Zumthor: Eine Revision." In *Der Wert der Oberfläche: Essays zu Architektur, Kunst und Ökonomie.* Zurich: gta Verlag, 2017: 158 – 171.

Stahel, Urs, "Modell und Bild: Eine friedliche Ehe gerät in Bewegung." *Werk, Bauen + Wohnen* no. 5 (2017): 22 – 27.

Roland Züger, "Die Guten unter den Schönen: Fünf Punkte für eine bessere Architekturfotografie." *Werk, Bauen + Wohnen* no. 5 (2017): 8 – 14.

2016

Gärten der Welt: Orte der Sehnsucht. Edited by Albert Lutz. Exh. cat., Museum Rietberg, Zurich, May 13 – Oct. 9, 2016. Zurich / Cologne: Museum Rietberg / Wienand, 2016.

Hönig, Roderick. "Wenn Kunst anders kommt als geplant." In *Kunst im öffentlichen Raum der Stadt Zug.* Edited by Stelle für Kultur der Stadt Zug and Bauforum Zug. Zurich: Hochparterre, 2016: 80 – 87.

Wagner, Sebastian. "Weiß auf Schwarz: Im Gespräch mit Hans Danuser." *Polykum* no. 7 (2016): 13 – 17.

2015

[7] Orte, [7] prekäre Felder. Edited by Urs Stahel and the Fotofestival Mannheim-Ludwigshafen-Heidelberg. 6th Fotofestival Mannheim-Ludwigshafen-Heidelberg, Sept. 18 – Nov. 15, 2015. Heidelberg / Berlin: Kehrer, 2015.

Felley, Jean-Paul, ed. *30 ans à Paris, 1985 – 2015: Centre culturel suisse.* Paris: Centre culturel suisse / Les Editions Noir sur blanc, 2015.

2014

Danuser, Hans. "Uni dui tre quattar." In *Arte Hotel Bregaglia: Das Kunstereignis—seine Entdeckung & Geschichten.* Edited by Progetti d'arte in Val Bregaglia and Luciano Fasciati, with essays by Gisela Kuoni, Angelika Affentranger-Kirchrath, Kathleen Bühler, Céline Gaillard, Nadine Olonetzky, Cordula Seger et al. Exh. cat., Arte Hotel Bregaglia, 2010 – 2013. Baden: hier + jetzt, 2014: 100.

Danuser, Hans and Urs Stahel. "Tabus ein Bild geben." *trans* no. 24 (2014): 164 – 170.

Gantenbein, Köbi. "Die weggesparte Kunst von Chur." *Hochparterre* nos. 1 – 2 (2014): 38 – 39.

Göldi, Peter. "Studienauftrag Kunst + Bau 2012." In Ulf Wendler, ed. *Schulpalast und Lebensraum: Das Quaderschulhaus im Wandel.* Chur: Stadtarchiv, 2014: 191 – 193.

Kunz, Stephan. "Der Fotograf als Künstler: Ein Gespräch zwischen Stephan Kunz und Hans Danuser." In *Andrea Garbald (1877 – 1958): Fotograf und Künstler im Bergell.* Edited by Beat Stutzer. Exh. cat., Bündner Kunstmuseum Chur, Feb. 15 – May. 11, 2014. Zurich: Scheidegger & Spiess, 2014: 190 – 200.

Scartazzini, Tanja. "Akka Bakka." In *Ersatzneubau Bürogebäude Stampfenbachstrasse 30.* Edited by the Hochbauamt of the Canton of Zurich. Opening ceremony documentation. Zurich: Baudirektion Kanton Zürich, 2013: 14.

Ursprung, Philip. "Kapelle Sogn Benedetg Sumvitg, Graubünden, 1985 – 1988." In *Peter Zumthor: Atmosphärischer Raum, Material, Form.* Edited by the Fachverband für Kunstpädagogik / Landesverband Baden-Württemberg. Zurich: Scheidegger & Spiess, 2014: 158 – 171.

2013

CrossOver: Fotografie der Wissenschaft + Wissenschaft der Fotografie (Photography of Science + Science of Photography). Edited by Christin Müller, with essays by Kelly Wilder, Christoph Hoffmann, Michel Frizot et. al. Exh. cat., Fotomuseum Winterthur, Sept. 7 – Nov. 17, 2013. Winterthur / Leipzig: Fotomuseum Winterthur / Spector Books, 2013.

Adam, Hubertus. "Interviews: Hans Danuser." In *Bildbau: Schweizer Architektur im Fokus der Fotografie.* Edited by Hubertus Adam and Elena Kossovskaja. Exh. cat., Schweizerisches Architekturmuseum Basel, Mar. 2 – May 20, 2013. Basel: Christoph Merian Verlag, 2013: 133 – 138.

Binotto, Johannes. "The Other Scene: On the Uncanny Architecture of Photography." Photographs from *In Vivo* by Hans Danuser. In *Concrete: Fotografie und Architektur.* Edited by Daniela Janser, Thomas Seelig, and Urs Stahel. Exh. cat., Fotomuseum Winterthur, Mar. 2 – May 20, 2013.

Zurich: Scheidegger & Spiess, 2013: 68–69, 228–231.

Danuser, Hans. "Burg aus Holz I–V." Picture inserts, each comprising 5 parts. In Wulf Rössler and Hans Danuser, eds. *Burg aus Holz: Das Burghölzli.* Zurich: NZZ libro, 2013.

Danuser, Hans. "Kunst kennt keine klaren Grenzen." In Maya Höneisen, Franco Brunner, and Yannick Andrea, eds. *Bündner Kulturschaffende II: Schöpferische Kraft aus den Bergen.* Zurich: Offizin, 2013: 24–28.

Danuser, Hans. "The 'Erosion Projects' and Visions for Arts." In Christina Bechtler, Hans Ulrich Obrist, and Beatrix Ruf, eds. *Engadin Art Talks.* Zurich: JRP / Ringier Kunstverlag, 2013: 176–182.

Hans Danuser, Photographs from the *Studio of the Architect* and *Caplutta Sogn Benedetg.* In Thomas Durisch, ed. *Peter Zumthor 1985–2013: Buildings and Projects,* vol. 1, 1985–1989. Zurich: Scheidegger & Spiess, 2014: 15–33, 49–65.

Bernasconi, Karin Frei, Hans Danuser, Philip Ursprung, and Peter Märkli. "Gespräch: Kämpfen und ringen gehört dazu." In *Kunst und Architektur im Dialog. 50 Kunst- und Bau-Werke in Zürich.* Edited by Roderick Hönig and the city of Zurich, Amt für Hochbauten. Zurich: Hochparterre, 2013: 16–23.

Gantenbein, Köbi. "Die Kapelle im Nebel." Photographs from *Caplutta Sogn Benedetg* by Hans Danuser. In Stephan Kunz and Köbi Gantenbein, eds. *Ansichtssache: 150 Jahre Architekturfotografie in Graubünden.* Exh. cat., Bündner Kunstmuseum Chur, Feb. 16–May 12, 2013. Chur / Zurich: Bündner Kunstmuseum / Scheidegger & Spiess, 2013: 295–308.

Höneisen, Maya. "Hans Danuser: Als Künstler kann man Träume bauen." *Du: Die Zeitschrift für Kunst und Kultur* no. 835 (2013): 35.

Jakob, Michael. "Stein, Stahl, Glas." Photographs from *Therme Vals* by Hans Danuser. In *Concrete: Fotografie und Architektur.* Edited by Daniela Janser, Thomas Seelig, and Urs Stahel. Exh. cat., Fotomuseum Winterthur, Mar. 2–May 20, 2013. Zurich: Scheidegger & Spiess, 2013: 68–69.

Schmid, Martin. "Auf der Suche nach der gemeinsamen Sprache: Verkehrsbereiche der Transdisziplinarität." Picture insert "Institutsbilder: Eine Schrift-Bild Installation an der Universität Zürich-Irchel" by Hans Danuser. In Martin Schmid and Elvan Kut, eds. *Heilen / Gesunden: Das andere Arzneibuch.* Zurich: Collegium Helveticum, 2013: 211–213, 214–224.

2012

Danuser, Hans. "Atelier Klaus Lutz, 110 East 7th Street New York." Picture insert. In *Klaus Lutz: Im Universum.* Edited by Dorothea Strauss. Exh. cat., Haus Konstruktiv, May 31–Sept. 2, 2012, Zurich. Heidelberg: Kehrer, 2012: 1–15.

Danuser, Hans. "Erosion und Landschaft in Bewegung." Picture insert. *trans* no. 20 (2012): 44–56.

Danuser, Hans. "Photography and Space: The Erosion Project." Picture insert. In Nanni Balzer and Wolfgang Kersten, eds. *Weltenbilder.* With essays by Peter Geimer, Bettina Gockel, Andreas Haus,

Hubertus von Amelunxen et al. Berlin: Akademie Verlag, 2011: 35–50.

Kerez, Christian. "Das Unanschauliche sichtbar machen: Eine Begegnung mit Hans Danuser." *trans,* no. 20 (2012): 57–59.

2011

Gerster, Ulrich. "Hans Danuser" [1998, 2011]. In *SIKART Lexikon zur Kunst in der Schweiz,* http://www.sikart.ch/KuenstlerInnen.aspx?id=4000221&lng=-de, accessed March 30, 2017.

Jaeggi, Martin. "Hans Danuser, In vivo, 1989." In *Schweizer Fotobücher 1927 bis heute: Eine andere Geschichte der Fotografie.* Edited by Peter Pfrunder, with essays by Martin Jaeggi, Urs Stahel, Martin Gasser et al. Exh. cat., Fotostiftung Schweiz, Oct. 22, 2011–Feb. 19, 2012. Zurich: Lars Müller, 2011: 388–397.

Merz, Michael. "Hans Danuser: Whispering Art." *Zurich: Minds Magazine* (2011): 22–31.

Stutzer, Beat. "Museum und Menschen 1982–2011: Hans Danuser." In *Bündner Kunstmuseum Chur 1982–2011.* Schriften zur Bündner Kunstsammlung, no. 4. With essays by Katharina Ammann, Barbara Gabrielli et al. Chur: Bündner Kunstmuseum, 2011: 109.

2010

Boogie Woogie: NY, NY; Schweizer Kunstschaffende in New York. Edited by Gabriele Lutz, with an essay by Christoph Keller. Exh. cat., Oxyd Kunsträume, Winterthur, Oct. 23–Nov. 21, 2010. Winterthur: Alataverlag, 2010.

Erste Begegnungen. Edited by Collegium Helveticum, with essays by Martin Schmid, Gerd Folkers, Johannes Fehr, and Uta Hassler; with an installation documentation by Ralph Feiner and a DVD, video 3 min., 48 sec. Companion book for the exhibition *Ein Colloquium der Dinge,* Zurich, Semper Sternwarte of ETH Zurich, Sept. 14, 2009–May 30, 2014. Zurich: Collegium Helveticum, 2010.

Kult Zürich Ausser Sihl: Das andere Gesicht. Edited by Galerie Museum Baviera, Zurich, with essays by Silvio R. Baviera, Daniel Meili, Dominique von Burg et al. Exh. cat., Galerie Museum Baviera, Zurich, Sept. 4, 2008–Jan. 31, 2009. Zurich: Um die Ecke, 2010.

Ammann, Katharina and Nicole Seeberger. "Hans Danuser. Erosion II." In *Fotoszene Graubünden: Albert Steiners Erben.* Edited by Bündner Kunstmuseum Chur. Exh. cat., Bündner Kunstmuseum Churm, Jun. 19–Sept. 12, 2010. Bern / Sulgen / Zurich: Benteli, 2010: 65–66.

Bühler, Kathleen. "Hans Danuser: In vivo." In *Don't look now.* Edited by Kunstmuseum Bern, with essays by Kathleen Bühler and Isabel Flury. Exh. cat., Kunstmuseum Bern, Jun. 11, 2010–Feb. 27, 2011. Bielefeld: Kerber, 2010: 48–54.

"Sich mit Haut und Haaren aussetzen: Die Fotografie im Spannungsfeld von Labor und Forschungsreise; Hans Danuser und Marie-Louise Nigg im Gespräch." In Ursula Bachman and Marie-Louise Nigg, eds. *Tangente: Inter- und transdisziplinäre Praxis in Kunst und Design.* Lucerne: Interact, 2010: 133–145.

Eggelhöfer, Fabienne. "Avaritia / Geiz, Habgier." With photographs from *Gold* and *In Vivo* by Hans Danuser. In *Lust und Laster: Die 7 Todsünden von Dürer bis Nauman.* Edited by Kunstmuseum Bern and Zentrum Paul Klee, with essays by Juri Steiner, Fabienne Eggelhöfer, Gerhard Schulze et al. Exh. cat., Kunstmuseum Bern / Zentrum Paul Klee, Oct. 15, 2010–Feb. 20, 2011. Ostfildern: Hatje Cantz, 2010: 222.

Seelig, Thomas. "Hans Danuser: Chemie II, aus der Serie 'In vivo'." In *Yesterday will be better: Mit der Erinnerung in die Zukunft.* Edited by Madeleine Schuppli, with essays by Alfred Fischer, Harald Welzer, Marianne Wagner, Thomas Seelig et al. Exh. cat., Aargauer Kunsthaus Aarau, Aug. 21–Nov. 7, 2010. Aarau / Bielefeld: Aargauer Kunsthaus / Kerber, 2010: 84–87.

2009

"Auszählen: The Counting out Rhymes Project; Bildserie von Hans Danuser." In Marco Baschera, ed. *Mehrsprachiges Denken.* With essays by Marco Baschera, Hans Danuser, Barbara Cassin, Francesco Sabatini, Franz Josef Czernin, Valère Novarina, Peter Utz et al. Universität Zürich, Seminar für allgemeine und vergleichende Literaturwissenschaft. Cologne / Weimar / Vienna: Böhlau, 2009: 20.

Danuser, Hans, "In vivo." Picture insert. In *Darkside II: Fotografische Macht und fotografierte Gewalt.* Edited by Urs Stahel, with essays by Brigitte Bischof, Silvana Gebhart, Daniela Janser, Annika Schwenn, Therese Seeholzer, and Thomas Seelig. Exh. cat., Fotomuseum Winterthur, Sept. 5–Nov. 15, 2009. Göttingen: Steidl, 2009: 313–318.

Danuser, Hans. "Reproduction and Repetition in Art." In Amrei Wittwer, Elvan Kut, Vladimir Pliska, and Gerd Folkers, eds. *Reproducibility: Arts, Science and Living Nature: 10th Villa Lanna Meeting on "Science, or else?"* Prague, Jan. 11–13, 2008. Zurich: Collegium Helveticum, 2009: 35–50.

Danuser, Hans and Andrew D. Barbour. "Interessant ist, dass der Mensch den Zufall ausschließen möchte." *Du: Die Zeitschrift für Kunst und Kultur* no. 795 (2009): 100–107.

Folkers, Gerd. "Allwissenheit befreit nicht vom Entscheiden." Photographs by Hans Danuser. *Du: Die Zeitschrift für Kunst und Kultur* no. 795 (2009): 90–99.

Frieling, Rudolf. "Hans Danuser, Landschaft VI." In *Vermessen. Strategien zur Erfassung von Raum.* Edited by Bündner Kunstmuseum, with essays by Katharina Ammann and Rudolf Frieling. Exh. cat., Bündner Kunstmuseum Chur, Apr. 11–Jun. 7, 2009. Nuremberg: Verlag für moderne Kunst, 2009: 64–65.

Gantenbein, Köbi, Marco Guetg, and Ralph Feiner, eds. *Himmelsleiter und Felsentherme: Architekturwanderungen in Graubünden.* Zurich: Rotpunktverlag, 2009.

Kaiser, Stefan. "Entscheidungsfindung: Ein Projekt von Hans Danuser." *Du: Die Zeitschrift für Kunst und Kultur* no. 795 (2009): 81.

Mauris, Marlène. "Hans Danuser, In vivo." In *Genipulation. Gentechnik und Manipulation in der zeit-*

genössischen Kunst. Edited by Dolores Denaro. Exh. cat., Centre Pasquart, Biel, Sept. 13 – Nov. 22, 2009. Nuremberg: Verlag für moderne Kunst, 2009: 60 – 67.

Signer, David. "Projekte machen, die Moden überleben: Gespräch mit Peter Zumthor." Photographs by Hans Danuser. Du: Die Zeitschrift für Kunst und Kultur no. 796 (2009): 47 – 51.

Ursprung, Philip. "Kapelle und Kraftwerk: Was verbindet die Kapelle Sogn Benedetg mit der Stromwirtschaft? Über die Zusammenarbeit von Hans Danuser und Peter Zumthor." Hochparterre nos. 6 – 7 (2009): 30 – 31.

Zweifel, Stefan. "Abzählreime an der Museumswand: Zur Wiederentdeckung des sinnlichen Sprachkörpers in der Literatur am Leitfaden des Abzählreims." Photographs by Hans Danuser. Du: Die Zeitschrift für Kunst und Kultur no. 795 (2009): 82 – 89.

2008

Baschera, Marco. "Von der vorzeitlichen Präsenz eines Platzes." In Marco Baschera and André Bucher, eds. Präsenzerfahrung in Literatur und Kunst: Beiträge zu einem Schlüsselbegriff der aktuellen ästhetischen und poetologischen Diskussion. Munich: Wilhelm Fink, 2008: 75 – 81.

Danuser, Hans. "Schiefertafel Beverin." In Marco Baschera and André Bucher, eds. Präsenzerfahrung in Literatur und Kunst: Beiträge zu einem Schlüsselbegriff der aktuellen ästhetischen und poetologischen Diskussion. Munich: Wilhelm Fink, 2008: 83 – 100.

Gantenbein, Köbi. "Ein Bild geht um die Welt: Er fotografierte drei Bauten von Peter Zumthor und setzte damit einen Markstein in der Szene; Interview mit Hans Danuser." Hochparterre no. 11 (2008): 44 – 45.

Gantenbein, Köbi. "Die Neuerfindung der Alpen." Hochparterre no. 3 (2008): 16 – 22.

Kuoni, Gisela. "Hans Danuser: Auszählen; The Counting out Rhymes Project." Kunstbulletin no. 11 (2008): 72 – 73.

Ursprung, Philip. "Zumthors Oberflächen." Picture insert from "Caplutta Sogn Benedetg" by Hans Danuser. Das Magazin des Instituts für Theorie der Gestaltung und Kunst Zürich (ZHdK) nos. 12 – 13 (2008): 49 – 58.

2007

André, Marie. "La part indistincte de l'image." In François Ansermet, ed. Clinique de la procréation et mystère de l'incarnation. L'ombre du futur. Paris: Presses Universitaires de France, 2007: 91 – 102.

Böhme, Hartmut. "Die Oberflächen sind niemals stabil." Conversation with Hans Danuser, photographs from In Vivo, Frozen Embryo, Strangled Body, and Erosion by Hans Danuser. In Thomas Macho and Kristin Marek, eds. Die neue Sichtbarkeit des Todes. Munich: Wilhelm Fink, 2007: 427 – 461.

Bühler, Kathleen. "Hans Danuser, Strangled Body." In Fleischeslust oder die Lust an der Darstellung des Fleischlichen. Edited by Kathleen Bühler and the Stiftung Bündner Kunstsammlung. Exh. cat.,

Bündner Kunstmuseum Chur, Sept. 29 – Nov. 18, 2007. Zurich: Scheidegger & Spiess 2007: 74 – 77.

Jaeggi, Martin. Tschöntsch: Wanderer zwischen den Welten. Zurich: Kein & Aber, 2007: 66 – 69.

Krell, Kornelius, Hans Danuser: Formale Elemente der fotografischen Bildsprache. Lic. Phil. Diss., Philosophische Fakultät I of Universität Zürich, Zurich 2007.

Rothenberger, Manfred and Anke Schlecht. Rubin: Institut für moderne Kunst Nürnberg 1967 – 2007. Nuremberg: Verlag für moderne Kunst, 2007.

2006

Fibicher, Bernhard. "Leichen, Totenköpfe und Skelette." Photographs from Strangled Body by Hans Danuser. In Six Feet Under: Autopsie unseres Umgangs mit Toten. Edited by Kunstmuseum Bern, with essays by Bernhard Fibicher, Helga Lutz, Hans Christoph von Tavel et al. Exh. cat., Kunstmuseum Bern, Nov. 2, 2006 – Jan. 21, 2007. Bielefeld: Kerber, 2006: 74 – 75.

Gantenbein, Köbi. "Platz Klinik Beverin, Cazis: Die Schieferbühne." In Bauen in Graubünden: Ein Führer zur zeitgenössischen Architektur. Edited by Bündner Heimatschutz. Zurich: Hochparterre, 2006: 160 – 161.

Masüger, Peter. "Das 'Schiefer-Floß' in der Klinik Beverin." In Richard La Nicca. Bilder der Baukunst. Edited by Psychiatrische Dienste of Grisons. Chur: Bündner Monatsblatt, 2006: 201 – 204.

2005

Bardill, Linard. "Dunkellicht." Insert of an image by Hans Danuser. Neue Zürcher Zeitung, supplement (Dec. 24 – 25, 2005): 65 – 67.

Curiger, Bice, ed. Before the Sun Rises: Walter A. Bechtler Stiftung. Zurich: JRP / Ringier Kunstverlag, 2005.

Jaeggi, Martin. "Fortschreitende Entortung: Zu den Fotografien von Hans Danuser." In Margrith Raguth, ed. Motte im Datenkleid: Schweizer Autorinnen und Autoren schreiben Science (Non) Fiction-Geschichten. Photographs by Hans Danuser. Bern: Benteli, 2005: 287 – 291.

2004

Eggenberger, Christian and Lars Müller, eds. "Hans Danuser." In Photosuisse. Baden: Lars Müller, 2004: 102 – 113.

Nelkin, Dorothy. "Embryonic Visions." In Suzanne Anker und Dorothy Nelkin, eds. The Molecular Gaze: Art in the Genetic Age. Cold Spring Harbour, NY: Cold Spring Harbour Laboratory Press, 2004: 140 – 145.

Olonetzky, Nadine. "Sonne auf dem Schiefer und Frost im Herzen." Neue Zürcher Zeitung (Feb. 8, 2004): 23.

Seelig, Thomas. "Cold Play, Série I: De la Collection du Fotomuseum Winterthur." Photographs from In Vivo by Hans Danuser. In Paris Photo 2004: Pictures of the World, Switzerland. Paris: International Production Management, 2004: XLVII – LIX.

Stahel, Urs. "Hans Danuser." In Geschiebe. Landschaft als Denkraum. Edited by Sibylle Omlin.

Exh. cat., Haus für Kunst und Außenraum, Altdorf, Jul. 30 – Oct. 17, 2004. Altdorf: Gisler 2004: 28 – 32.

2003

Cold Play: Set 1 aus der Sammlung des Fotomuseums Winterthur. Edited by Thomas Seelig. Exhibition brochure, Fotomuseum Winterthur, Nov. 15, 2003 – Jun. 13, 2004. Winterthur: Fotomuseum Winterthur, 2003.

Nosotros y el mundo que nos rodea: Arte fotografico contemporaneo de Suiza. With essays by Urs Stahel et al. Exh. cat., Sala del Canal de Isabel II, Madrid, Feb. 7 – Mar. 23, 2003. Madrid: Comunidad de Madrid, Consejerìa de las Artes, 2003.

Not Neutral: Contemporary Swiss Photography. Journal for an exhibition at Grey Art Gallery, New York University, Apr. 15 – Jul. 19, 2003. New York: Grey Art Gallery, 2003.

Interessengemeinschaft Kunst im Öffentlichen Raum Graubünden, ed. "Hans Danuser, Kantonale Psychiatrische Klinik Beverin, Cazis, 2001." In Kunst im öffentlichen Raum Graubünden. Lucerne: Quart Verlag, 2003: 136 – 137.

Kuhn, Matthias, ed. "Hans Danuser." In Fink Forward: The Collection / Connection. Exh. cat., Kunsthaus Glarus, Jun. 29 – Aug. 24, 2003. Zurich: Edition Fink, 2003: 36.

Stahel, Urs. Ja, was ist sie denn, die Fotografie? Eine Rede über Fotografie zum 10-Jahres-Jubiläum des Fotomuseums Winterthur. Winterthur / Zurich: Fotomuseum Winterthur / Scalo, 2003.

Stutzer, Beat. "Hans Danuser: Frozen Embryo Series VIII, 2000/01." In Sternstunden: Von Angelika Kauffmann bis Hans Danuser. Edited by Beat Stutzer. Exh. cat., Bündner Kunstmuseum Chur, Apr. 12 – Jun. 1, 2003. Chur: Bündner Kunstmuseum, 2003: 132 – 133.

Stutzer, Beat. "Schärfe und Beharrlichkeit: Zu den Bildern von Hans Danuser." Bündner Jahrbuch: Zeitschrift für Kunst, Kultur und Geschichte Graubündens vol. 45 (2003): 11 – 26.

2002

Danuser, Hans, Wanda Kupper, and Linda Blair. Art at Allianz Risk Transfer. Zurich: Allianz, 2002.

Denaro, Dolores, ed. "Hans Danuser." In Photographie "à la carte": Un festival et douze institutions photographiques suisses. Exh. cat., Photoforum Pasquart, Biel, Jun. 1 – Sept. 29, 2002. Biel: Centre Pasquart, 2002: 22 – 23.

Fetz, Gelgia. "Hans Danuser für seine akribische Kunst gewürdigt." Bündner Tagblatt (Sept. 20, 2002): 17.

Guetg, Marco. "Die Bühne aus Schiefer." Hochparterre no. 3 (2002): 20 – 22.

Koenig, Thilo. "Hans Danuser: Frost." Kunstforum no. 159 (2002): 416 – 417.

Schenkel, Christoph, ed. "Öffentliche Kunst: Hans Danuser." In Public Plaiv, art contemporauna illa Plaiv: Gegenwartskunst im Landschafts- und Siedlungsraum La Plaiv, Oberengadin. Zurich: Hochschule für Gestaltung und Kunst, 2002: 110 – 113.

Wahjudi, Claudia. "Zeitgenössische Fotokunst aus der Schweiz." Kunstforum no. 159 (2002): 303 – 305.

Wasmuth, Ernst. "Hans Danuser." In *Zeitgenössische Fotokunst aus der Schweiz*. Edited by Neuer Berliner Kunstverein. Exh. cat., Neuer Berliner Kunstverein, Jan. 12 – Feb. 24, 2002; Hallescher Kunstverein, Apr. 7 – May 19, 2002; Museum Bochum, May 29 – Jul. 7, 2002; Städtische Galerie, Villingen-Schwenningen, Sept. 22 – Dec. 1, 2002. Tübingen: Ernst Wasmuth, 2002: 64 – 71.

Zwimpfer, Hans. "1+1=3 oder Erfahrungen mit 'Kunst und Architektur'." In *Peter Merian Haus Basel: An der Schnittstelle von Kunst, Technik und Architektur*. Basel: Birkhäuser, 2002: 75 – 81.

2001

Flying over Water. Edited by Peter Greenaway. Exh. cat., Konsthall Malmö, Sept. 16, 2000 – Jan. 14, 2001. Malmö: Konsthall, 2001.

Berry, Ian, ed. "Hans Danuser." In *Paradise Now: Picturing the Genetic Revolution*. With essays by Mike Fortun et al. Exh. cat., Tang Museum, New York, Sept. 15, 2001 – Jan. 6, 2002. New York: Tang Teaching Museum and Art Gallery Skidmore College, 2001: 55 – 54.

Danuser, Hans. "Erosion / Ablagerung." Picture insert. *Schweizer Kunst = Art suisse = Arte svizzera = Swiss art* no. 1 (2001): 41 – 45.

Heusser, Hans-Jörg. "Hans Danuser: Landschaft III." In Hans-Jörg Heusser, ed. *Kunst. Welt. Stadt. Zürich. Zürcher Gegenwartskunst bei ZKB Private Banking*. Zurich: Zürcher Kantonalbank, 2001: 28 – 29.

Steiner, Juri. "Fotografie: Eine zweidimensionale Bühne für aufgeladene Räume." *Bulletin* no. 55 (2001): 13 – 15.

2000

Beyond Borders: Kunst zu Grenzsituationen. Edited by Coninx Museum, with essays by Cynthia Gavranic, Zvjezdana Cimerman, and Daniel Ammann. Exh. cat., Coninx Museum, Zurich, Sept. 15, 2000 – Jan. 28, 2001. Zurich: Coninx Museum, 2000.

Le siècle du corps: 100 photographies 1900 – 2000. Edited by William A. Ewing. Exh. cat., Musée de l'Elysée, Lausanne, Oct. 12, 2000 – Jan. 14, 2001. Paris: Editions de La Martinière, 2000.

Beil, Ralf, ed. "Hans Danuser." In *Eiszeit: Kunst der Gegenwart aus Berner Sammlungen*. With essays by Ralf Beil and Marc Fehlmann. Exh. cat., Kunstmuseum Bern, Jul. 21 – Oct. 1, 2000. Bern: Kunstmuseum Bern, 2000: 14 – 15.

Danuser, Hans. "Therme Vals." In Fritz Hauser. *Sounding Stones: Therme Vals*. Companion book for compact disc, 41 min. Basel: Fritz Hauser, 2000.

Koenig, Thilo. "Hans Danuser." In *Allgemeines Künstler-Lexikon*. Edited by Günter Meißner. Vol. 24. Munich / Leipzig / Berlin: K. G. Saur / De Gruyter 2000: 219.

Stutzer, Beat. "Hans Danuser." In *Bündner Kunstmuseum Chur*. Geneva / Zurich: Banque Paribas (Suisse) / Schweizerisches Institut für Kunstwissenschaft, 2000: 118.

Zwimpfer, Hans, ed. "Die Gestaltung der sechs inneren Lichthöfe: Morellet, Zoderer, Danuser." In *Protokollheft zum Projekt "Kunst + Architektur" im Bahnhof Ost Basel*, vol. 6. Baden: Lars Müller, 2000: 14 – 19.

1999

Guidon, Curdin. "Künstlerisches Konzept für die Sanierung der Klinik." *Bündner Tagblatt* (Aug. 17, 1999): 23.

Lichtensteiger, Sibylle. "Tod." Picture insert from *In Vivo* by Hans Danuser. In *Last Minute: Ein Buch zu Sterben und Tod*. Edited by Stapferhaus Lenzburg, Hans Ulrich Glarner, Beat Hächler, and Sibylle Lichtensteiger. Exh. cat., Stapferhaus Lenzburg, Oct. 30, 1999 – Apr. 2, 2000. Baden: hier + jetzt, 1999: 84 – 87.

Systor AG, ed. "Nah und Fern: Hans Danuser, Fotograf und Künstler." In *Momentaufnahmen. Menschen, Architektur und Kunst im Peter Merian Haus Basel*. Catalog published in conjunction with the exhibition *Anfänge, Neubarock, Außenwelten, Lichträume, Kunst-informatik*. Bahnhof Ost, Basel, Jan. – Mar. 1999. Zurich: Systor AG, 1999: 82 – 86.

Ulmer, Brigitte. "Linse im Gensalat: Das Metropolitan Museum kauft zwei Serien des Bündner Fotokünstlers Hans Danuser." *Cash* (Dec. 10, 1999): 69.

1998

Fünf Komma fünf: Fünfeinhalb Jahre Fotomuseum Winterthur; Fotografie Benefiz-Auktion zugunsten des Fotomuseums Winterthur. Fotomuseum Winterthur, Oct. 27, 1998. Winterthur / London: Fotomuseum Winterthur / Christie's, 1998.

Seitenblicke: Die Schweiz 1848 bis 1998; Eine Photochronik. Edited by Schweizerische Stiftung für die Photographie and Forum der Schweizer Geschichte / Schweizerisches Landesmuseum, with essays by Peter Pfrunder, Walter Binder et al. Exh. cat., Forum der Schweizer Geschichte, Canton of Schwyz, May 21 – Sept. 13, 1998; Centre culturel suisse, Paris, Sept. 25 – Nov. 22, 1998; Maison Tavel, Geneva, Dec. 17, 1998 – Apr. 25, 1999; Museo Cantonale d'Arte, Lugano, May 22 – Jul. 11, 1999. Zurich: Offizin, 1998.

Affentranger-Kirchrath, Angelika. "Die Magie des Realen: 'Fünf komma fünf' im Fotomuseum Winterthur." *Neue Zürcher Zeitung* (Sept. 30, 1998): 54.

Gerster, Ulrich. "Hans Danuser." In *Biographisches Lexikon der Schweizer Kunst*. Edited by Schweizerisches Institut für Kunstwissenschaft Zürich und Lausanne. Zurich: Verlag Neue Zürcher Zeitung, 1998: 249.

Rencontres Internationales de la Photographie Arles, ed. "Hans Danuser." In *Un nouveau paysage humain*. Arles: Actes Sud, 1998: 155.

Smolenicka, Maria, ed. "Hans Danuser." In *Foto Relations*. Exh. cat., Kunsthaus Brünn, Jan. 13 – Mar. 1, 1998. Bern: Stämpfli, 1998: 36 – 37.

1997

Alpenblick: Die zeitgenössische Kunst und das Alpine; Trans alpin 2. Edited by Wolfgang Kos and Kunsthalle Wien. Exh. cat., Kunsthalle Wien, Oct 31, 1997 – Feb. 1, 1998. Basel: Stroemfeld / Roter Stern 1997.

amanfang: Carte Blanche von Hans Danuser. Exhibition publication, Helmhaus, Zurich, Dec. 5, 1997 – Jan. 18, 1998. Zurich: Helmhaus, 1997.

Bildhauerei: Markus Casanova. Edited by Bündner Kunstmuseum. Visual concept and photographs by Hans Danuser. Exh. cat., Bündner Kunstmuseum Chur, Apr. 26 – Jun. 8, 1997. Baden: Lars Müller, 1997.

Im Dunkeln zum Licht. Edited by Irène Preiswerk. Exhibition publication, Galerie Semina rerum, Zurich, Jan. 25 – Feb. 28, 1997. Zurich: Semina rerum, 1999.

Die Schwerkraft der Berge 1774 – 1997: Trans alpin 1. Edited by Stephan Kunz, Beat Wismer, and Wolfgang Denk. Exh. cat., Aargauer Kunsthaus Aarau, Jun. 15 – Aug. 24, 1997; Kunsthalle Krems, Sept. 7 – Nov. 23, 1997. Frankfurt am Main / Basel: Stroemfeld / Roter Stern, 1997.

Ammann, Daniel and Zvjezdana Cimerman. *Kunst und Gentechnologie: Werkbeispiele aus Bildender Kunst, Photographie, Musik, Literatur, Film, Theater und Kabarett*. Edited by Schweizerische Arbeitsgruppe Gentechnologie. Basel: Schwabe, 1997.

Danuser, Hans. "Frozen Embryo Series." In *Leitbild*. Edited by the Bundesamt für Kultur. Bern: Bundesamt für Kultur, 1997.

Danuser, Hans. "Frozen Embryo Series." In *Jahresbericht*. Edited by Zürcher Kunstgesellschaft. Zurich: Zürcher Kunstgesellschaft 1997: 13.

Arlitt, Sabine. "Freier Blick auf die Berge: Kunsthaus Aarau; Berg- und Tal-Fahrten durch zwei Jahrhunderte Kunstgeschichte." *Tages-Anzeiger* (Jun. 28 – 29, 1997): 63.

Kuoni, Gisela. "'Die Vorlage': Eine Fotoserie zur Bildhauerei von Markus Casanova." *Bündner Zeitung* (May 9, 1997): 15.

Masüger, Peter. "Hans Danusers Sehweise von Markus Casanovas Bildhauerei." *Bündner Zeitung* (May 9, 1997): 15.

Phillips-Krug, Jutta. "Einführung." Photographs from *In Vivo* by Hans Danuser. In *Frankensteins Kinder: Film und Medizin*. Edited by Jutta Phillips-Krug et al. Exh. cat., Museum für Gestaltung, Zurich, Mar. 8 – Apr. 20, 1997. Ostfildern-Ruit: Cantz, 1997: 9 – 13.

Szeemann, Harald. "Hans Danuser." In *L'autre: 4e biennale d'art contemporain de Lyon*. La Halle, Tony Garnier, Lyon, Jul. 9 – Sept. 24, 1997. Edited by the Réunion des musées nationaux (RMN) and the Biennale de Lyon. Paris: Seuil, 1997: 118 – 119.

Von Weizsäcker, Christine, Adolf Muschg, and Franz Hohler. *Mythos Gen*. Photographs from *Chemistry II* by Hans Danuser. Ennetbaden: Utzinger / Stemmle, 1997.

Zarnegin, Kathy. "Also schreibt K." Photographs from *Strangled Body* by Hans Danuser. *Basler Magazin* no. 40 (1997): 6 – 7.

1996

Anon. "Eine Fahrt durch die Fotogeschichte: 'Im Kunstlicht,' eine Ausstellung mit 800 Fotos im Kunsthaus." *Tagblatt der Stadt Zürich* (Aug. 27, 1996): 9.

Bagattini, Renato. "Tabuthemen künstlerisch verarbeitet: Neue Fotoarbeiten von Hans Danuser im Kunsthaus Zürich." *Neues Wiler Tagblatt* (Apr. 12, 1996): 31.

Gerster, Ulrich. "Um Geburt und Tod: Ausstellung Hans Danuser im Kunsthaus Zürich." *Neue Zürcher Zeitung* (Apr. 10, 1996): 52.

Lang, Heinz and Urban Marty. *Kunst und Technik: Der gesellschaftliche Umgang mit der Gentech-*

nologie in der bildenden Kunst. Term paper. Zurich: ETH Zurich, 1996.

Koidl, Nina. "Hans Danuser." In Prospect 96: Photographie in der Gegenwartskunst. Exh. cat., Steinernes Haus and Schirn Kunsthalle, Frankfurt, Mar. 9 – Apr. 12, 1996. Edited by Frankfurter Kunstverein and Schirn Kunsthalle Frankfurt. Kilchberg: Stemmle, 1996: 85 – 87.

Kuoni, Gisela. "Fotografische Überfülle im Kunstmuseum Zürich: 'Im Kunstlicht'." Bündner Zeitung (Sept. 25, 1996): 19.

Kuoni, Gisela. "Ein Glaubensbekenntnis an die Macht der Fotografie in Frankfurt." Bündner Zeitung (Mar. 21, 1996): 25.

Kuoni, Gisela. "Grenzen und Möglichkeiten der Fotografie: Hans Danuser im Gespräch mit Beat Stutzer im Schloss Haldenstein." Bündner Zeitung (Feb. 26, 1996): 20.

Mack, Gerhard. "Linse statt Pinsel: Immer mehr Künstler benutzen die Fotografie als Medium für ihre Werke." Cash (Apr. 12, 1996): 38.

Magnaguagno, Guido, ed. "Hans Danuser." In Im Kunstlicht: Photographie im 20. Jahrhundert aus den Sammlungen im Kunsthaus Zürich. Exh. cat., Kunsthaus Zürich, Aug. 23 – Nov. 10, 1996. Zurich: Kunsthaus Zürich, 1996: 61.

Magnaguagno, Guido. "Hans Danuser: Delta; Fotoarbeiten 1990 – 1996." Kunsthaus Zürich no. 2 (1996): 22 – 23.

Masüger, Peter. "Kunsthaus Zürich: 'Delta'-Fotoarbeiten; An der Grenze des Erkennbaren." Bündner Tagblatt (Jun. 14, 1996): 30.

Müller, Franz. "Randbereiche des Lebendigen: Fotoarbeiten von Hans Danuser im Kunsthaus Zürich." Der Landbote, Feuilleton (Apr. 24, 1996): 1.

Oberholzer, Niklaus. "Kunsthaus Zürich: Der Fotokünstler Hans Danuser; Über die Grenzen des Lebens hinaus." Neue Luzerner Zeitung (Apr. 13, 1996): 28, 45.

Papst, Manfred. "An Schwellen: Hans Danusers Räume in der Universität Irchel." Neue Zürcher Zeitung (Sept. 3, 1996): 54.

Pfrunder, Peter. "Hans Danuser." In The Eye of the Beholder: Seven Contemporary Swiss Photographers. Edited by the Swiss Federal Office of Culture. Exh. cat., The Swiss Institute, New York, Feb. 15 – Mar. 23, 1996. Baden: Lars Müller, 1996, 71 – 78.

Schaub, Martin. "Fotografische Weltbilder und Kabinettstücke: 'Prospect 96' in Frankfurt widmet sich ausschließlich der Fotografie." Tages-Anzeiger (Mar. 15, 1996): 92.

Schaub, Martin. "Die Fotografie als Stoff und als Medium: Hans Danuser im Kunsthaus Zürich." Tages-Anzeiger (Apr. 17, 1996): 31.

Sturm, Martin, ed. Elisabeth Schimana, Obduktion: Intermediale Installation mit Projektionen von Thomas Freiler. Photographs from In Vivo by Hans Danuser. Exh. cat., Offenes Kulturhaus, Linz, Jan. 26 – Feb. 11, 1996. Linz: Offenes Kulturhaus, 1996: 11, 14.

Tresch, Christine. "Bild und Sprachhäute: 'Delta'-Fotoarbeiten von Hans Danuser im Kunsthaus Zürich." WoZ (Apr. 19, 1996): 15.

Zwez, Annelise. "Dimensionen des Lebens und des Todes: Hans Danuser im Kunsthaus Zürich." Aargauer Tagblatt (Apr. 18, 1996): 22.

Zwez, Annelise. "Zur Ausstellung von Hans Danuser im Kunsthaus Zürich: Mit Fotografie die Eckpunkte des Lebens ausleuchtend." Zürcher Oberländer (Apr. 13, 1996): 21; Aargauer Tagblatt (Apr. 18, 1996): 27.

1995

La collezione fotografi ca svizzera della Banca del Gottardo. Edited by Guido Magnaguagno. Exh. cat., Galleria Gottardo, Lugano, Sept. 12 – Nov. 18, 1995; Centro d'arte contemporanea, Bellinzona, Sept. 12 – Oct. 22, 1995; Galleria Matasci, Tenero, Sept. 12 – Oct. 22, 1995. Bellinzona: Arti Grafiche Salvioni, 1995.

Anon. "Was sind, was sollen, was müssen die Künste in dieser Gesellschaft?" Tages-Anzeiger (Nov. 21, 1995): 21.

Danuser, Hans. Picture insert from the Frozen Embryo series. Parkett 44 (1995): 181 – 196.

Edwards, Elizabeth. "Seeing How Others Die." Picture insert from In Vivo by Hans Danuser. In The Dead. Exh. cat., National Museum of Photography, Film & Television, Bradford, Oct. 5, 1995 – Jan. 7, 1996. Pictureville: National Museum of Photography, Film & Television, 1995, 52 – 53.

Kübler, Christof. "Grenzverschiebung und Interaktion: Der Fotograf Hans Danuser, der Architekt Peter Zumthor und der Schriftsteller Reto Hänny." In Georges-Bloch-Jahrbuch. Edited by Kunstgeschichtliches Seminar der Universität Zürich. Zurich: Kunsthistorisches Institut der Universität Zürich, 1995, 163 – 183.

Stahel, Urs. "Interview mit Hans Danuser." Photographs from In Vivo, the Frozen Embryo series, and Erosion by Hans Danuser. In Ohne Titel: Eine Sammlung zeitgenössischer Schweizer Kunst. Edited by the Stiftung Kunst Heute Bern, with an essay by Beat Stutzer. Exh. cat., Aargauer Kunsthaus Aarau, Jan. 28 – Mar. 19, 1995. Baden: Lars Müller, 1995, 48 – 53.

1994

Fuller, Gregory. "Hans Danuser." In Endzeitstimmung: Düstere Bilder in goldener Zeit. Cologne: Du-Mont, 1994, 128 – 132.

Hänny, Reto. Helldunkel: Ein Bilderbuch. Frankfurt am Main: Suhrkamp, 1994.

Kübler, Christof. "Archäologie und Alchemie: Hans Danuser fotografiert Architektur." Architese no. 4 (1994): 44 – 49.

Kübler, Christof. "Gestaltete Naturwissenschaft: Naturwissenschaftliche Gestaltung." Uni Zürich: Magazin der Universität Zürich no. 2 (1994): 61 – 63.

Kuoni, Gisela. "Hans Danusers Foto-Installation an der Universität Zürich-Irchel." Bündner Zeitung (Aug. 20, 1994): 17.

Ringger, Heini. "Schwarztöne eines Fotoalchemisten." Picture insert from Institutsbilder by Hans Danuser. Uni Zürich: Magazin der Universität Zürich no. 2 (1994): 4 – 5.

Tyran, Jean-Robert. "Der Markt macht's möglich." Photographs from In Vivo by Hans Danuser. WoZ (Apr. 1, 1994): 7.

Wolf, Conradin. "Der verschwiegene Tod: Eine Polemik." Berner Zeitung (May 2, 1994): 24.

1993

Kübler, Christof. "Gegen das Primat der reinen Dokumentation: Beobachtungen: Hans Danuser fotografiert Bauten des Ateliers Zumthor." Bündner Zeitung (Apr. 29, 1993): 33.

Kuoni, Gisela. "Besuch beim Fotografen Hans Danuser in der Arnold-Böcklin-Villa in Zürich." Bündner Zeitung (Sept. 29, 1993): 5.

Kuoni, Gisela. "Hans Danuser im Kunstmuseum Graubünden." Kunstbulletin no. 11 (1993): 38 – 39.

Kuoni, Gisela. "Hans Danuser, 'Wildwechsel': Eine besondere Ausstellung." Bündner Zeitung (Oct. 14, 1993): 35.

Meuli, Kaspar. "Zurück in die atomare Zukunft?" Photographs from In Vivo by Hans Danuser. WoZ, Dossier Atomenergie (Jan. 15, 1993): 25 – 27.

Tresch, Christine. "'Wildwechsel': Ausstellung von Hans Danuser in Chur; Kein Unschuldsland." WoZ (Oct. 8, 1993): 18.

1992

"Fotograf Hans Danuser erhält 1992 den Conrad-Ferdinand-Meyer-Preis." Bündner Zeitung (Jan. 15, 1992): 5.

Danuser, Hans. "Chemie II, In vivo." Picture insert. Entwürfe für Literatur und Gesellschaft no. 4 (1992): 12 – 16.

Meier, Marco. "Peter Zumthor: Architektur der Gelassenheit." Picture insert by Hans Danuser. Du: Die Zeitschrift für Kunst und Kultur no. 5 (1992): 49 – 59.

Schweizerische Stiftung für die Photographie, ed. "Hans Danuser." In Photographie in der Schweiz von 1840 bis heute. Bern: Benteli, 1992, 261.

1991

Baer, Dagmar. "Hans Danuser" in Schweizer Lexikon 91. Edited by Kollektivgesellschaft Mengis + Ziehr. Horw / Lucerne: Verlag Schweizer Lexikon, 1991, 2: 128.

Danuser, Hans. "In vivo." Picture insert. In The Interrupted Life. Edited by Jan Heller Levi, with essays by Peter Greenaway, Charles Merewether, Anthony Vidler, Silvère Lotringer et al. Exh. cat., The Museum of Contemporary Art, New York, Sept. 12 – Dec. 29, 1991. New York: New Museum of Contemporary Art, 1991, 136 – 148.

Jost, Carl. "Hans Danuser." In Künstlerverzeichnis der Schweiz: 1980 – 1990. Edited by Schweizerisches Institut für Kunstwissenschaft Zürich und Lausanne. Frauenfeld: Huber, 1991, 111.

Stahel, Urs. "The Photo-Essays of Hans Danuser." Arts Magazine no. 12 (1991): 23 – 26.

1990

Altdorfer, Sabine. "Fotokunst pur: Zu Hans Danusers Fotoband In vivo." Badener Tagblatt (Mar. 3, 1990): 10 – 12.

Dietrich, Andreas. "Nach dem Tod." Picture insert from In Vivo by Hans Danuser. Das Magazin no. 39 (1990): 24 – 34.

Huber, Jörg. "Wichtige Bilder: Zur zeitgenössischen Schweizer Fotografie." *Kunstbulletin* nos. 7–8 (1990): 36–39.

Kühner, Claudia. "Statt Rembrandts: Fotos sammeln." *Kunstforum* no. 110 (1990): 274–277.

Rothenberger, Manfred. "Agitation durch die Hintertür." *Mitteilungen des Instituts für moderne Kunst Nürnberg* nos. 51–52 (1990): 61–62.

Stahel, Urs. "Hans Danuser: In vivo" and "Fotografie in der Schweiz." In *Wichtige Bilder: Fotografie in der Schweiz.* Edited by Martin Heller and Urs Stahel. Exh. cat., Museum für Gestaltung, Zurich, Jun. 28–Aug. 26, 1990. Zurich: Der Alltag, 1990, 58–65, 147–240.

Wolf, Conradin. "Vorstoß in Tabuzonen: Eine Publikation des Fotografen Hans Danuser." *Tages-Anzeiger* (Jan. 10, 1990): 11.

Zollikofer, Doris. "Ästhetik des Grauens." *Hochparterre* no. 3 (1990): 98.

1989

Danuser, Hans. *Das Weiß in der Fotografie.* Picture insert from *Feingold. Du: Die Zeitschrift für Kunst und Kultur* no. 12 (1989): 48, plate 14.

Fischbacher, Roland. "Hans Danuser: In vivo." Picture insert. *Fabrik Zeitung* no. 58 (1989): 4–5.

Jahnn, Hans Henny. "Jeden ereilt es." Picture insert from *In Vivo* by Hans Danuser. In *Die Trümmer des Gewissens.* Bern: Stadttheater Bern, 1992, 17–23.

Huber, Jörg. "Kunstblatt: Hans Danuser, A-Energie." *Beobachter* no. 5 (1989): 21.

Jankowski, Adam. "Zukunft gestalten: Einspruch, Widerspruch, Gegenbild." Picture insert from *In Vivo* by Hans Danuser. *Hochparterre* no. 10 (1989): 70–75.

Von May, Glado, ed. *Hochhuths Unbefleckte Empfängnis: Ein Kreidekreis.* Stadttheater St. Gallen Program, picture insert from *In Vivo* by Hans Danuser. St. Gallen: Ostschweiz Verlag, 1989.

Oberholzer, Niklaus. "Fotografie im Aargauer Kunsthaus: Danusers unerbittliche Schule der Wahrnehmung." *Vaterland* (Jun. 3, 1989): 7.

Stahel, Urs. "Hans Danuser: In vivo." *Der Alltag* no. 1 (1989): 22–25.

Stutzer, Beat. "Hans Danuser." In *Bündner Kunstmuseum Chur: Gemälde und Skulpturen.* Edited by the Stiftung Bündner Kunstsammlung Chur. Chur: Stiftung Bündner Kunstsammlung, 1989, 259–261.

Wismer, Beat. "Photographie der Herausforderung." *Tages-Anzeiger* (Nov. 16, 1989): 25.

Wolf, Conradin. "Auf den Inseln der Verdrängung: Der bedeutende Schweizer Fotograf Hans Danuser im Kunsthaus Aarau." *Tages-Anzeiger* (Jun. 12, 1989): 11.

Zumthor, Peter. "Die Verwandtschaft der Formen." Photographs from *Caplutta Sogn Benedegt* by Hans Danuser. *Werk, Bauen + Wohnen* no. 4 (1989): 24–31.

1988

Partituren und Bilder: Architektonische Arbeiten aus dem Atelier Peter Zumthor 1985–1988. Photographs by Hans Danuser. Exhibition publication, Architekturgalerie Luzern, Oct. 2–23, 1988; Haus der Architektur, Graz, Jul. 27–Aug. 18, 1989. Edited by Architekturgalerie Luzern. Lucerne: Architekturgalerie Luzern, 1988.

Billetter, Fritz. "Kunst als Deutung & Daseinsspur: Rundgang durch Zürcher Galerien." *Tages-Anzeiger* (Mar. 26, 1996): 13.

Stutzer, Beat, ed. "Angelika Kauffmann, Miriam Cahn, Hans Danuser." In *Konfrontationen: Von Angelika Kauffmann bis Miriam Cahn.* Exh. cat., Bündner Kunstmuseum Chur, Jun. 26–Sept. 17, 1988. Chur: Bündner Kunstmuseum, 1988: 4–5.

1987

Offenes Ende: Junge Schweizer Kunst. Edited by Institut für moderne Kunst Nürnberg. Exh. cat., and exhibition documentation, Nuremberg, various places, May 31–Jul. 17, 1987. Zirndorf: Verlag für moderne Kunst, 1987.

Meuli, Andrea. "Hans Danuser: Faszination der Grenzbereiche." *Bündner Zeitung* (Dec. 21, 1987): 11.

Schaub, Martin. "Der Fotograf Hans Danuser im Gespräch mit Leben und Tod." *Tages-Anzeiger Magazin* no. 14 (1987): 38–41.

Wolf, Conradin. "Hans Danuser." *Kunstbulletin* no. 5 (1987): 2–6.

1985

De Jong, Peter. "Mit der Kamera Verborgenes ans Licht bringen." *Neue Zürcher Zeitung,* Feuilleton (Dec. 27, 1985): 31.

Magnaguagno, Guido. "Neue Wahrnehmungen: Über die Schweizer Photographie der letzten Jahre." *Du: Die Zeitschrift für Kunst und Kultur* no. 8 (1985): 55–67.

Schaub, Martin. "Aus Tabuzonen der Gegenwart: Die transzendierende Sachlichkeit des Fotografen Hans Danuser." *Tages-Anzeiger* (Dec. 11, 1985): 25.

Stahel, Urs. "Zwölf Photographen und ihre Arbeiten." *Du: Die Zeitschrift für Kunst und Kultur* no. 8 (1985): 26–29.

1984

Danuser, Hans. "Art: Preservation Baths; Anatomy Dissect Hall." Picture insert. *pan arts* no. 1 (1984): 30–31.

1983

Aktuell '83: Kunst aus Mailand, München, Wien und Zürich. With essays by Erika Billeter and Armin Zweite. Exh. cat., Städtische Galerie im Lenbachhaus, Munich, Sept. 21–Nov. 20, 1983. Munich: Städtische Galerie im Lenbachhaus, 1983.

Billeter, Erika. "Die Neue Kunstszene." *Schweizer Illustrierte.* no. 39 (1983): 58–70.

Herzer, Heinz et al., ed. *Neue Kunst in München* no. 19 (1983).

Irgang, Margrit. "Unbehauste Zeit." *Die Weltwoche* (Oct. 20, 1983): 11.

Keller, Werner. "New York: Zürcher Atelier für Bündner." *Neue Zürcher Zeitung* (Jun. 24, 1983): 29.

Kesser, Caroline. "Junge Kunst bemächtigt sich historischer Räume." *Tages-Anzeiger* (Sept. 27, 1983): 25.

Lehrerservice des WWF Schweiz (ed.). *Atomenergie: Mappe mit acht Fotografien und didaktischem Kommentar.* Picture insert from *A-Energy* and *In Vivo* by Hans Danuser. Zurich: WWF-Lehrerservice, 1983.

Ruppen, Oswald. "Tendenzwende …? Eidgenössisches Stipendium für angewandte Kunst 1983." *Schweizerische Photo-Rundschau* no. 9 (1983): 16–27.

1982

Danuser, Hans. "A-Energie." Picture insert. *Trans-Atlantik* no. 8 (1982): 31–34.

Gagel, Hanna. "Das 82er Lebensgefühl in fotografischen Spuren." *Tages-Anzeiger* (Dec. 29, 1982): 19.

1981

Heusser, Hans-Jörg. "Danuser, Hans, Fotograf." In *Lexikon der zeitgenössischen Schweizer Künstler.* Edited by the Schweizerisches Institut für Kunstwissenschaften. Frauenfeld / Stuttgart: Huber, 1981: 78.

Radio and TV

2017

Seiler, Barbara. "The Last Analog Photograph / Landschaft in Bewegung: Der Fotokünstler Hans Danuser." 50 min., 55 sec., a story for *Sternstunde*, Jun. 11, 2017. SF Schweizer Fernsehen.

2011

"Die Kunst im Prime Tower." 1 min., 25 sec., writing installation *Piff Paff Puff* by Hans Danuser. A feature for *Kulturplatz*, Aug. 24, 2011. SF Schweizer Fernsehen.

2009

Seiler, Barbara. *Landschaft in Bewegung: Unterwegs mit dem Künstler und Fotografen Hans Danuser.* Documentary, 52 min. Producer: René Baumann; camera: Christine Munz; editing and music: Brian Burman; location sound mix: Michael Ryffel. Zurich: Videoladen, 2009.

Seiler, Barbara. "Landschaft in Bewegung, Unterwegs mit dem Künstler und Fotografen Hans Danuser." 49 min., 54 sec., a story for *Sternstunde*, Jan. 18, 2009. SF Schweizer Fernsehen.

2007

Danuser, Hans et al. *Tschöntsch: Eine Filmskizze.* 19 min. Zurich: Peter Frei, 2007.

2005

Schaub, Christoph. "Hans Danuser." 12 min. Camera: Pio Corradi; sound: Marin Witz; cutting: Marina Wernli; music: Balz Bachmann; editing: Christian Eggenberger. A story for *Photosuisse*, Nov. 27, 2005. SF Schweizer Fernsehen.

2002

Brew, Kathy and Roberto Guerra et al. *Paradise Now: Picturing the Genetic Revolution.* VHS-video, 50 min. New York: Mosquito Productions, 2002.

2001

Salm, Karin. "Gespräch mit Hans Danuser." 60 min., an interview for *Musik für einen Gast*, Nov. 25, 2001. Schweizer Radio DRS 2.

Seiler, Barbara. "Hans Danuser: Die Schiefertafel in Beverin." 12 min., a story for *B. Magazin*, Oct. 7, 2001. SF Schweizer Fernsehen.

2000

Jud, Edith. "Hans Danuser." 6 min., a story for *Kulturzeit*, Dec. 8, 2002. 3sat.

1997

Kaiser, Stefan. "Die vielschichtigen Matographien von Hans Danuser im Nidwaldner Museum." 8 min., a story for *Next*, Oct. 26, 1997. SF Schweizer Fernsehen.

1996

Hegglin, Michael. "Zeichen im Dunkel. Hans Danuser." 26 min., 46 sec., a story for *Satellitenprogramm*, Apr. 10, 1996. 3sat.

1993

Hegglin, Michael. "Fotografien von Hans Danuser." 4 min., 44 sec., a feature for *10 vor 10*, May 28, 1993. SF Schweizer Fernsehen.

1989

Von Däniken, Hans-Peter. "Hans-Peter von Däniken im Gespräch mit dem Fotografen Hans Danuser über sein Fotobuch *In vivo*." 12 min., 27 sec., a story for *Reflexe Kunst*, Dec. 22, 1989. Schweizer Radio DRS 2.

Regli, Beat. "Ausstellung Hans Danuser im Aargauer Kunsthaus." 1 min., 45 sec., a story for *Kultur Aktuell*, May 21, 1989. SF Schweizer Fernsehen.

First edition in English 2018

© 2018 for the photographs: see catalog of works in this volume
© 2018 for the essays by the authors
© 2018 for this edition: Bündner Kunstmuseum Chur
and Steidl Verlag, Göttingen

This edition was published in conjunction with the exhibition
Hans Danuser: The Darkrooms of Photography
Bündner Kunstmuseum Chur
June 20 to August 20, 2017

Steidl
Düstere Str. 4 / 37073 Göttingen
Tel. +49 551 49 60 60 / Fax +49 551 49 60 649
mail@steidl.de
steidl.de

ISBN 978-3-95829-337-3
Printed in Germany by Steidl

Exhibition

Curators: Stephan Kunz, Lynn Kost
Academic associate: Misia Bernasconi
Exhibition office: Esther Brasser
Administration: Laurent Ostinelli
Public relations: Kathrin Gartmann
Exhibition technicians: Roy Perfler, Duri Salis, Stephan Schenk,
Markus Scherer, Thomas Strub

Publication

Edited by Bündner Kunstmuseum Chur,
Stephan Kunz and Lynn Kost
Concept: Hans Danuser, Stephan Kunz, Lynn Kost
Essays: Lynn Kost, Stephan Kunz, Jörg Scheller, Urs Stahel, Philip Ursprung,
Kelley Wilder, Stefan Zweifel
Translations: Christiane Oberstebrink
Text editor: Sylee Gore, Berlin
Proofreader: Andrea Linsmayer
Design: Hanna Williamson-Koller, Zurich
Scans: Martin Flepp, Somedia Productions
Separations: Steidl image department
Production: Gerhard Steidl, Bernard Fischer
Overall production and printing: Steidl, Göttingen

Cover image

THE LAST ANALOG PHOTOGRAPH, 2007–2017
LANDSCHAFT IN BEWEGUNG (LANDSCAPE IN MOTION) / Moving Desert,
work in progress, Part III of the EROSION project
Analog photograph, gelatin silver on baryta paper
Several bodies of works
Detail of image no. A1
Paper 40 x 50 cm, image 21 x 46 cm
In the artist's personal collection

Picture credits

H.D. Casal, pp. 178–179
Hans Danuser, Zurich, p. 10
Ralph Feiner, Malans, pp. 6–7, 19–47, 58–59, 76–77, 100–101,
126–127, 156–157, 168–169, 188–189, 204–205, 216–217
Cover image
Gaechter & Clahsen, Zurich, p. 11
Brigitta Nideröst, Zurich, p. 13
Christian Schwager, Winterthur, pp. 60–61, 64–65, 72
Thomas Strub, Chur, pp. 16–17
V.B.D., Fabrikationshalle 2, Zurich, p. 52
Cristina Zilioli, Zurich, p. 12

Every effort has been made to trace the copyright holders
and obtain permission to reproduce this material.
Please inform us of any outstanding claims or corrections.

**The exhibition and catalog were made
possible with the generous support of:**

Erna and Kurt Burgauer Foundation
Ernst Göhner Foundation
Graubündner Kantonalbank
Kulturförderung Kanton Graubünden
Kulturförderung Stadt Chur
Sophie and Karl Binding Foundation
Volkart Foundation

Amt für Kultur / Bündner Kunstmuseum Chur
Uffizi da cultura / Museum d'art dal Grischun Cuira
Ufficio della cultura / Museo d'arte dei Grigioni Coira

SWISSLOS
KULTURFÖRDERUNG
KANTON GRAUBÜNDEN

Stadt Chur

N° 69 im Programm der
Binding **Sélection d'Artistes**

Partner

Graubündner
Kantonalbank

MARMOGRAPHIEN /
MARBLEGRAPHS
1976

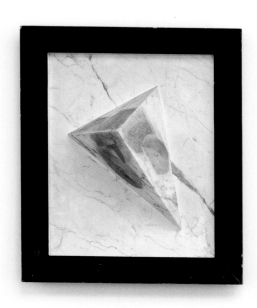

Table of Contents

Hans Danuser

Darkrooms of Photography

Edited by
Stephan Kunz and Lynn Kost

Bündner Kunstmuseum Chur

Steidl

Binding
Sélection d'Artistes

N° 69